POPE JOHN PAUL II

A Life in Pictures

Pope John Paul II
A Life in Pictures

© 2005 powerHouse Cultural Entertainment, Inc.
Text © 2005 Henri Tincq
Photographs © 2005 the photographers, as indicated on page 248

Published in the United States by powerHouse Books,
a division of powerHouse Cultural Entertainment, Inc.
68 Charlton Street, New York, NY 10014-4601
telephone 212 604 9074, fax 212 366 5247
e-mail: info@powerHouseBooks.com
website: www.powerHouseBooks.com

First edition, 2005

Library of Congress Cataloging-in-Publication Data:

Pope John Paul II : a life in pictures / edited by Yann-Brice Dherbier and Pierre-Henri
 Verlhac ; essay by Henri Tincq.. -- 1st ed.
 p. cm.
 ISBN 1-57687-265-3
 1. John Paul II, Pope, 1920---Pictorial works. 2. John Paul II, Pope, 1920- 3.
 Popes--Biography. I. Dherbier, Yann-Brice. II. Verlhac, Pierre-Henri.

 BX1378.5.P657 2005
 82'.092--dc22
 [B] 2005048731

Hardcover ISBN 1-57687-265-3

Printed and bound in China

Designed by Atalante Paris
42 rue Sedaine 75011 Paris, France
www.atalante-paris.fr

A complete catalog of powerHouse Books and Limited Editions is available upon request;
please call, write, or visit our website.

10 9 8 7 6 5 4 3 2 1

POPE JOHN PAUL II

A Life in Pictures Texts Henri Tincq, edited by Yann-Brice Dherbier & Pierre-Henri Verlhac

pH powerHouse Books

New York, NY

JOHN PAUL II

A Biography by Henri Tincq

FOREWORD

Man of God and Guardian of the World

The ceiling coffers are painted or gilded. Frescoes and ancient maps on the walls retrace the steps of the evangelization of the New World. Through the bronze door located in the right wing of Bernini's colonnade, the visitor enters the pontifical palace and the pope's apartments. In the Courtyard of Saint Damasus, and then down the hushed corridors and elevators, he is greeted by the Swiss Guards, who, in accordance with unchanging protocol, strike their halberds on a small rostrum. The monsignors, in cassocks or austere black suits and clerical collars, greet the visitor with a slight nod of their heads before returning their gaze to the marble floor.

Nothing seems more disproportionate in comparison with the solemnity of these places, the wealth of treasures and art amassed throughout history, and the size of the Vatican (nearly one hundred nine acres) than the simplicity of the men who live there. However long legends feeding on political intrigue may linger on the gold and marble of the Apostolic Palace, nothing is more inflated than the nefarious reputation that at times still clings to the papal court.

To be convinced of this, one only has to enter the pope's private chapel for his 7:00 AM morning mass, which he never misses, except when traveling. He celebrates the mass in the company of the Polish clerics who serve him, a hand-picked group of about thirty guests, and Monsignor Stanslas Dziwiscz (the ever-present secretary and confidant who came with the pope from Kraków in 1978). In Rome, they call Dziwiscz "Dom Stanislas," and speak his name with a mixture of sympathy and fear.

Amid the swirl of grey marble in the private chapel, one can only see a splash of white, green, or violet (colors that change with the liturgical seasons: Advent, Easter, and others), stretched out on the floor or kneeling on a prie-dieu. The frail silhouette of the pope, deep in prayer, can be made out under the alb in which he will celebrate mass. Not a single noise seems to disturb his personal encounter with God. His body is as still as a stone statue. Then he rises, mounts the altar, and recites the mass with the same unction, the same gestures, as a simple priest, alone—like one in a country church, a slum, or even a prison.

The pope is above all a priest, that is, a shepherd of souls. Karol Wojtyla often recalls his years as a vicar in a rural parish in Niegwicz, near Kraków. More than once he has also recalled that his first article for *Tygodnyk Powszechny*, written in 1949, was about the French worker-priests. He shows unending respect for the curate of Ars—like himself, a prisoner of the altar and the confessional. Cardinal Lustiger, who knows him well, one day

told us in confidence, "One cannot understand anything about this man without knowing that he spends at least three hours a day in prayer. Key decisions are made not in his office, but in his chapel."

And so we have seen this pope dozens of times, climbing up or down the stairs to an airplane, his popemobile cleaving its way through streets bursting with jubilant crowds waving small white and yellow flags with the Vatican's coat of arms. We have seen him speak to multitudes of men, women, and youth at huge gatherings. We have seen him in consultation with heads of state, in the VIP lounge of an airport, in residences both princely and common. We have seen him embrace his "brothers" of all religions. But the profound truth of the man is above all his unique and silent relationship with his God. Every three days his secretary slips several small pieces of paper bearing a name, an address, or a cause for prayer into a box in the chapel. "All the woes of the world are brought here," his spokesman Joaquin Navarro-Valls told us one day.

What unfailingly stuns a visitor, be it a statesman, bishop, or journalist, is the focused attention granted him by the pope. It is as if all his concerns and responsibilities vanished in an instant as he listens in deep concentration—in his office, at his table, or as he is leaving an audience in the Clementine Room. It was there, for example, where in April, 1988 he received *Le Monde*'s correspondent for an interview on the consequences for France of the Lefebvre affair, and the hypothesis of a schism in the Church. "You must have great faith," he concluded, in excellent French.

Nothing could be further from the truth than to harbor an image of him— before he was stricken by illness and the rigors of age—as a globetrotting head of state, hopping from one airplane to another, from one audience to another, adhering to a tightly timed schedule. John Paul II was extraordinarily accessible to people and events, and capable of forgetting the photo-op, the officials, and the bodyguards assigned to him. Nothing was more important to him than to find God and to speak to the Other.

In the Alitalia plane that took him to the ends of the earth, on almost every journey except the last few, when fatigue prevented him, he would leave his comfortable first class seat in front of his nurse, his secretary, his doctor, and the delegation of cardinals to go to the back of the cabin. There, he would exchange a few words with journalists, answer questions, bless a hostess, or roar with laughter amid the forest of microphones, cameras, photo equipment, and arms extended out to him.

On the return flight, although worn out from the pace of events, he would still ask a journalist to come forward to his seat—with the agreement of Dom Stanislas, Joaquin Navarro-Valls, and the ever-present photographer Arturo Mari—not to suggest an article, or even less to reproach him, but to chat for a few seconds in the journalist's mother tongue to ask for news of his family or to bless a picture.

In Lourdes in August, 1983, for once at some distance from the cameras, we saw him caress the faces or the fingers of the sick and handicapped lying on stretchers, giving each one several minutes, without concern for his tight schedule. In the church of Gethsemani in Jerusalem in March, 2000, at the foot of the rock where Christ suffered his agony, we likewise saw his face buried in his hands, indifferent to the movement of the officials and crowd surrounding him, as he inwardly relived the pain and abandonment of Jesus on His last night.

The same emotion appeared in 1987, next to the church of Saint Nicolas Kostka in Warsaw, above the tomb of the assassinated priest Jerzy Popieluszko. The tomb was blanketed by a mountain of flowers, and surrounded by red and white Polish flags and candles burning day and night. The same intensity occurred in May, 1991 at Fatima, in front of the statue of the blessed Virgin Mary. John Paul II firmly believed the Virgin had spared him from the bullet fired by Ali Agça ten years earlier in Saint Peter's Square, which was meant to have killed him. What hasn't been said of his devotion to Mary, confused for better or worse with an early transference of affection after the death of his mother, Emilia Kaczorowska, when he was only nine years old?

Lasting images from interviews and tours around the world! His visit to Lithuania in 1993, to the hill planted with almost as many crosses as that country numbers its martyrs to communism. His astounding trek by foot to Jerusalem's Western ("Wailing") Wall in March, 2000, seeking to erase in one stroke, with one message slipped into a crack in Herod's wall, the Church's two thousand years of anti-Semitism. His return trips to his father's home in Wadowice, which he described as his "first seminary," and where the presence of his father, a widower and retired army man, could still be felt—overseeing his studies; cautioning him against anti-Semitism; teaching him about prayer and frugality; introducing him to German and the great Polish romantic poets, Adam Mickiewicz and Juliusz Slowacki; cultivating his love of theater, poetry, and his country's culture.

In 1987 in Augsburg, Germany, we witnessed his distress when the high mass that had been in preparation for six months was cancelled because the fields were washed out by floods. We saw his solemnity in the square of the Martyrs of Beirut in 1997, facing the sea and in the middle of an indescribable crush of humanity. We saw his infinite patience in the traffic jams in Abuja, Nigeria in 1998. His robust faith and his familiarity with the crowds—singing, miming, and improvising in Gniezno, Gdansk, and Czestochowa. Especially, though, in his native Poland. In his home country, which had been worked over in every sense imaginable, he lit the fuse for the fall of communism, and sturdy workers carrying "Solidarity" banners burst into tears before him.

Did he get even one day's rest in the last twenty-five years? He was called a prisoner in exile at the Vatican, a pope without borders, and a universal guardian. He was called the bogeyman of the planet. But those who saw him in the slums, surrounded by children, the elderly, and the handicapped could never again resort to such offensive clichés.

From "God's sportsman," as he was called at the beginning of his papacy, he went on to be known as the "suffering servant" of the prophet Isaiah in the Bible. But in front of journalists, leaning on his cane, he would smile and joke about his difficulty in walking. And before those who engaged in infinite speculation over whether he would step down, he would feign innocence. "Step down? But to whom would I leave this?" He fulfilled his triple mission as pope to the very end—blessing, teaching, preaching—and guiding the ship of Saint Peter to infinite shores.

—**Henri Tincq,** editor for *Le Monde*

John Paul II (1920-2005)
One Life, One Work

One surely cannot explain the pope's actions, the steadfastness of his commitment to mankind and to his Church, solely by the circumstances of his childhood, adolescence, and family and intellectual background in Wadowice: the small Carpathian city not far from Kraków, ancient royal capital of Poland. But leaving all sentimentality aside, and without distorting his solid faith and natural optimism, neither can one ignore the succession of personal, family, and national tragedies that touched Karol Wojtyla at an early age. These undoubtedly contributed to his tragic view of the world and mankind's fate, and soon pointed him toward his plans for a new, ethical world order.

His mother, Emilia Kaczorowska, was described as a warm, gentle woman, and it was said that the young Karol physically resembled her. She died on April 13, 1929 at the age of forty-five, following a heart ailment that had already kept her frequently bedridden in the family home. Karol Wojtyla, who was born on May 18, 1920, was not yet nine years old. Until her death, Emilia had compensated for her frail health by showing extreme affection for her two sons, Edmund and Karol. It was she who gave them the rudiments of a Christian education, teaching them their prayers and to make the sign of the cross. Her neighbor, Franciszek Zadora, says that Emilia once paid her youngest son the compliment every mother bestows. "You'll see," she said. "My son will become a great man."

Years later at the Vatican, John Paul II confided that his mother had always dreamed of having one son become a doctor and the other a priest. Her wish was doubly granted, but she would not live to see her dream come true. One of the first poems written by Karol Wojtyla while a student in Kraków was to the memory of his idealized and little-known mother. It took a long time for the wound to heal, if indeed it ever did. For many years at school, he had the reputation of being an orphan, and later they spoke of him as a child looking to take his revenge on life. This period of deep mourning, soon followed by others, was a source from which he drew deep sensitivity and great determination. Did this motherless child find a substitute mother in the Virgin Mary, to whom he prayed endlessly, his entire life? That is what has been said and written, but of course only God knows for certain.

In Wadowice, in the third-floor apartment at 7 Koscielna Street, just a few feet from the parish church and Rynek's central square, life went on without the mistress of the house. His father, also named Karol Wojtyla, was the son of a tailor and had served as a lieutenant in the Austrian army prior to November, 1918. After independence, he became captain of the 12th Infantry Regiment, stationed in this small town in southwest Poland. To the town folk, he remained "the lieutenant," and he always dressed to the nines in his military uniform. He was known for his sense of duty and discipline. After his wife's death, he retired and left the army to devote himself entirely to the education of his two sons, Edmund, the eldest, and fourteen-year-old Karol. A little girl, born in-between the two, had not survived.

According to everyone who knew this highly regarded but ordinary family, the widower Karol Wojtyla succeeded in maintaining a home atmosphere focused on work, tenderness, simplicity, and unostentatious piety. His youngest son became a very serious student—upright, hard-working, and devoted to the Church. He was always at the head of his class, yet he was not a solitary "stuffed shirt." On the contrary, he was friendly and sociable, a born leader. He played goalie at soccer games. He had lots of friends, the best of them being Jerzy Kruger, son of the president of the town's Jewish community. Kruger often climbed the stairs of the small grey building leading to the Wojtyla's door so Karol's father could look over the two boys' homework. It was clear that Karol Wojtyla was naturally gifted, making him an exceptional student. In the words of Jerzy Kruger, "If he had gotten a job at General Motors, he would have become president of the company." Every day, Karol went to the parish church in Wadowice and served at mass for Abbot Kazimierz Figlewicz. Figlewicz also taught catechism at Karol's school, along with professor Edward Zacher.

Three years after the death of his mother, Karol suffered another blow. On December 4, 1932, his brother Edmund, a doctor in Bielsko (an hour's drive from Wadowice), died from scarlet fever contracted from a patient at the local hospital. Everything seemed to be going well for this brilliant doctor, who was only twenty-six years old at his death. This deepened the pain and solitude of the two Karols; the son was just twelve years old at the time, in his second year of middle school. Precocious in everything, as he would be later in the Catholic hierarchy, the younger Karol was also deeply troubled. In 1983, during a visit to the prestigious Jagiellonian University in Kraków where both Wojtyla brothers had studied, the pope confided that this second death had an even deeper effect on him than that of his mother Emilia. He said this was because his brother had died from a contagious disease (incurable during that time without antibiotics), and because he himself had been more mature.

Another protective barrier fell. Through the love of his father and friends, and through prayer, Karol found compensation for these brutal emotional hardships. He became an inseparable companion to his father around the house, at church, and on endless walks along the Skawa River, which flows through Wadowice. It can also be said that the elder Karol was an overprotective widower who dedicated himself exclusively to his son, acting simultaneously as father, mother, best friend, and confidant. In large part, he also shielded his son from their material difficulties and the often squalid reality of their existence. Their daily life was austere but not self-righteous. The father encouraged his son in his studies, took on the

housework, and commented on news in the country. He also told war stories, over and over again. Years later, the pope confided that throughout his entire childhood, he heard endless stories from old soldiers about the battlefield horrors of World War I.

Another war loomed, already on everyone's mind and in every conversation. In 1938, after receiving his baccalaureate (his grades were "very good" in all subjects at the Marcin Wadowita High School in Wadowice), he entered university in Kraków to study philology. He also went regularly to the Church of the Silesian Fathers in Kraków and assiduously attended meetings of a spiritual circle led by Jan Tiranowki. A tailor by trade, Tiranowki was an engaging and somewhat enigmatic person who introduced the future pope to Saint John of the Cross, the great Spanish mystic. Saint John would become the subject of Wojtyla's doctoral thesis in theology when he later studied at the Angelicum in Rome. He joined a theater group, wrote poetry, and devoured the works of the great Polish authors of the last century. In April, 1939, he joined the theater group Studio 39 and, along with his friend Mieczslaw Kotlarczyk, developed his natural talent as a director. In 1941, the two friends founded the Rhapsodic Theater, which played to small, clandestine audiences. As the young actress Halina Krolikiewicz, a close friend of the future pope, once said, "We chose to fight, not with arms, but with words and poetry."

Born in 1920 in a country left battered by its struggle for independence, and which counted its dead, wounded, and disabled in the millions, Karol Wojtyla was twenty years old when the bombs rained down on Kraków. He had to find work to avoid deportation to Germany, and he became a factory worker in a Solvay chemical plant. For two years he broke rocks with a sledgehammer in the Zakrzówek quarry near Kraków, before being transferred to a water purification station. One bitterly cold day in February, 1941, he discovered that his father had died, alone in his bed, from the hardships of winter and the occupation. Once again, he was gripped by one of the many tragedies he would experience.

At the same time, he matured in his priestly vocation. At the age of twenty-two, in the midst of war, he began studying at night in the clandestine seminary of Monsignor Adam Sapieha, archbishop of Kraków and a great figure in the Catholic resistance to the occupation. Sapieha, who died a cardinal in 1951, remained a role model for Wojtyla, who greatly respected his ideas about the rights of a nation, built on a foundation of history and culture. Ordained as a priest on November 1, 1946, Abbot Wojtyla then left for Rome, where he studied theology at the Angelicum, a Dominican theological university. There, he devoured the works of Saint John of the Cross and Saint Thomas Aquinas, studied languages, devoted himself to the interpretation of texts, and struck up his first Roman friendships. In 1948, he received his doctorate after writing a thesis on the spirituality of Saint John of the Cross, under the direction of the great French interpreter Father Garrigou-Lagrange.

Karol Wojtyla returned that same year to his country, which had been plunged into a new darkness—communism. He began his career as a simple priest in a small rural parish near Kraków while preparing, at the Catholic University in Lublin, for his qualifying exam in philology on the phenomenology of Max Scheler. While teaching, he lived from the charity of his students. At a youth camp in the lake region of Mazurie in July, 1958, he learned that he had been named Bishop of Kraków by Pius XII (who died three months later). He was only thirty-eight years old. Giving up his university activity and his religious work with youth was painful.

Nevertheless, he rapidly ascended the ecclesiastic hierarchy and became archbishop of Kraków on January 13, 1964. At that time, he took an active part in the Second Vatican Council, or Vatican II, of 1962-1965, drawing the attention of more than a few bishops. Notably, he helped edit the Council's constitution, *Gaudium et spes* (The Church in the Modern World), and defended the document's statement on religious freedom, which was attacked by the conservative minority. Once he was pope, faced with the death throes of communism in the 1980s, it was precisely the question of religious freedom, that is, freedom of conscience and religious choice, that John Paul II would make the source of and pillar for all other freedoms.

He was closely linked to both the Catholic intellectuals who published *Tygodnyk Powszechny*, a well-known weekly in Poland edited by his friend Jerzy Turowicz, and to the magazine *Znak*. These journals became the spearhead of the anticommunist opposition and later provided the leaders for the Solidarity trade union. Alongside them (and with Warsaw's primate, Cardinal Wyszinski), Monsignor Karol Wojtyla, made a cardinal by Paul VI in 1967, identified himself with the Polish Church's fight to defend, every inch of the way, the historic rights of society and the nation. Wojtyla saw the Church as the mouthpiece for a national identity opposing a communist state that had been imposed from without. This was already the theme of his homilies when, as archbishop of Kraków, he presided over the great pilgrimages to the Black Madonna of Czestochowa — part popular gatherings, part political demonstrations. He was already investigating the relationship between religious devotion, notably to Mary, and the defense of the nation's identity. It is in this approach that we find the seed of spiritual resistance with which he would later oppose communism.

One could reread the entire history of the pontificate of John Paul II— elected in Rome on October 16, 1978 and deceased on April 2, 2005—in the light of his early years. And one could justify the sort of austerity that was the trademark of his teachings on the Church with regard to the family and sexuality by virtue of the tragic circumstances of his youth and the moral rigors of his education. Above all what one should keep in mind from this long look back over his past is that John Paul II was the product of Karol Wojtyla, and that this pope, raised under the shadow of Nazism and communism, drew from his years in Poland the great instincts of his pontificate. His vision of the world and the health of mankind, his actions

and his theology, were determined by the dual experience of his direct personal contact with the two murderous totalitarianisms of the twentieth century: first Nazism, which gave Karol Wojtyla a yardstick for barbarity, and then communism, which he knew as a priest in post-war Poland, as a professor of ethics at the university in Lublin, as archbishop of Kraków, and then as pope in Rome. Throughout his life, John Paul II felt that both were systems devoted to totalitarian imprisonment and the annihilation of mankind. Both represented a rupture with the order desired by the Creator. By declaring the death of God, both provoked the death of man, in Auschwitz and in the gulag.

That is the common thread that guided his thoughts and actions throughout his twenty-six years as pope. Moreover, it was his unique personal experience at the helm of the Church in Poland during the troublesome years of the mid-twentieth century which earned him the vote of the cardinals. On October 16, 1978 in the Sistine Chapel, at the end of a three-day conclave and eight days of balloting, Karol Wojtyla became Peter's successor, supreme leader of the Catholic Church. It was an unprecedented election—for the first time in four and a half centuries, the college of cardinals chose a pope who was not Italian, and for the first time in the entire history of the Church, a man from Eastern Europe. John Paul II was from the countries of Slavic culture and communist regimes imprisoned behind the Iron Curtain, from the "silent Church," simultaneously bemoaned in the West and poorly regarded for its supposed conservatism.

Throughout his speeches and his fourteen encyclicals (or treatises on social doctrine and moral philosophy), John Paul II could never find words harsh enough to settle the score with those who deemed religion an illusion or a form of derangement. He denounced the materialistic and permissive ideologies that completely exclude God and transcendental values. For him, without God, all society is dehumanized. His school of thought is essentially Thomistic, stemming from the teachings of Saint Thomas Aquinas in the thirteenth century. There is no conflict between *reason*, when it is prescribed according to truth and conforms to nature as revealed by God, and *faith*, which refers to the divine source of all truth. Reason and faith reveal two different levels of consciousness. Reason is limited, finite, and composed of partial understanding. It cannot attain the unity desired and created by God.

If there are two other key words in his speeches, they are *liberty* and *truth.* They define the two major phases of his pontificate. From 1978 to the fall of the Berlin Wall in 1989, Karol Wojtyla was committed to the task of defending freedom of religion and thought, and the rights of man everywhere in the world. He began in Poland, where in June, 1979 he made his first fearless trip to demand respect for the sovereignty of his country. He followed this trip with visits to the countries of Central and Latin America, Africa, and Asia that were under the yoke of authoritarian civil or military regimes. During a 1983 trip to Haiti, the pope exclaimed, "things

must change here," and he destabilized the Duvalier dictatorship. The regime of the *tontons-macoutes*, the symbolic name of that regime of repression, had less than three years to live. It was the same in the Philippines, one of the few Catholic countries in Asia, where, with the help of the local Church, John Paul II denounced oppression and contributed in his way to the fall of the Marcos dictatorship in 1986.

The first years of his pontificate were dominated by this pope's single-minded determination to create a universal moral norm of democracy and human rights. His journeys across five continents, which stunned the world with their number, breadth, direction, and dazzling media coverage, represented both a way to support the Church's involvement in difficult local situations and a means to denounce authoritarian, corrupt, and unjust regimes. In Third World countries, he spoke out for social justice against structural inequalities that encouraged underdevelopment and poverty. Everywhere he went he recalled the Christian values that were breaking down in a secularized world. In Paris in 1980, he asked, a bit provocatively, "France, what have you made of your baptismal promises?" In his first great encyclical, *Redemptor hominis* (The Redemption of Man, 1979), he wrote that "man is the road to the Church." Man and his rights are placed at the heart of the Church's thought and mission.

From the beginning of his pontificate, John Paul II's style was surprising. Who was this pope who broke into song with the young people at the foot of the nunciature in Mexico or in the many capitals he visited? Who had ready answers for the crowds of youth in the Parc des Princes in Paris on June 2, 1980? Who applauded an African dance performance right in front of his papal throne? Better than anyone, this pope knew how to use the media to effectively communicate his message. Yet Karol Wojtyla made his mark, above all, as the pope who defeated communism. This may seem excessive, but nobody contests the fact that it was in him that the "silent Church," crushed by its persecution in the post-war years and the suppression of its fundamental rights, discovered a powerful spokesman. The Church became an active force in the events that preceded the fall of the Berlin Wall in 1989, and a return to free and democratic administrations throughout the countries of Eastern Europe.

Prior to John Paul II, the Vatican's *Ostpolitik* (a policy of engagement of the Eastern bloc) relied on state-to-state negotiations—an art in which Cardinal Casaroli, his secretary of state who also served under Paul VI and John Paul I, was the reigning master. But Karol Wojtyla did not look for tactical accommodations with the communist countries. He stood only on the platform of values and rights. His name symbolizes an entire spiritual resistance based on the rights of conscience, culture, and nationhood. The networks of influence that he put in place, the individuals that he appointed and that he received, and his support for the most traditional forms of Catholicism (the worship of Mary, pilgrimages, canonizations, and the like) reinforced his image in the West as a conservative pope. But for churches in

the East, those were the signs and means of affirming their very existence, their will to survive.

We were slow to understand John Paul II's instinct for liberation, which he had long practiced under communism as a means to combat it. He did not ignore the repressive power of the states which he sized up or, depending on the period, negotiated with, but rather added a whole other dimension to the resistance that he called for in his greetings and papal allocations: these are the very *rights* of nations, the *resources* of society and culture. John Paul II surprised and sometimes irritated people when he insisted on celebrating holy days and Saints' days. But he acted this way less out of theological conservatism than an interest in rehabilitating Church history in these countries, where religious memory had been eradicated. This clear-sightedness made him the victim of an assassination attempt on May 13, 1988 in Saint Peter's Square in Rome—an event that nearly killed him. He was attacked by a Turkish terrorist, Mehmet Ali Agça, and rescued for the first time by Gemelli hospital. The complicity of the Bulgarian secret service in the attack was proven, but the suspected involvement of the KGB was more difficult to demonstrate.

His other favorite theme was truth—when, on a visit to Poland, he held forth on this subject in the majority of his homilies, it was as much through doctrinal conviction as political intelligence. In a country where words are illusions and lies are promulgated as a principle of government, "truth is as necessary as coal," as Lech Walesa, the future president of Poland, said.

The pope made religion an arena of political resistance, cultivating everything that subverted communist power: truth, history, ethics, and national identity and solidarity. The Church's platform under John Paul II was to fight more than just the atheistic character of communist regimes and Marxist ideology, which Pius XI had already characterized in 1937 as "intrinsically perverse." John Paul II also battled against their typically totalitarian nature, which denied the aspirations of society and the rights of man. It was this expansion of perspective that allowed Christian believers in Czechoslovakia, Poland, East Germany, and elsewhere to stand shoulder to shoulder with the secular left and dissidents from various points on the intellectual map.

Up at 5:30 AM and to bed in his apartment in the Vatican by 11:00 PM , this hard worker was above all an intellectual and a mystic who wanted to put God back at the center of the world—believing that he had been chased from there by such social philosophers and scientists as Marx, Freud, and Sartre. He spent long hours editing encyclicals or meditating in his private chapel before an icon of the Black Madonna of Czestochowa—expressing the intentions of the prayers that reached him from all over the world. But this pope of freedom for oppressed countries was also, within his Church, the pope of a return to order, the pope of standards, the pope who wanted to put an end to the excesses that he feared would eradicate the evangelical message.

He condemned liberation theology in Latin America for being complicit with Marxism and revolutionary guerillas. He quickly became a bogeyman in Western liberal milieus because he opposed hedonism and sexual liberation. He was more popular in the Third World than in the wealthy and secular nations of the West. He brought back discipline to the Church in the Netherlands, Germany, and Austria, where religious orders like the Jesuits were influenced by progressive currents. Without leniency, he set the record straight with dissident theologians like Hans Küng, Charles Curran, and Eugen Drewermann. He placed his confidence in the most zealous and mystical movements, from Opus Dei to the Charismatics.

The second half of his pontificate was dominated by a response to the challenges of the post-communist world—a response developed through his travels and in his writings. The World Youth Days, inaugurated in Czestochowa, Poland in 1991, became larger and larger over time. Three million youth came to him in 1995 in Manila in the Philippines, one million more in Paris in 1997, two million in Rome in 2000, the year of the Christian Jubilee. In his major encyclicals, *Centesimus annus* (The Hundredth Anniversary, of the social encyclical of Leo XIII, 1991), *Splendor veritatis* (Splendor of Truth, 1993), and *Evangelium vitae* (The Gospel of Life, 1995), he questioned the world: what is the value of the freedom that mankind has so dearly acquired in the East if, he said, its use is so trivialized?

In *Centesimus annus*, he denounced a liberalism without faith or laws, and avowed that the defeat of Marxism did not give capitalism a blank check to do whatever it wished. He continued with very harsh words for the economic neo-liberalism and savage competition of a globalization of markets, making the rich richer and the poor poorer. In *Splendor veritatis* he warned individuals as well as states of the risks of freedom that becomes a law unto itself, of a democracy that goes beyond the limits of all ethical norms, of a culture devoid of any "moral sense" that has lost all capacity to differentiate between good and evil. In *Evangelium vitae*, he recapitulated his entire teachings on respect for life, from conception to death. He was frequently reproached for his denunciation, in tragic tones, of the "culture of death" that ruled in the world—abortion and euthanasia, but also genocide, war, terrorism, drug addiction, and all sorts of violence—which he contrasted with the "culture of life" desired by God. We saw him pray at places where man was oppressed: on Gorée Island, the island of slaves in Senegal, at concentration camps such as Auschwitz and Matthausen, and at the "Hill of Crosses" in Lithuania, a reminder of the martyrs to the Soviet occupation.

No pope before John Paul II had such close contact with his contemporaries. This unclassifiable pope, a media star unlike any of his predecessors, tirelessly brought God to the center of the world. To be sure, he symbolized a strict dogmatism, a strict moralism for couples, and forms of Roman centralization that were believed to have died after Vatican II. But what

endures of his work is that his was the voice of the voiceless, that he embodied the hope of the oppressed masses behind the Iron Curtain—those decimated by wars, poverty, and epidemics. His unprecedented initiatives to encourage conversation between the different religions of the world and his contributions to peace, against all violence, all wars, and all forms of terrorism will also go down in history.

From this point of view, there are dates that are true turning points in the life and work of John Paul II. On April 13, 1986, he was the first pope to cross the threshold of the synagogue in Rome. He greeted the Jews as the "older brothers" of Christians. It was the start of a work of reconciliation and revision of the attitude of the Catholic Church toward Judaism. This view began with Vatican II, but John Paul II amplified it in spectacular fashion, without demanding anything in return. In 1993, the Holy See recognized the state of Israel. In 2000, in the final stages of an effort for the "purification of memory" and "repentance," he exhorted the faithful on the eve of the third millennium of Christianity. At that time, he again surprised the world, going to Jerusalem where he visited both the Yad Vashem memorial, the most revered place for Jewish remembrance of the Shoah, and the Western Wall.

On October 26, 1986, the pope gathered the leaders of the worlds' religions in Assisi, the Umbrian city of Saint Francis, and invited them all to pray — without any demand for reconciliation of form or practice—for world peace. In every country he visited, the pope met with members of religious communities like Anglicans and other Protestants, but above all with non-Christians: Jews, Muslims, Buddhists, Hindus. World peace comes through peace between religions, he proclaimed everywhere. In January, 2002, shortly after the attacks of September 11, the pope, already sorely afflicted by illness and age, relaunched the "Spirit of Assisi." He once again convened world religious leaders in the same city. Together they repeated that religious extremism has nothing to do with religion, and that nothing justifies killing in the name of God.

Pope of encounters between religious traditions, pope of peace, John Paul II took a stand against all wars: the war in Lebanon in the 1980s in which Christians were implicated, the Gulf War of 1990-91, when Iraq invaded Kuwait, the numerous conflicts that broke out in the Great Lakes Region of Africa, and more. Speaking in anguished tones, in Zagreb in 1994 and Sarajevo in 1995, he pleaded for an end to hostilities between the Catholic, Orthodox, and Muslim communities in the Balkans. Throughout the 1990s, although his body increasingly showed the effects of his illness (he underwent several operations after the 1981 attack, and had others while suffering from the Parkinson's disease which, little by little, totally paralyzed him), John Paul II became the "supplicant for peace." In 2002, he was one of the most vigorous adversaries of the war in Iraq. His forceful pacifist protests took the American and British allies, struggling against Saddam Hussein, by surprise.

One can only regret the impasse that closed off the ecumenical dialogue. The pope's overriding desire to reaffirm Catholic identity and papal authority, and his belief that the Catholic Church represents the "full truth" as revealed by Jesus Christ—a theme he reiterated over and over — often irritated participants in dialogues with other branches of Christianity that had been separated from Roman Catholicism for many centuries. His message was spread particularly by German cardinal Josef Ratzinger, the unshakable guardian of the doctrine of the faith. Ratzinger would become John Paul II's successor, Benedict XVI, on April 19, 2005. The dialogue with Anglicans became strained after 1992, when the Church of England decided to ordain women as priests. John Paul II broke with the Orthodox Church of Eastern Europe after the Soviet empire collapsed and religious freedoms were restored. The Catholic Church was admonished for reviving "unitarism" (the longstanding Western effort to reunite the eastern Orthodox Christians with the Church in Rome) and for proselytizing in traditionally Orthodox Christian lands. This would be the biggest disappointment for the pope who visited so many countries and met with so many religious leaders, Christians and non-Christians alike. He would never visit an ancient Christian country like Russia, or reconcile the "two lungs" of Christianity: Eastern and Western, Latin and Byzantine.

Throughout a quarter of a century, this pope was constantly on television, tirelessly repeating words like "non-violence," "peace," "respect for life," and "repentance," greeting children, establishing a dialogue between different cultures and denominations. He rejected the notion of a "supermarket" religion, where people could pick and choose whatever they wanted. No other pope beatified or canonized as many as he, for he thought that believers needed models and guideposts for living. In the one hundred four trips he made outside of Italy, he looked to anchor the Church in the diversity of national cultures, and in opposition to the destructive "globalization" of identities.

John Paul II ascended Saint Peter's throne in 1978, at a time when the Church was deeply divided by the repercussions of Vatican II and by young people's desertion of the Church. He followed Pope Paul VI, a hesitant, tormented, and scrupulous man, but John Paul II used his power and his long experience to resist human folly. From the time of his installation mass on October 22, 1978, he surprised the world by declaring in a firm voice the words that would accompany him his entire life. "Do not be afraid! Open, open all doors to Christ."

His last battle was against the merciless illness that came to dominate him: the Parkinson's disease that diminished all his faculties, devastating his ability to walk, and then, after he underwent an emergency tracheotomy on February 24, 2005 at Gemelli Hospital, crippling his ability to speak. His last weeks were his personal Calvary. He aroused the pity of the entire world and still tried to communicate with it, as if the crowd of pilgrims in Saint Peter's Square were his last hope for survival. But the man who had spoken

so much had become mute. Following in the footsteps of Christ, it was his cross to bear. His death on April 2, 2005 left the whole world in tears, knowing that it had lost a spokesperson for mankind's tragedies and hopes. He was a giant.

—**Henri Tincq**

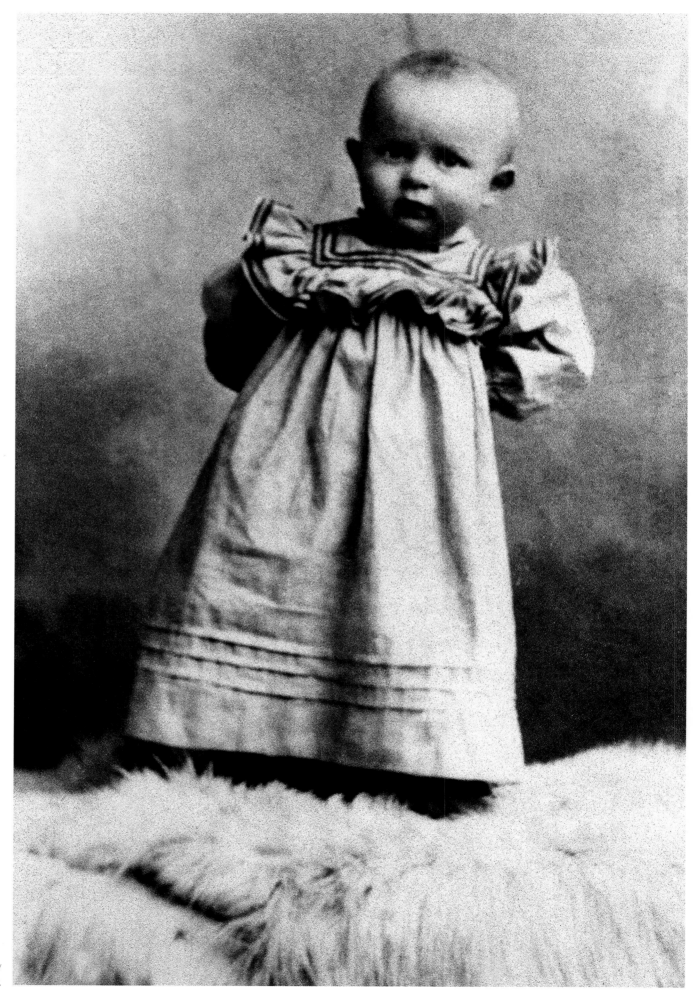

May 18, 1921 / Wadowice, Poland /
Portrait of Karol on his first birthday.

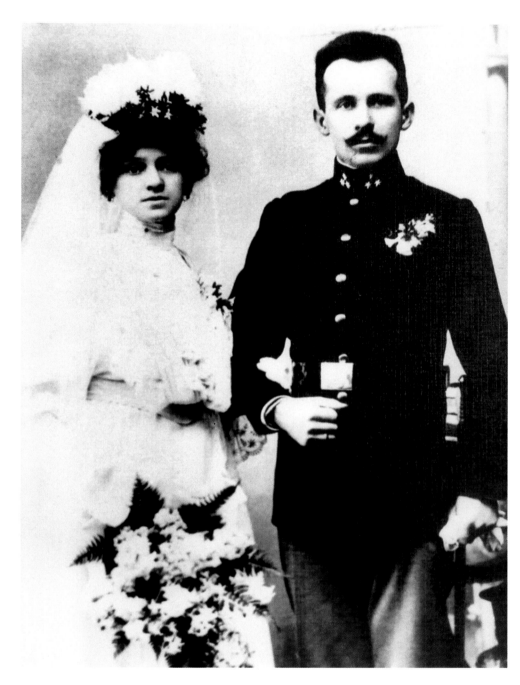

1907 / Wadowice, Poland /
Wedding of Karol's parents,
Lieutenant Karol Wojtyla and Emilia
Kaczorowska.

May 18, 1920 / Wadowice, Poland /
The Wadowice birth records office
issues the birth certificate for
Carolus Joseph Wojtyla (reference
71), upon which his progress in the
church hierarchy is noted.

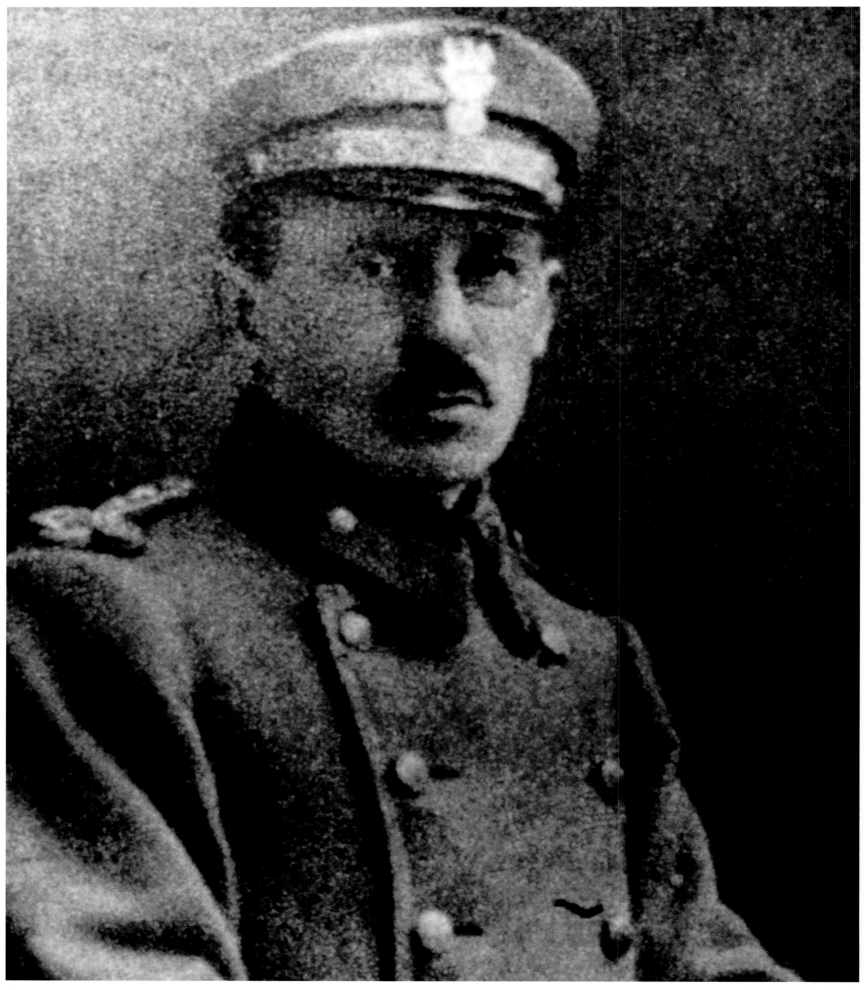

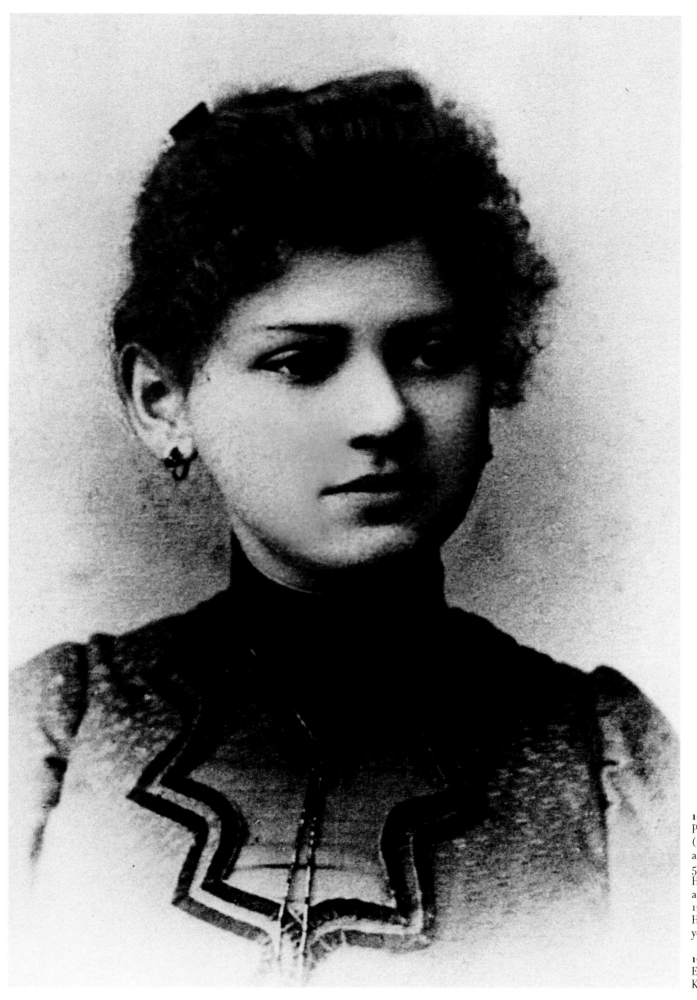

1922 / Wadowice, Poland /
Portrait of Lieutenant Karol Wojtyla
(1879-1941), Karol's father, who was
a non-commissioned officer in the
56th Infantry Regiment of the Austro-
Hungarian Army before being
attached to the supply corps of the
12th Infantry Regiment of Wadowice.
He died when his son was only twenty
years old.

1920 / Kraków, Poland /
Emilia Kaczorowska (1884-1929),
Karol's mother.

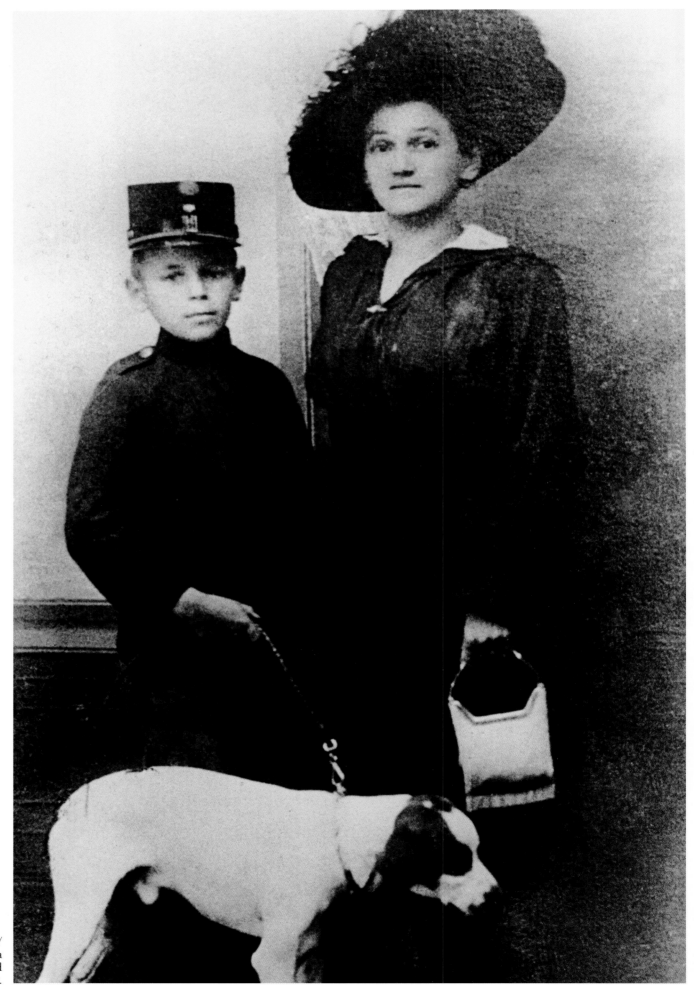

1918 / Kraków, Poland /
Edmund (1906-1933) and Emilia
Wojtyla, Karol's older brother and
mother.

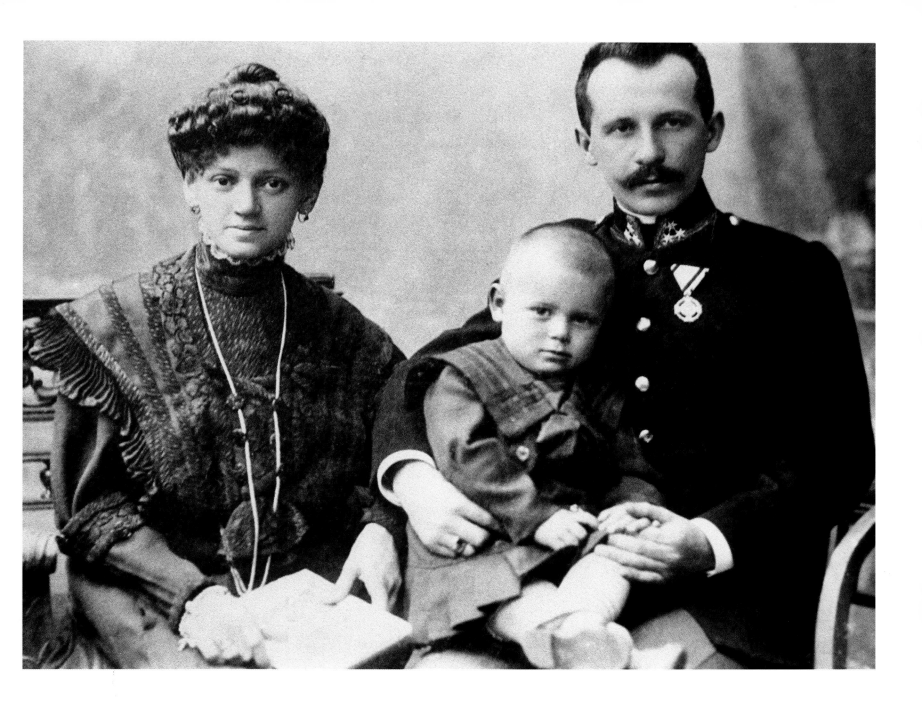

December 31, 1920 / Wadowice, Poland / Karol Wojtyla with his parents, Emilia Kaczorowska and Karol Joseph Wojtyla.

1931 / Wadowice, Poland / Karol Wojtyla, age eleven, is an altar boy. He is seated, first row, second from the left, next to Father Kazimierz Figlewicz, who remained his confessor for many years.

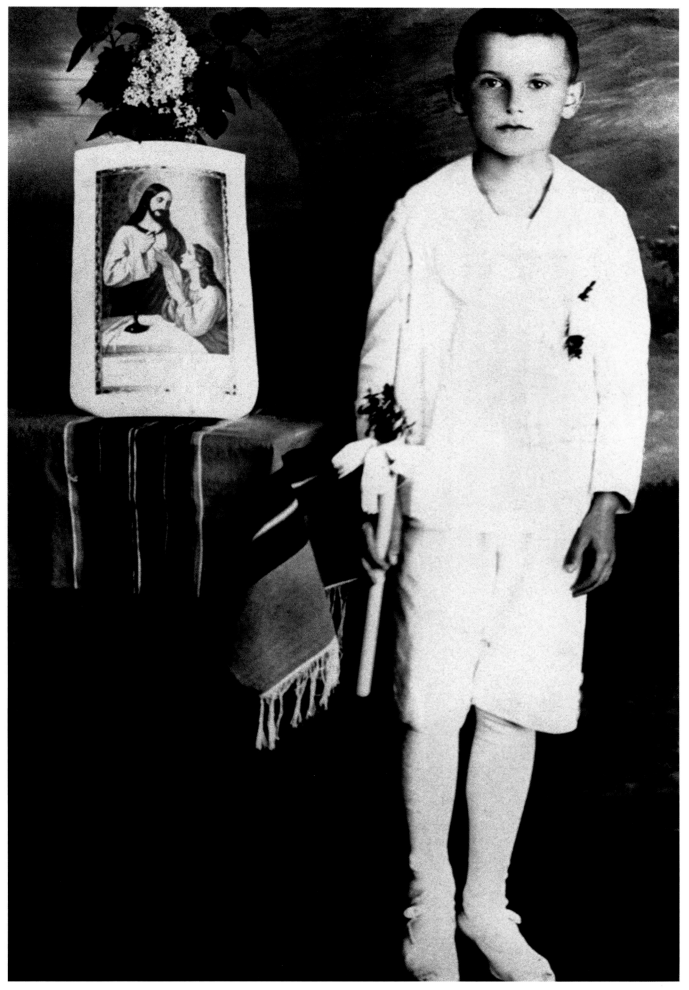

May 25, 1929 / Wadowice, Poland /
Karol Wojtyla on the day of his first
communion.

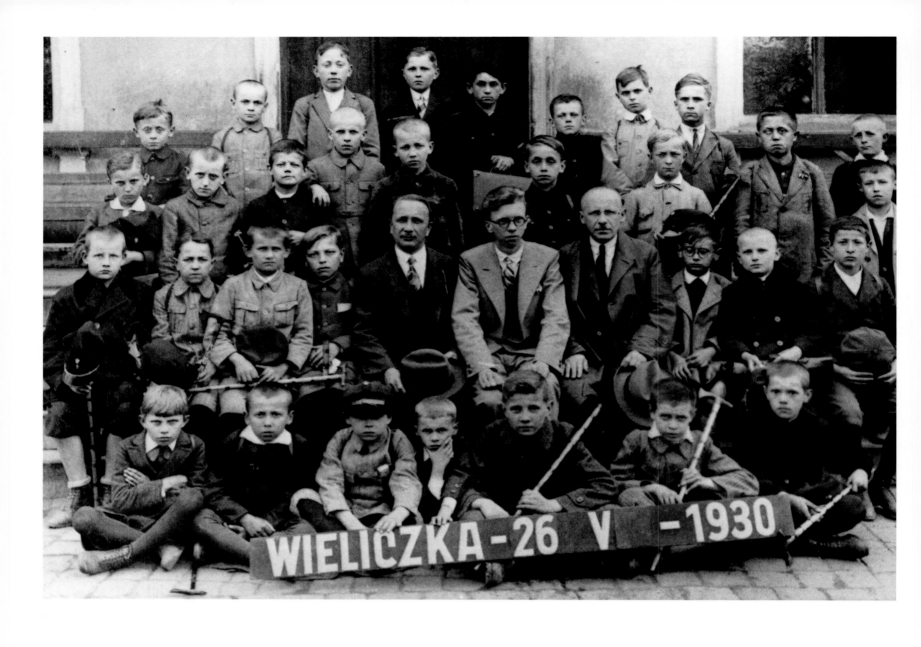

1930 / Wieliczka, Poland / Class photo taken on a trip to Wieliczka. Karol Wojtyla, second from the right in the second row, is nine years old at the time. In the center, wearing a raincoat, is his father, seated next to his teachers.

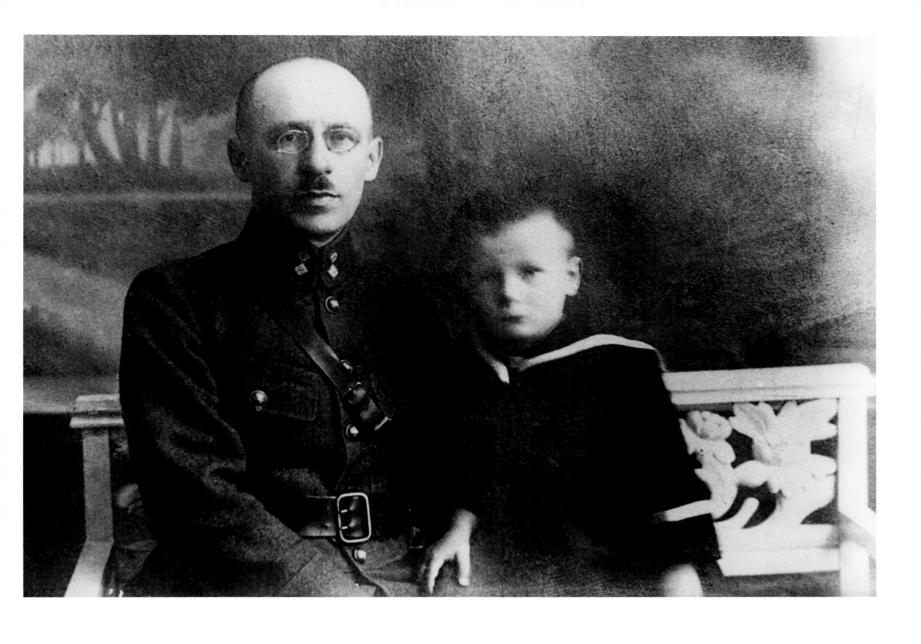

June 30, 1925 / Wadowice, Poland / Portrait of Karol, posing with his father, a lieutenant in the 12th Infantry Regiment of Wadowice.

April 13, 1929

Death of Emilia Kaczorowska Wojtyla, Karol's mother.

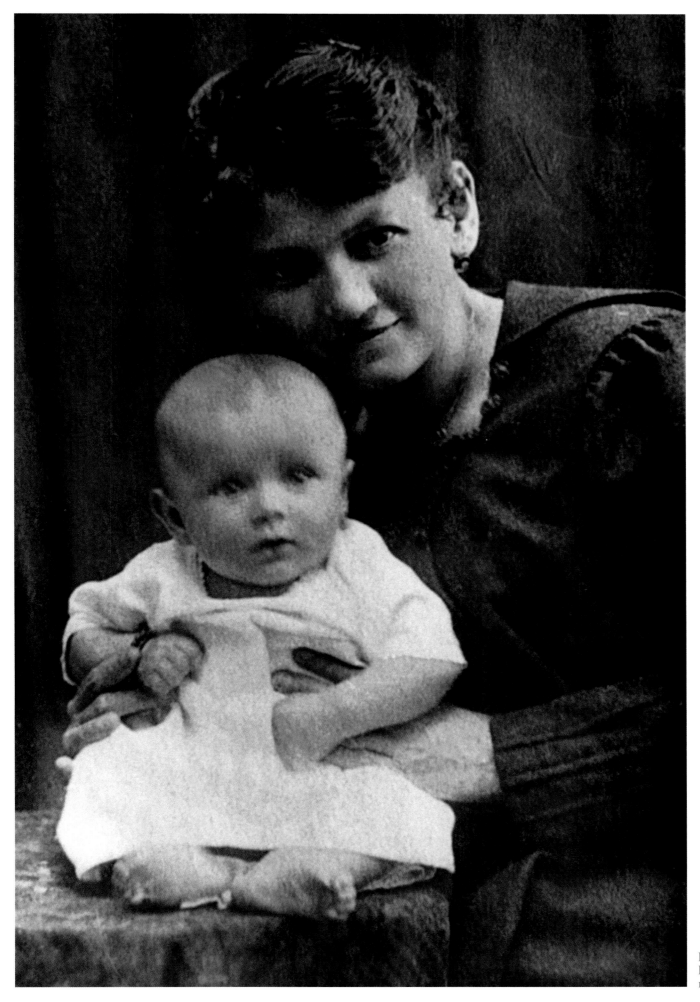

December 31, 1920 / Wadowice, Poland / Karol at six months, with his mother, Emilia.

1920 / Wadowice, Poland / House where Karol Wojtyla was born, at 4 Rynek (Church) Street, today 7 Via Koscielna. Karol Wojtyla's parents' apartment was on the second floor, at the end of the balcony. It has since been made into a museum.

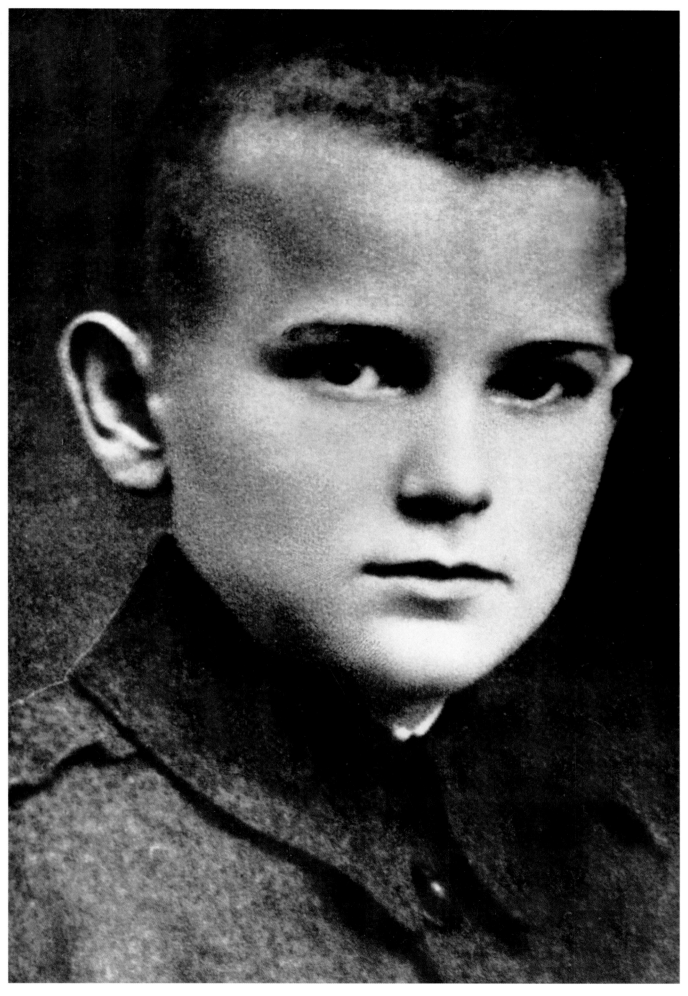

June 30, 1932 / Kraków, Poland /
Portrait of Karol at the age of twelve.

27

December 5, 1932

Death of Edmund Wojtyla, Karol's older brother.

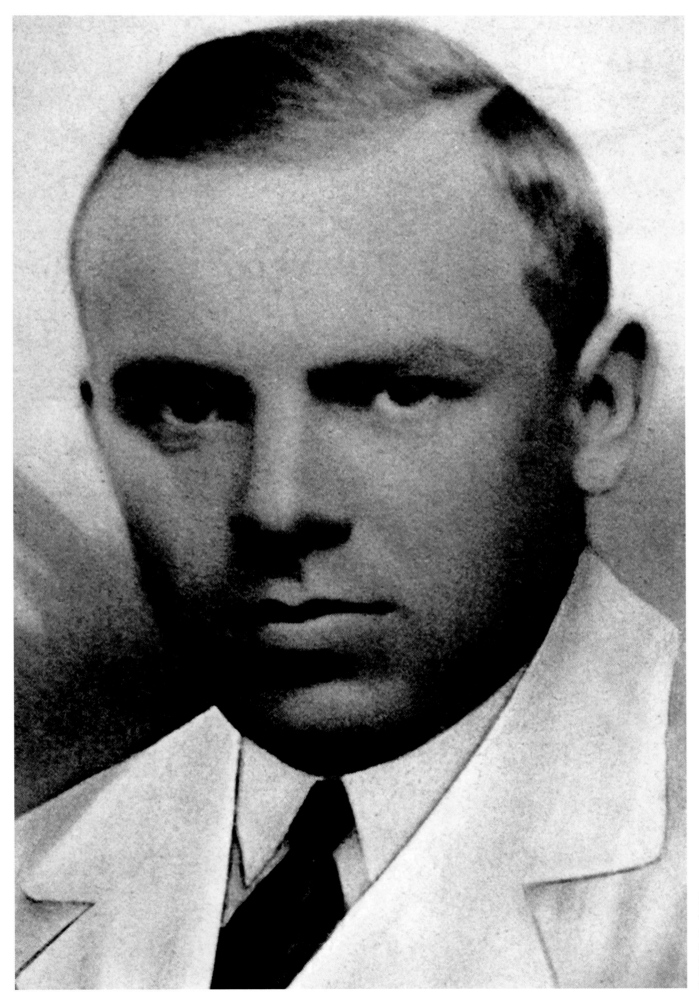

1931 / Wadowice, Poland /
Portrait of Edmund Wojtyla, Karol
Wojtyla's older brother. He became a
medical doctor in 1930, and died
suddenly two years later, after
contracting scarlet fever from one of
his patients. It was a shock for Karol,
who had lost his mother in 1929.

"Culture is the expression of man. It is the confirmation of his humanity. Man creates it and through it creates himself." John Paul II

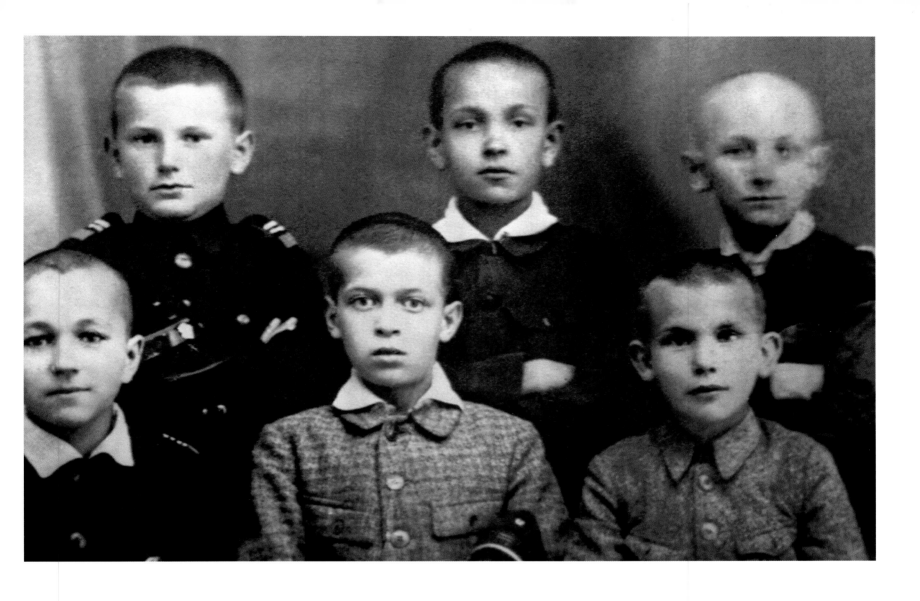

1932 / Wadowice, Poland / Portrait of Karol Wojtyla, top left, at Marcin Wadowita High School.

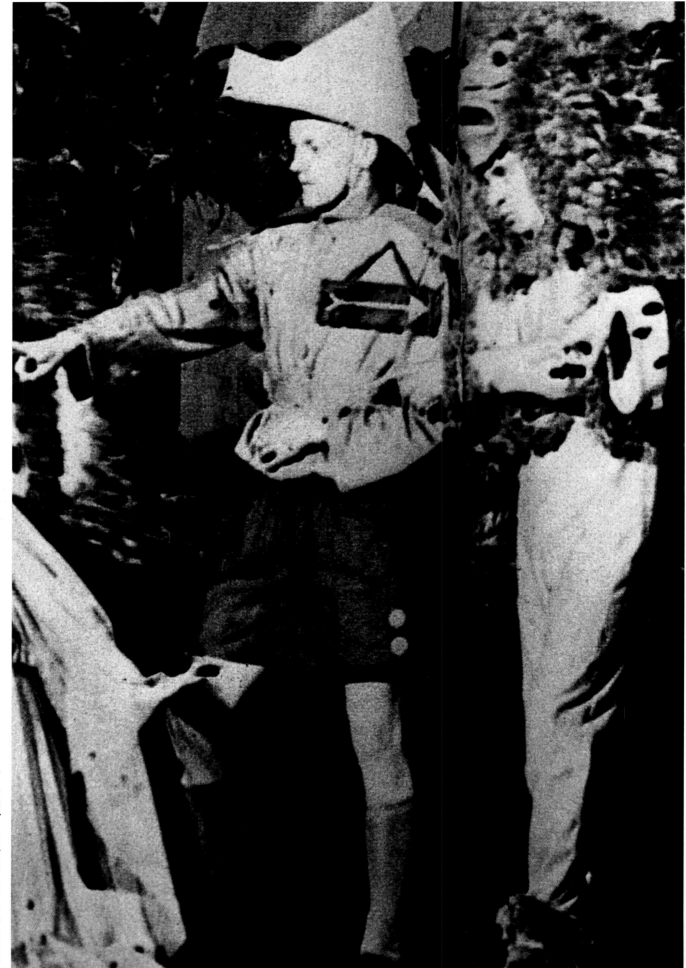

1935 / Wadowice, Poland /
Karol Wojtyla performs with the
Marcin Wadowita High School drama
group in a light comedy, *Le Chevalier
de la Lune* (The Knight of the Moon),
a play in five acts by William
Shakespeare in which all the signs of
the zodiac are portrayed. Karol, at
center, plays the role of Sagittarius.
He had performed in school
productions of literary readings such
as Slowacki's *Kordian*, Sophocles's
Antigone, and Alexander Fredro's
Sluby Panienskie. Karol had a real
passion for the theater and hesitated
before joining the seminary.

1936 / Wadowice, Poland / Theatrical production at Marcin Wadowita High School. Karol Wojtyla and Halina Krolikiewicz (the maiden and stage name of the actress Halina Krolikiewicz-Kwiatkowska), far right, appearing in *Sluby Panienskie* (Maidens' Vows), a play by the nineteenth-century Polish playwright Alexander Fredro. Lolek, as Karol was known then, plays Gucio, a frivolous character. He painted on a mustache with the help of a piece of burnt cork.

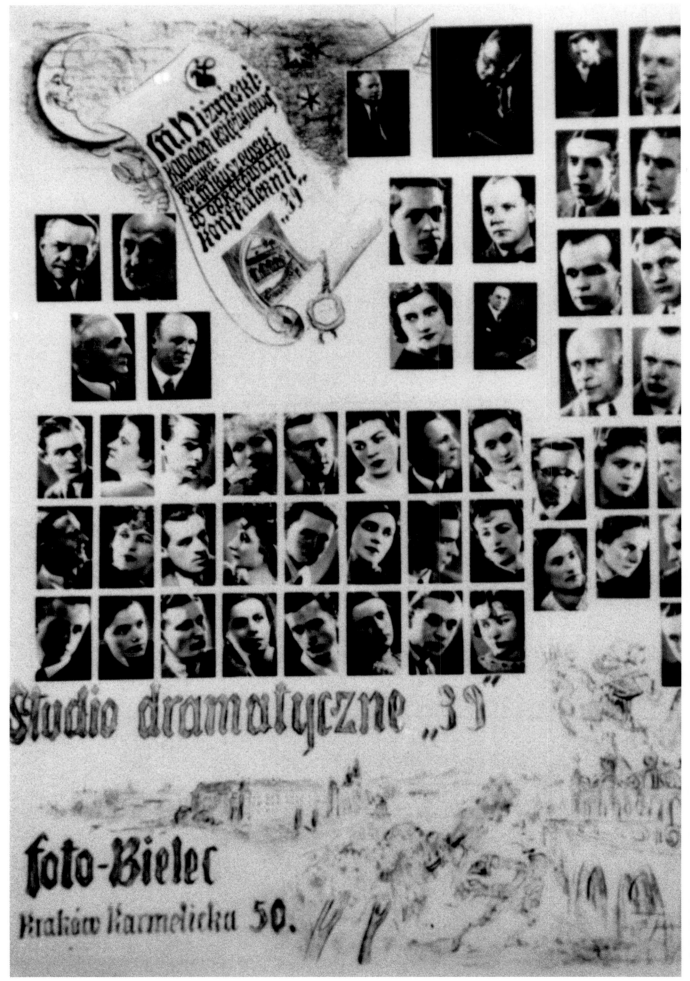

1938 / Kraków, Poland / Poster for the Studio 39 theater troupe in which Karol Wojtyła performed. Studio 39 mounted a production of the comic tale *Kawaler Księżycowy de Niżyński* during the Days of Kraków festival in June, 1939. The tale was inspired by the story of a real-life character, Pierre Twardowski, a nobleman and alchemist who lived in Kraków in the sixteenth century. History attributes supernatural powers to him.

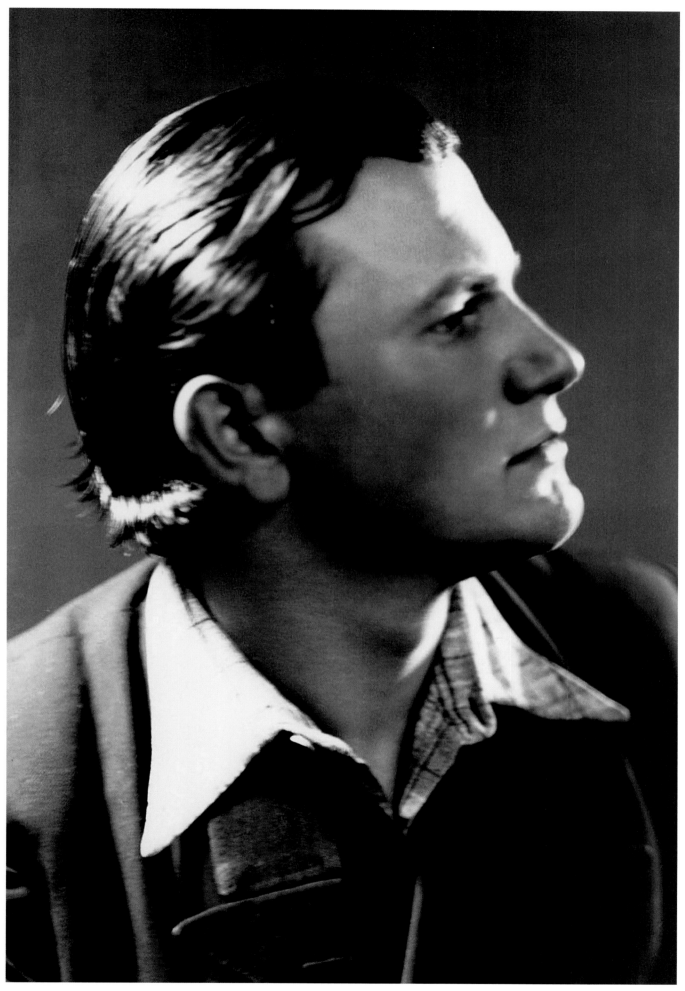

1942 / Kraków, Poland /
Portrait of Karol Wojtyła, then a
twenty-two-year-old student.

1936 / Wadowice, Poland / Karol Wojtyla, in the third row on the far left in short pants, on an outing to Wieliczka with his high school friends.

... ostatnie oceny roczne w klasach VI — VIII

... y na egzaminie wstępnym do wymienianego

...tów następujących:

Polsn z propedeutyki filozofii *bardzo dobry*

dobry z ćwiczeń cielesnych *bardzo dobry*

...rdze z higieny *bardzo dobry*

...dobry

...sja Egzaminacyjna uznała *Wojtyłę*

...żefa za dojrzałego do studiów

...u niniejsze świadectwo.

...owice dnia 14 maja 1938 roku.

PRZEWODNICZĄCY
PAŃSTWOWEJ KOMISJI EGZAMINACYJNEJ

CZŁONKOWIE
PAŃSTWOWEJ KOMISJI EGZAMINACYJNEJ:

ŚWIADECTWO DOJRZAŁOŚCI

Wojtyłę Karol Józef

urodzony dnia 18 miesiąca *maja* roku 1920 w *Wadowicach* województwa *krakowskiego* wyznania *rzymskokatolickiego* po ukończeniu nauki w *państwowym* gimnazjum im. M. *Wadowity* w *Wadowicach,*

do którego był przyjęty w *wrześniu* 1930 r., zdawał.
w dniu *14 maja* 1938 r. gimnazjalny zwyczajny egzamin dojrzałości nowego typu klasycznego wobec Państwowej Komisji Egzaminacyjnej, powołanej przez Kuratorium Okręgu Szkolnego *Krakowskiego* pismem z dnia *30 marca* 1938 r. Nr I-5112, i otrzymał następujące oceny ostateczne z przedmiotów egzaminacyjnych:

z religii *bardzo dobry*

z języka polskiego *bardzo dobry*

z języka łacińskiego *bardzo dobry*

z języka greckiego *bardzo dobry*

z kultury klasycznej —

z historii wraz z nauką o Polsce Współczesnej . . . —

z fizyki wraz z chemią . . . —

z języka niemieckiego . . . *bardzo dobry*

May 14, 1938 / Wadowice, Poland / End of year report card for eighteen-year-old Karol Wojtyla. Except for physics and astronomy, he received a grade of "very good" (*bardzo dobry*) in all his subjects: Polish, German, Latin, Greek, modern history, philosophy, and physical education.

"The aim of university is knowledge and wisdom. The aim of the Church is salvation, the Gospel, the order of love, and the supernatural order. The order of knowledge and the order of love are not identical, they are complementary." John Paul II

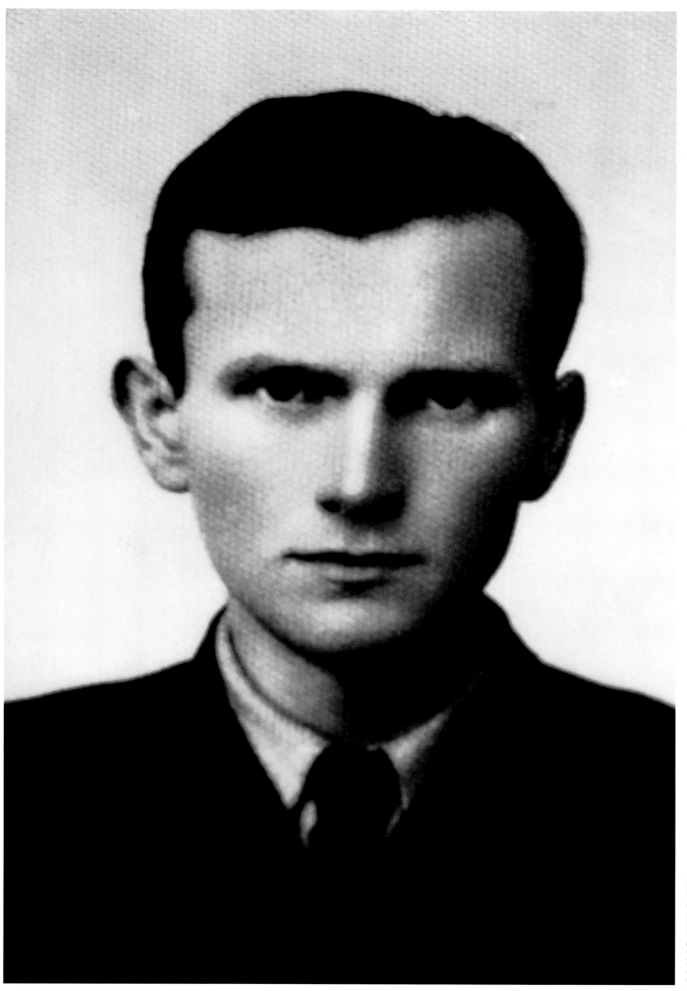

1938 / Kraków, Poland /
Portrait of Karol at the time of his enrollment in the Department of Philology at Jagiellonian University in Kraków. He was then eighteen years old. He chose to focus his studies on history, classical and modern literature, dramatic arts, and the theater.

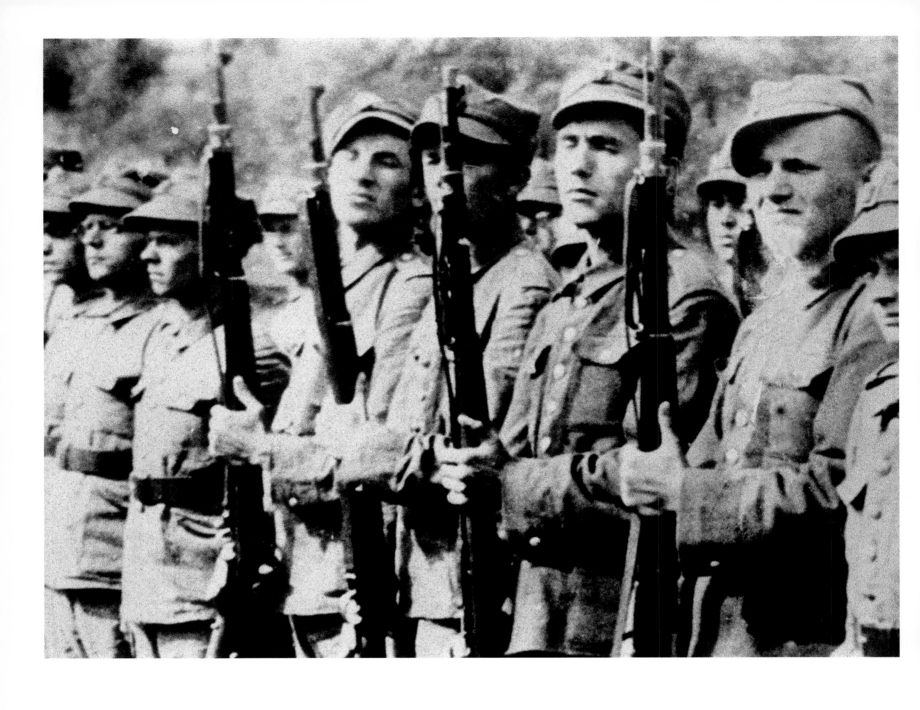

1938 / Ozomla, Poland / Karol Wojtyla participates in a required military training course in Ozomla, near Sadowa Wisznia.

July 1939 / Ozomla, Poland / Karol Wojtyla, at right, was nineteen when he joined the Academic Legion for Polish and Ukrainian Students. This photo was taken two months before the beginning of the Second World War.

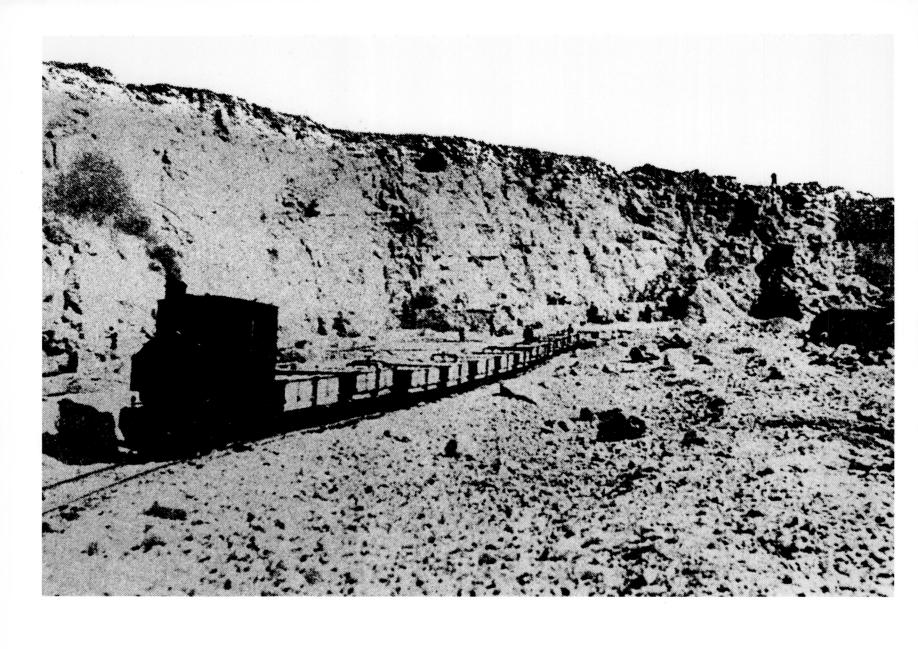

October 26, 1940 / Zakrzówek, Poland / The Zakrzówek stone quarry where Karol Wojtyla worked in order to avoid deportation. For four years, starting in the beginning of the 1940-41 academic year, he worked as a laborer in this quarry, then in a factory belonging to the Solvay chemical group.

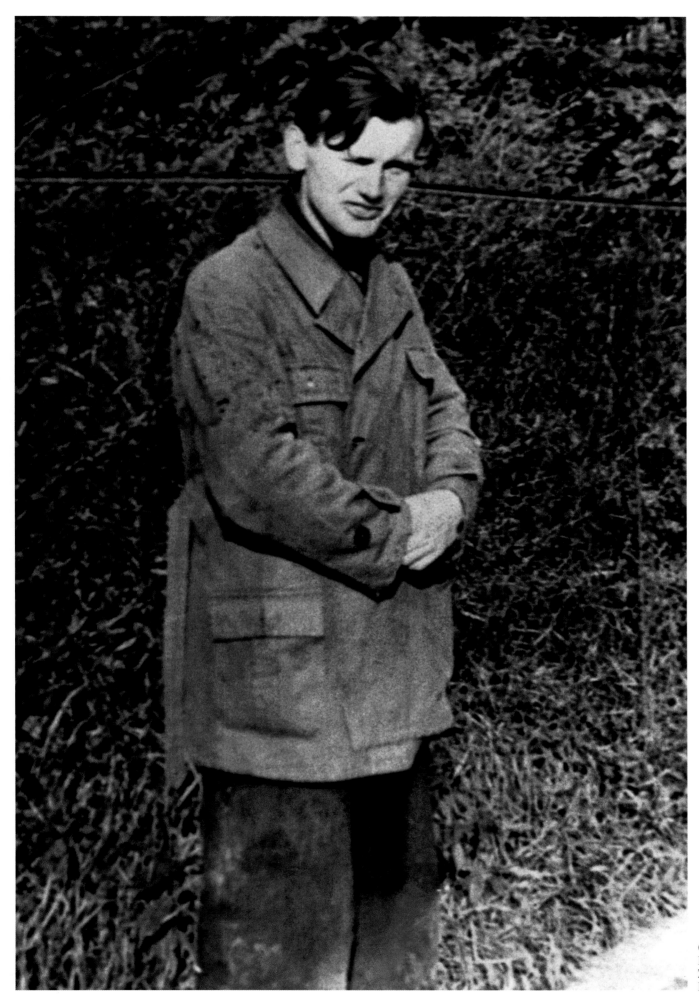

October 26, 1940 / Zakrzówek,
Poland / Karol Wojtyla working in the
Zakrzówek stone quarry, near
Kraków.

February 18, 1941

Death of Karol Wojtyla, Karol's father.

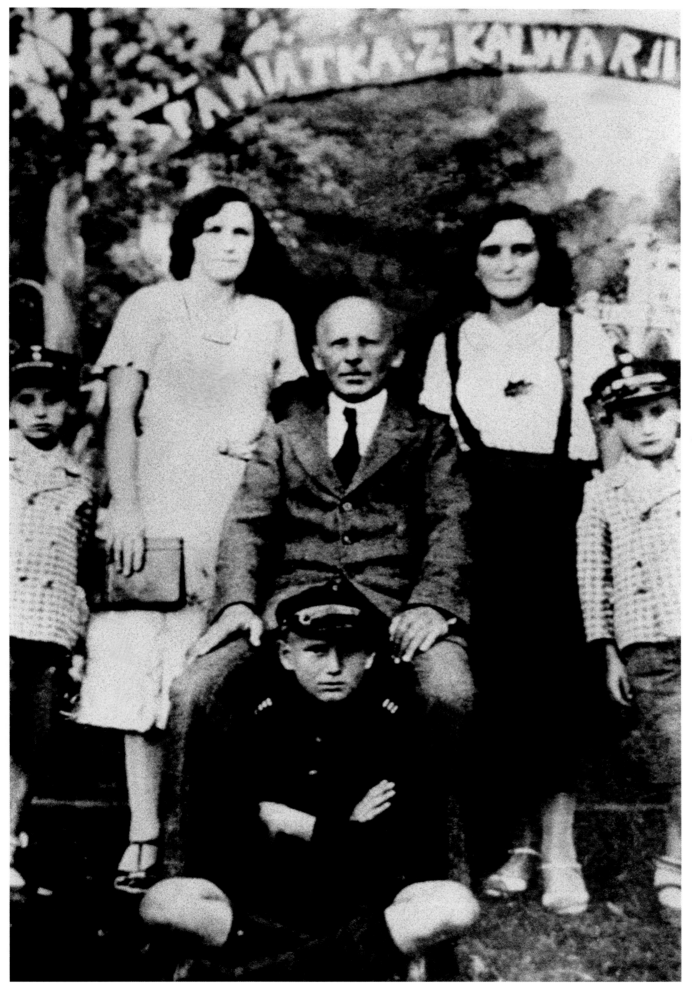

1932 / Wadowice, Poland /
Karol, seated cross-legged in front of
his father, during a pilgrimage to the
sanctuary of Kalwaria Zebrzydowska.
Its natural setting, framing symbolic
sites dedicated to the Passion of Jesus
Christ and to the life of the Virgin
Mary, has remained nearly
unchanged since the seventeenth
century. It is still a site for
pilgrimages today.

November 5, 1946 / Kraków, Poland / Shortly after his ordination, Karol Wojtyla, center, poses in front of the Kraków Seminary.

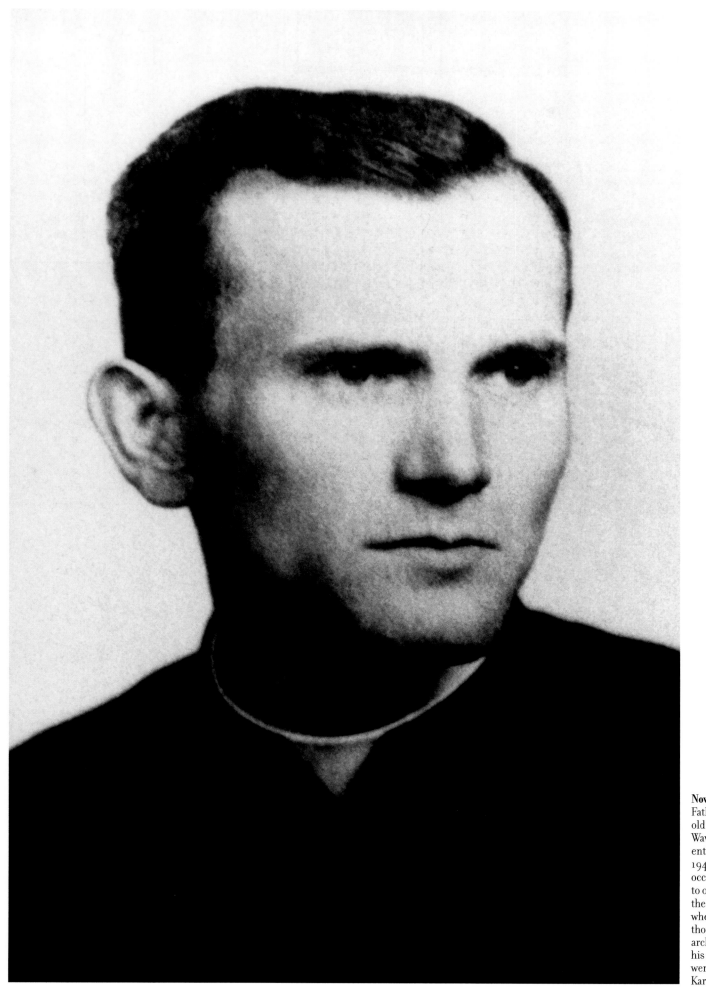

November 1, 1946 / Kraków, Poland / Father Karol Wojtyla, twenty-six years old, after his ordination as a priest at Wawel Royal Castle. Karol Wojtyla entered the Kraków Seminary in 1942, but because of the Nazi occupation, the seminary was forced to operate in secret, especially after the "black Sunday" of August 6, 1944, when the Gestapo arrested seven thousand clergymen. Prince Sapieha, archbishop of Kraków, sheltered in his palace many seminarians who were sought by the police, including Karol.

"Every person should have, now more than ever, a chance to participate honorably in the banquet of life." John Paul II, January 16, 1993

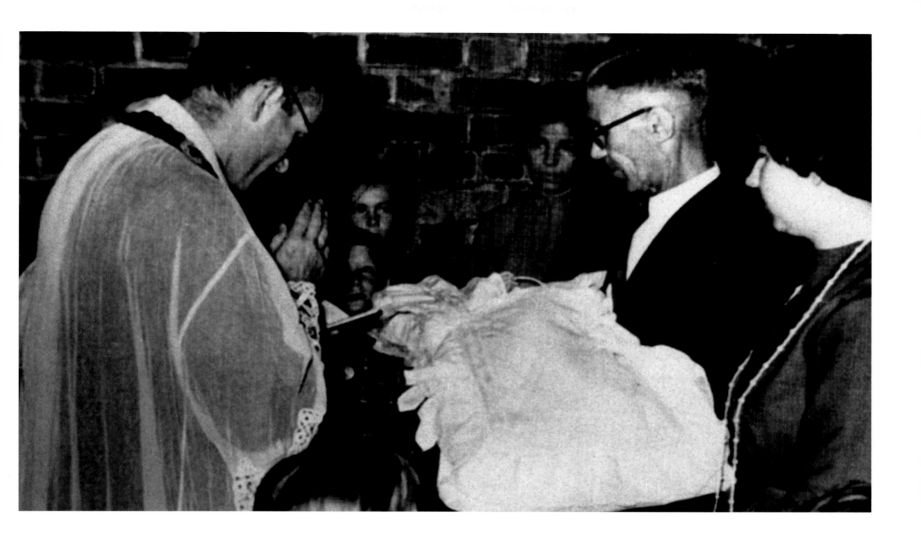

November 11, 1946 / Kraków, Poland / First baptism by the young priest Karol Wojtyla.

1948 / Niegowic, Poland / Parish house where Father Wojtyla lived from 1948 to 1949. On his return to Poland in 1948, Karol was assigned to the rural parish of Niegowic and received his doctorate in theology from Jagiellonian University.

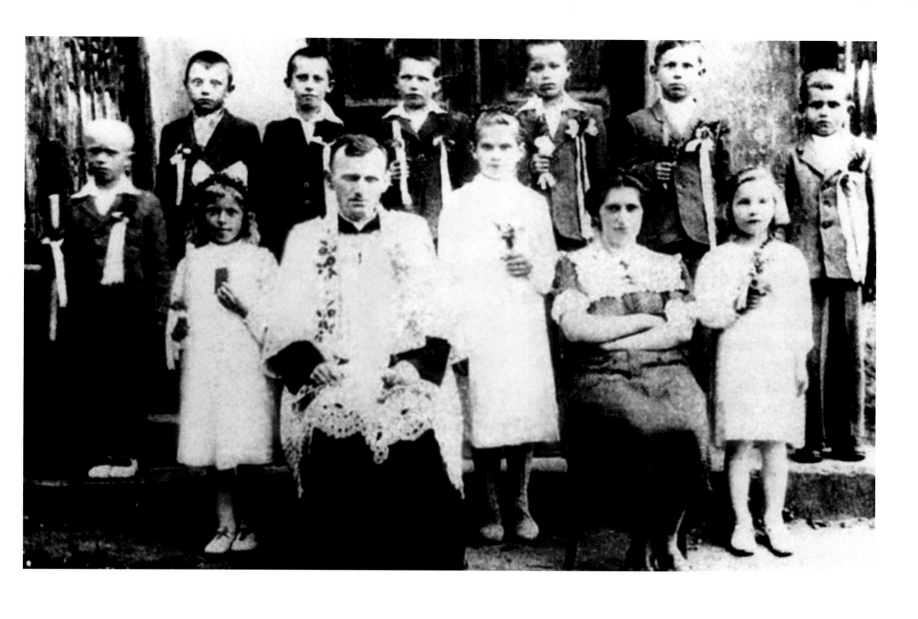

1948 / Niegowic, Poland / Karol Wojtyla, a young country curate, surrounded by his parishioners. Karol stayed in this parish for only one year. Before he left, he saw to it that a new church was built in place of the old one, which was considered too run-down.

1950 / Galitzia, Poland / Karol rode his bicycle regularly on the roads of Galitzia. Cycling was one of his favorite sports, and he didn't hesitate to compete in 250k races with groups of young people.

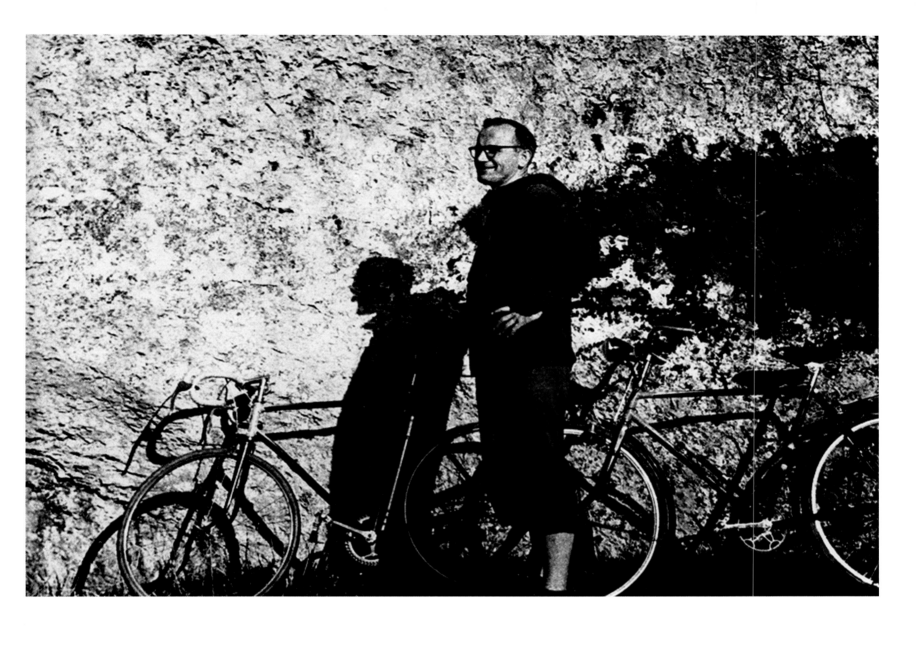

1950 / Mazurie, Poland / Father Wojtyla takes a walk in Mazurie, a region in northeastern Poland known for its large lakes. Recalled to Kraków at the beginning of 1949 to the parish of Saint Florian, Karol founded a Gregorian choir with whom he organized mountain hikes and canoeing and kayaking trips to Mazurie. During this period he also published his poetry under the two pseudonyms Andrzej Jawien and Stanislaw Andrzej Gruda.

1951 / Tatras Mountains, Poland /
The young priest Karol Wojtyla
camping out.

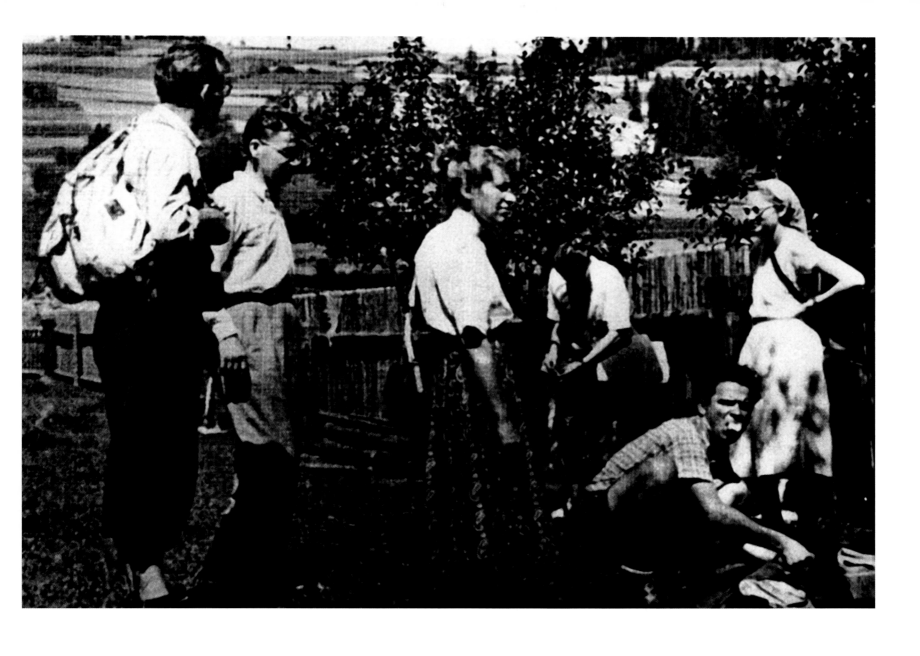

1951 / Tatras Mountains, Poland / Karol Wojtyla on one of the clandestine walks in which philosophical and religious reflections were shared with students and young married couples. He is dressed in civilian clothes and was called *wujek* (uncle). The communist authorities had forbidden outings with clergymen.

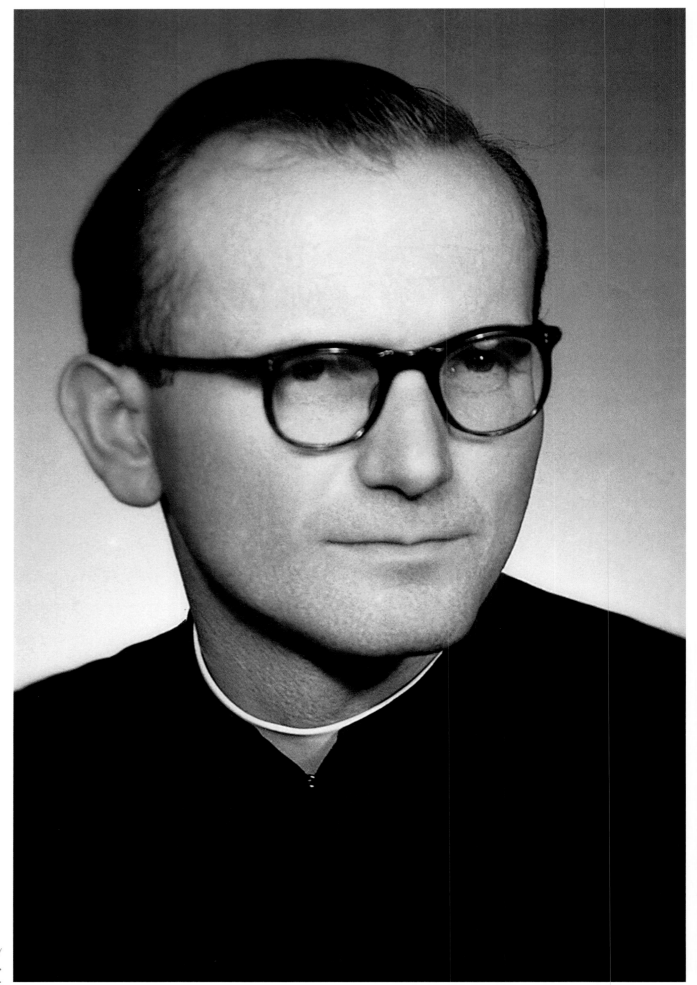

1953 / Kraków, Poland /
Portrait of Father Wojtyla,
thirty-two years old.

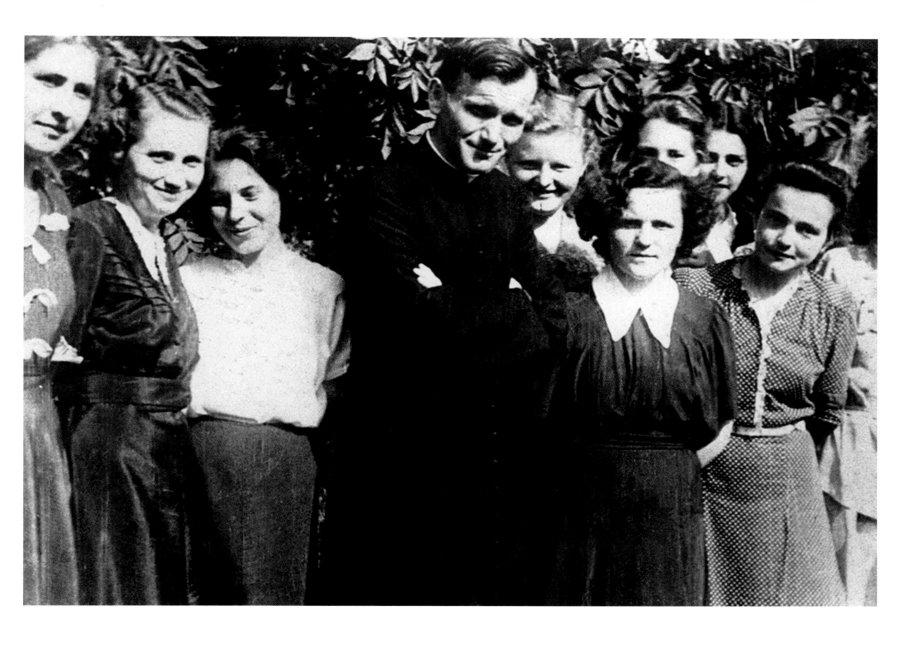

1952 / Kraków, Poland / At the request of his archbishop, Karol Wojtyla was named Vicar of Saint Florian of Kraków in 1949. Monsignor Sapieha called upon him to work in an urban setting, in the center of Kraków, his adopted city. The young priest is shown here in his parish, surrounded by the students whom he served as chaplain.

1953 / Vybon Alk, Poland / Father Wojtyla on a hike with friends.

1953 / Bieszczady Mountains, Poland / Father Wojtyla hiking in the Bieszczady Mountains, a massif located in the eastern Carpathians.

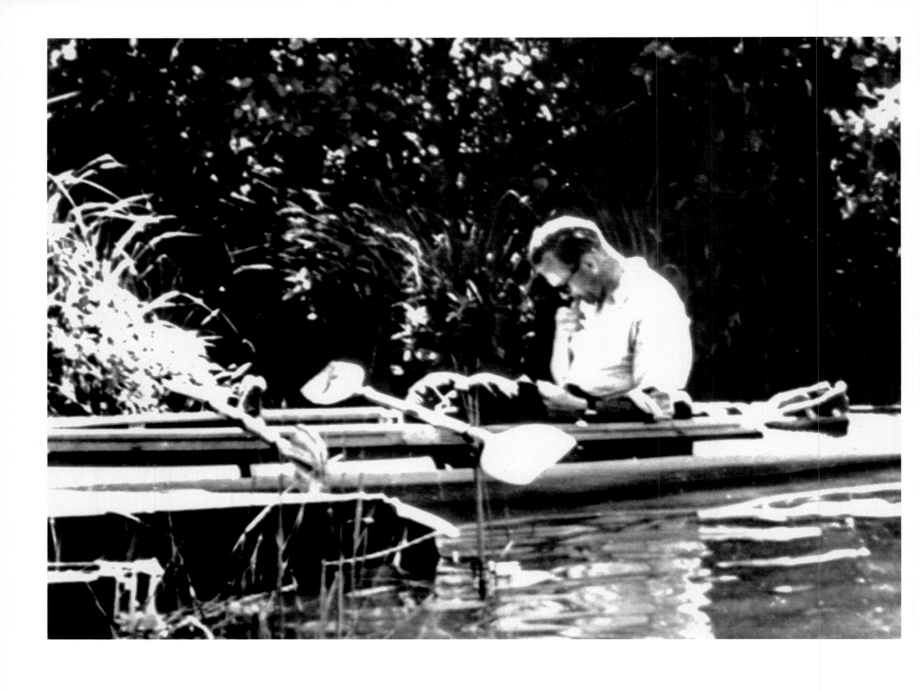

June, 1953 / Brda River, Poland / An athlete and nature lover, Father Wojtyla loved to go walking, cycling, and kayaking.

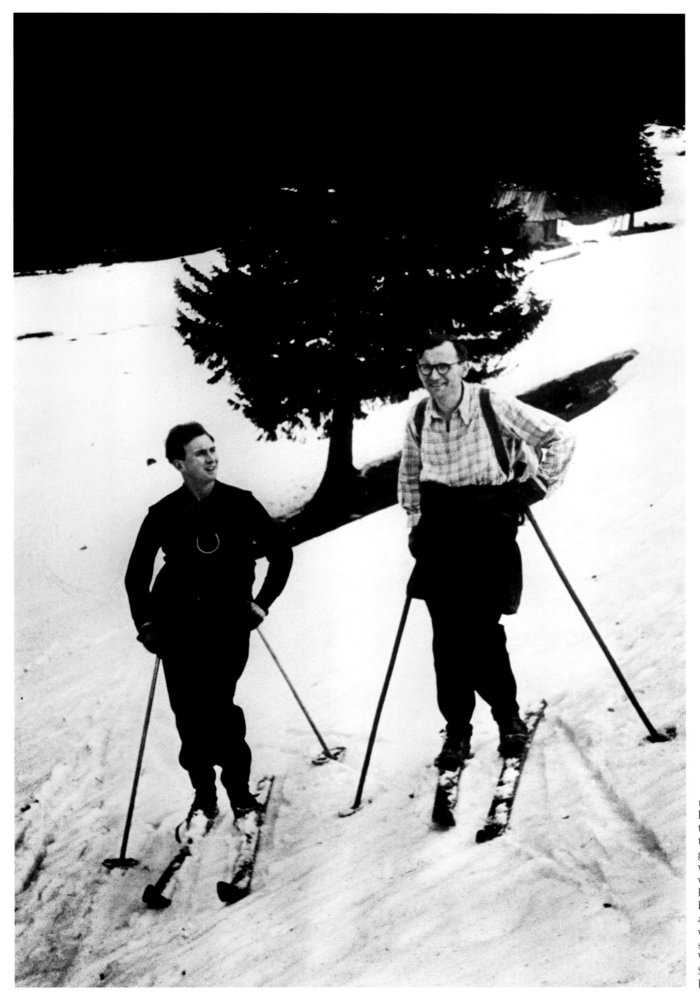

1955 / Bieszczady Mountains, Poland /
Father Wojtyla participated in more
than half a dozen sports. He learned
to ski in his late forties, and did not
give up practicing this sport until he
was seventy-two years old. In 1976,
while skiing in the Tatras Mountains,
he ventured too near the border
between Poland and Czechoslovakia
and was arrested by customs officers,
who believed that this skier had
stolen his papers from a Father
Wojtyla. Here Karol skis with
Stanislaw Dziwisz, who later became
his private secretary.

July 19, 1954 / Lublin, Poland / Father Wojtyla at the lectern at the Catholic University of Lublin. Karol was appointed to the Department of Philology there and continued his studies at Jagiellonian University in Kraków.

1959 / Tatras Mountains, Poland / Karol Wojtyla camping out in the Tatras Mountains, in the High Carpathians along the Slovak-Polish border.

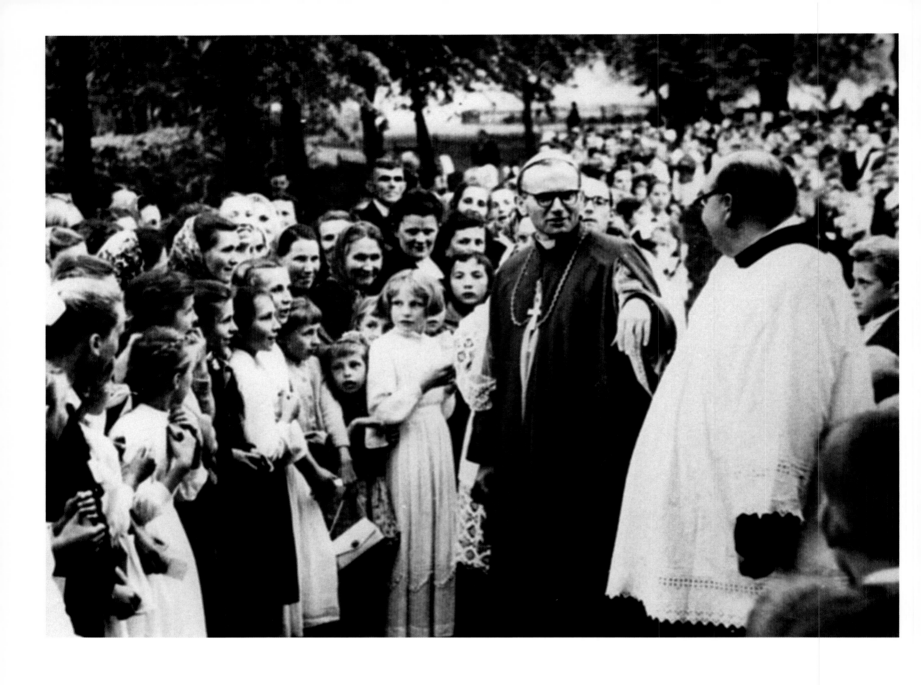

1957 / Kraków, Poland / Father Wojtyla celebrates mass outdoors on a communion day.

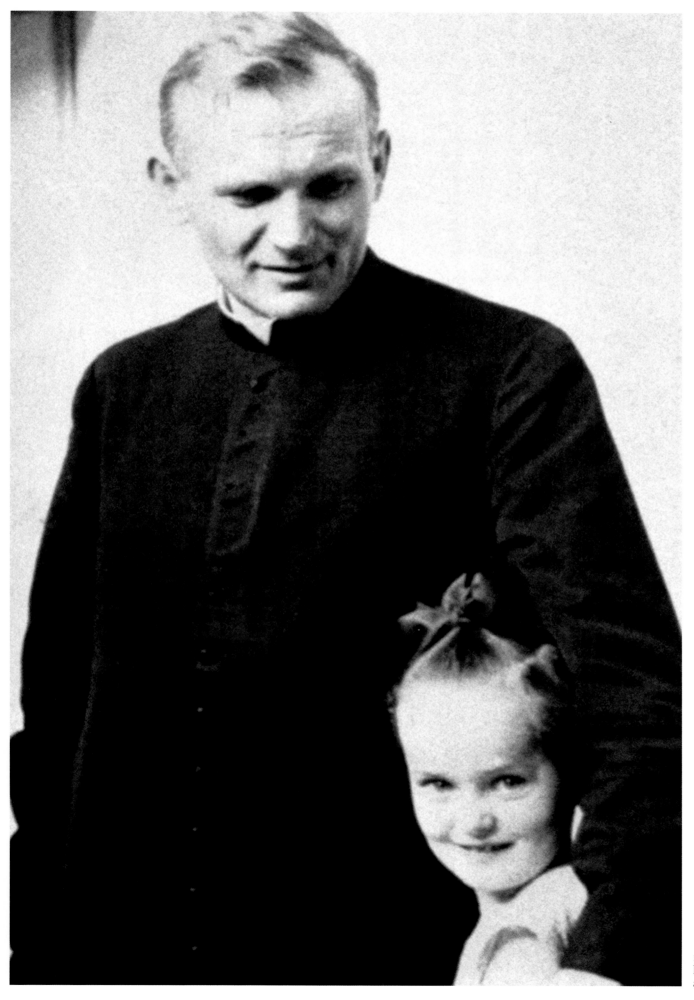

1954 / Kraków, Poland /
Father Wojtyla next to the daughter of
a friend.

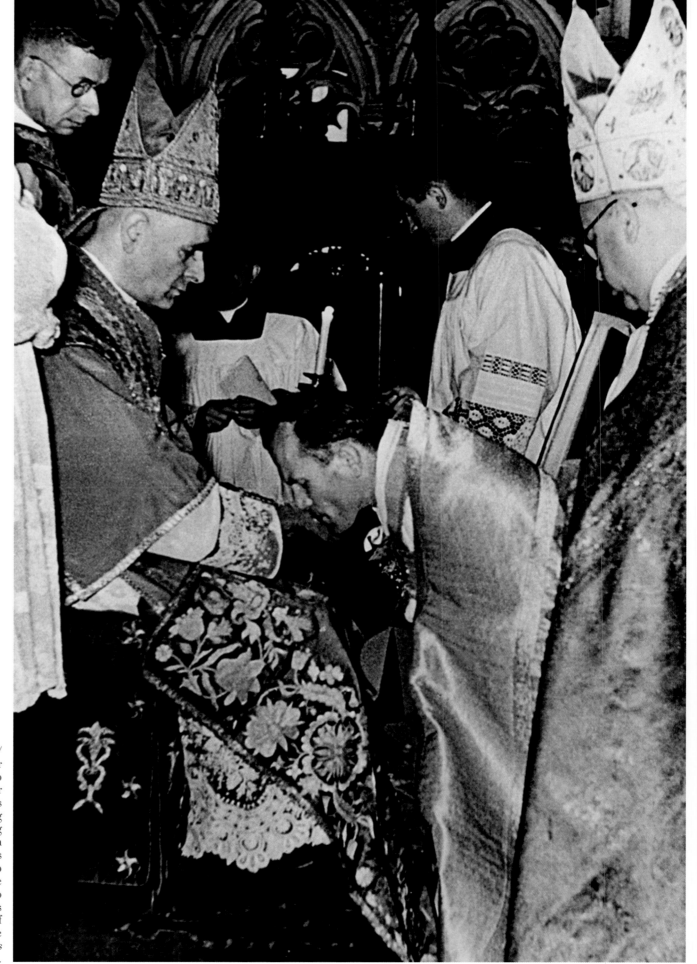

September 28, 1958 / Kraków, Poland /
Episcopal consecration of Father
Karol Wojtyla by the archbishop
primate of Poland, Monsignor
Eugeniusz Baziak. Several weeks
earlier, during a vacation camping
retreat in the mountains with young
people, Karol Wojtyla had received a
telegram announcing that Pope Pius
XII had named him auxiliary bishop
of Kraków. As custom decreed, the
new bishop had to choose a motto
that summed up the meaning of his
life. Karol Wojtyla chose a saying of
Saint Louis Marie Grignion de
Montfort: *Totus tuus*
(Totally yours).

September 28, 1958 / Kraków, Poland /
Episcopal consecration of Karol
Wojtyla, who became the youngest
bishop in Poland. Custom decreed
that an auxiliary bishop be attached
to one of the bishoprics of the Early
Church, from which derives the title
of bishop *in partibus infidelium* (in
the land of the unbelievers). Thus
Karol Wojtyla was named titular
bishop of Ombi, near Thebes, in
Upper Egypt. The place is known
today as Kom Ombo and is located to
the south of modern Luxor, in the
middle of the desert.

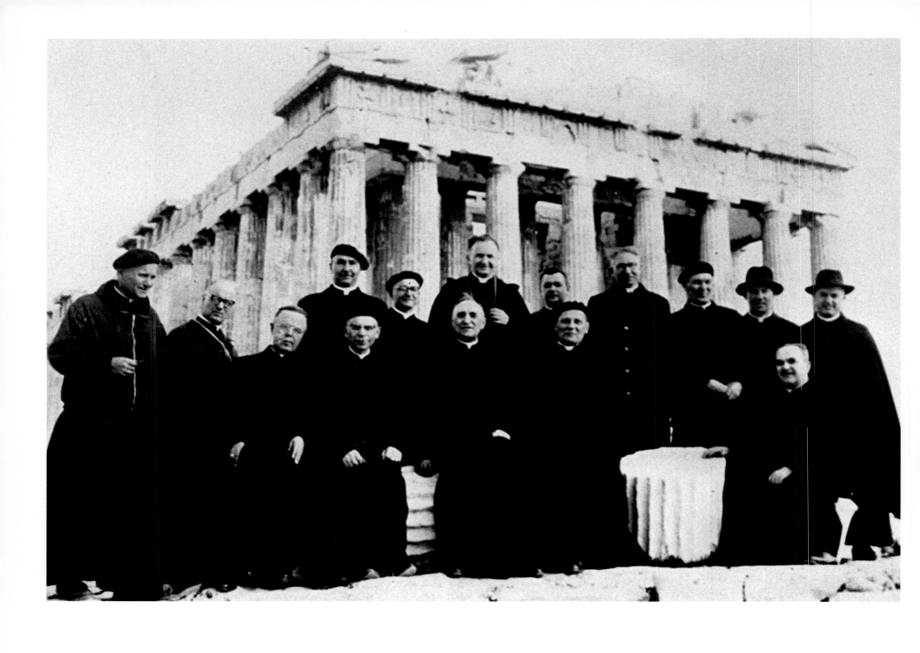

December 5, 1963 / Athens, Greece / Karol Wojtyla, at left, was part of a group of bishops attending the Second Vatican Council, or Vatican II, stopping over in Athens on a pilgrimage to the Holy Land. In 1962 and 1963, Karol was a part of Vatican II, where he personally contributed to *Gaudium et spes*.

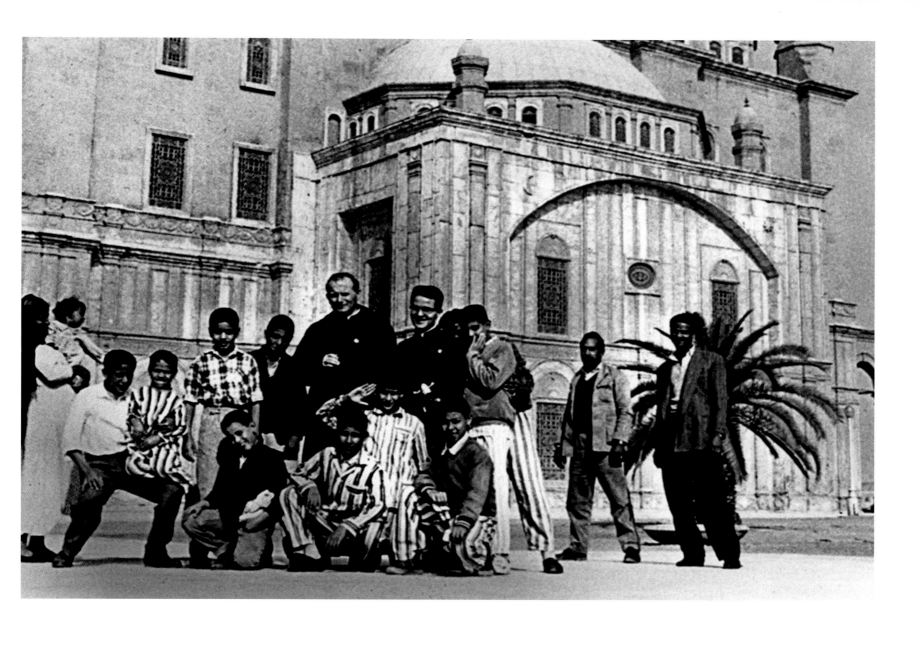

December 10, 1963 / Israel / During a pilgrimage to the Holy Land with several other bishops of various nationalities attending Vatican II, Karol Wojtyla poses amidst a group of the faithful.

"It is you who will bring the Church into the third millennium." John Paul II

January 13, 1964 / Kraków, Poland / Karol Wojtyla, a few days after the issue of the papal bull by Paul VI naming him archbishop of Kraków. Several months later, Paul VI granted him the pallium, which symbolizes participation in the supreme pastoral power of the pope and which can only be worn by the pope or by a bishop who receives the privilege from the pope. Since the ninth century, this privilege has been exclusively reserved for archbishops, primates, patriarchs, and the cardinal dean.

70

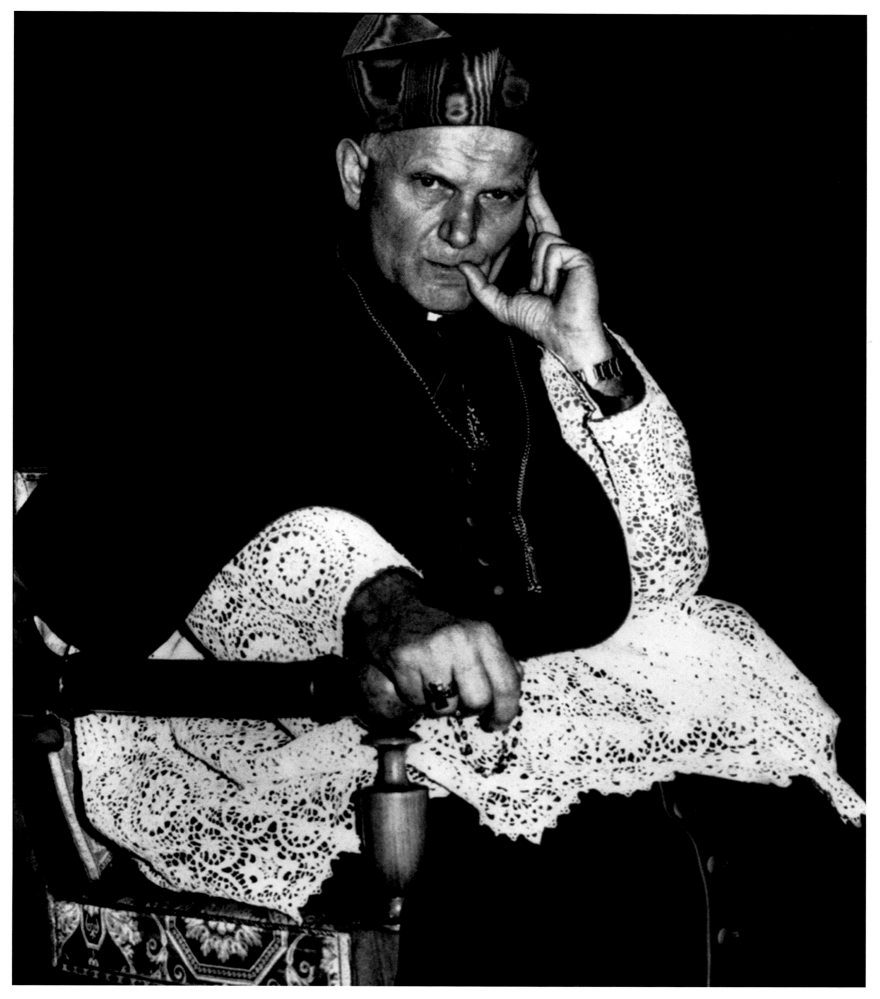

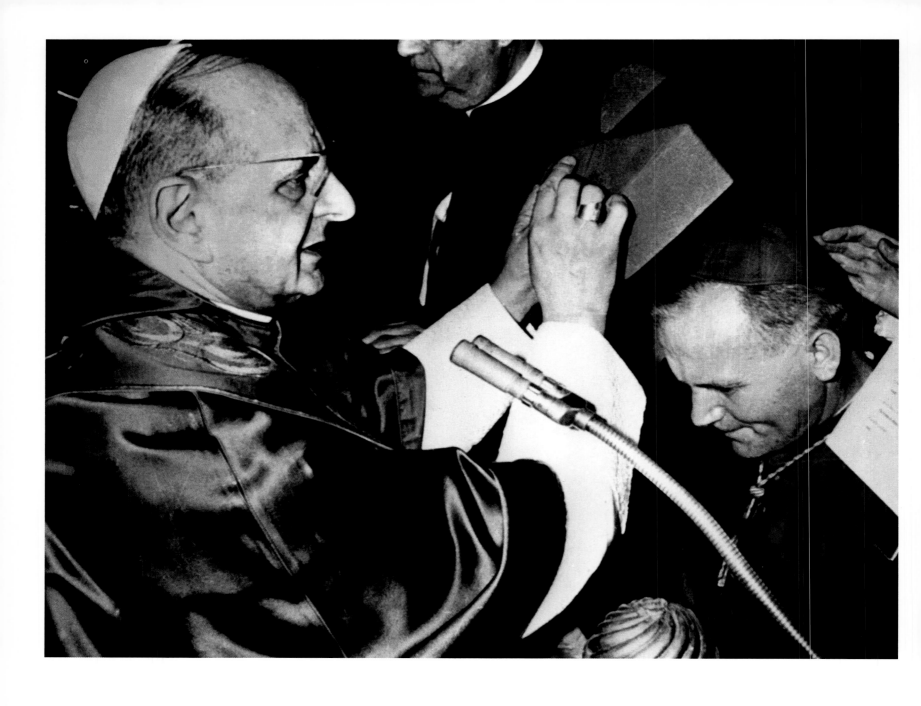

June 28, 1967 / Rome, Italy / Monsignor Karol Wojtyla is made a cardinal by Paul VI in the Sistine Chapel. The pope grants him the guardianship of San Cesareo, a church in Palatio.

June 29, 1967 / Rome, Italy / Karol Wojtyla has just been made a cardinal. At the age of forty-seven, he becomes the second-highest-ranking church official in Poland. The color red associated with the rank of cardinal signifies that he who wears it agrees to defend his faith and his church "even to the shedding of blood."

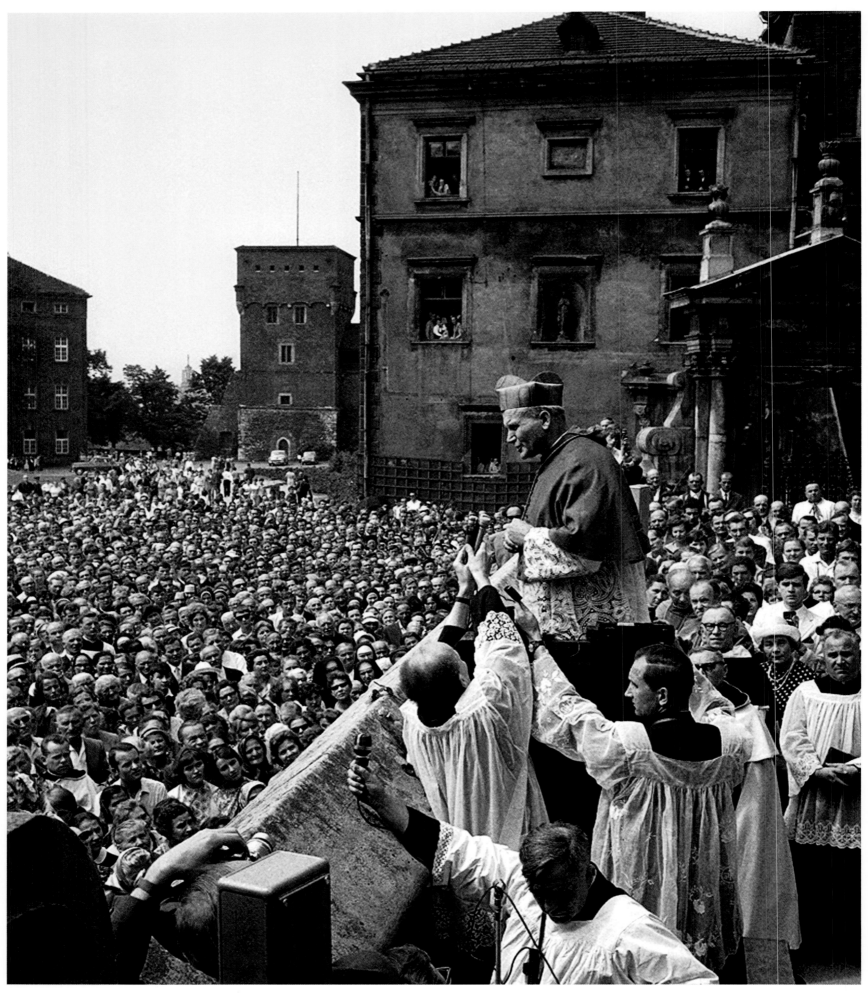

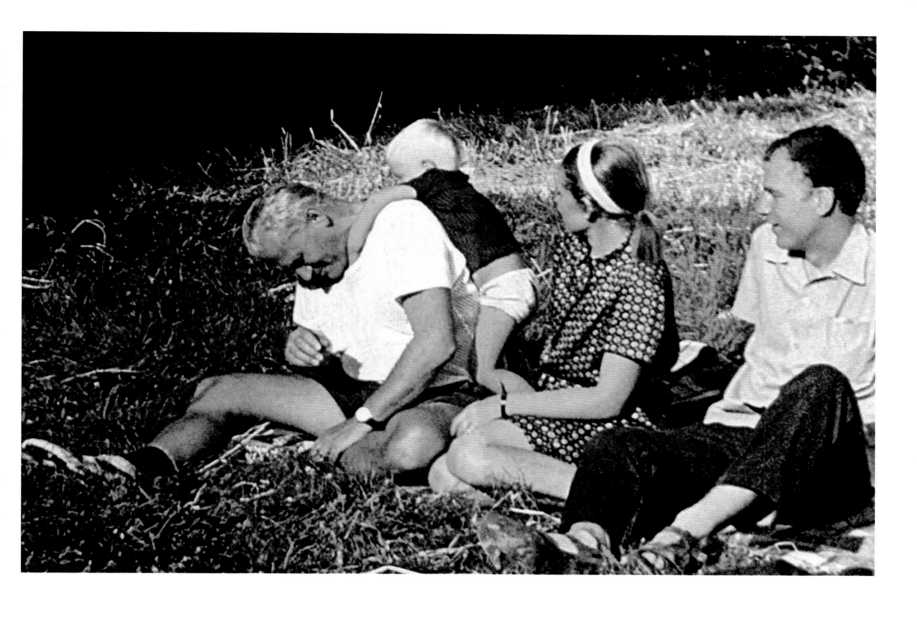

1972 / Tatras Mountains, Poland / Cardinal Wojtyla hiking with two of his former students and their son.

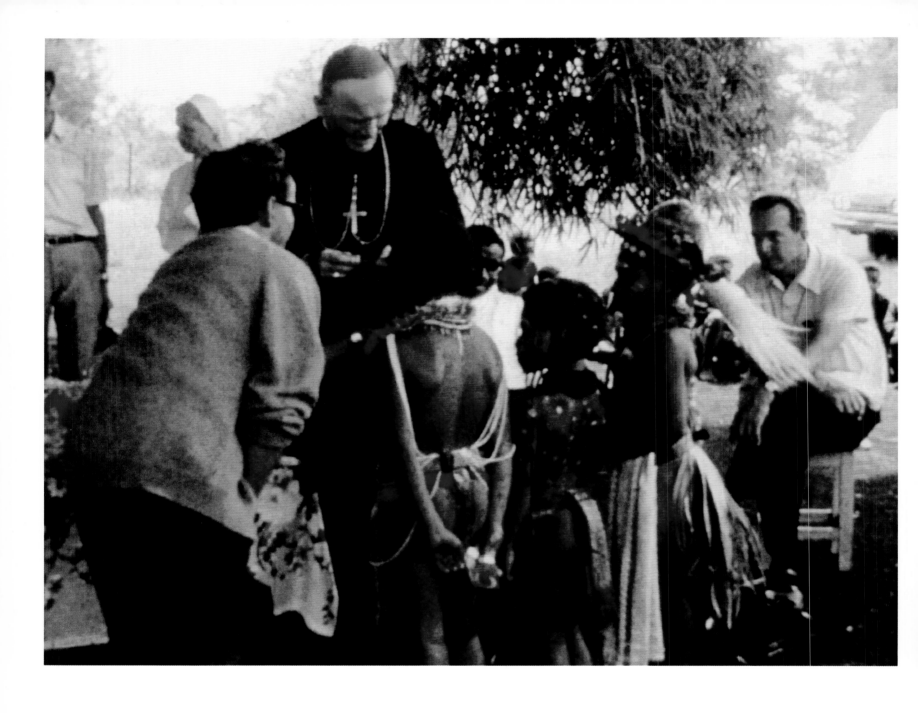

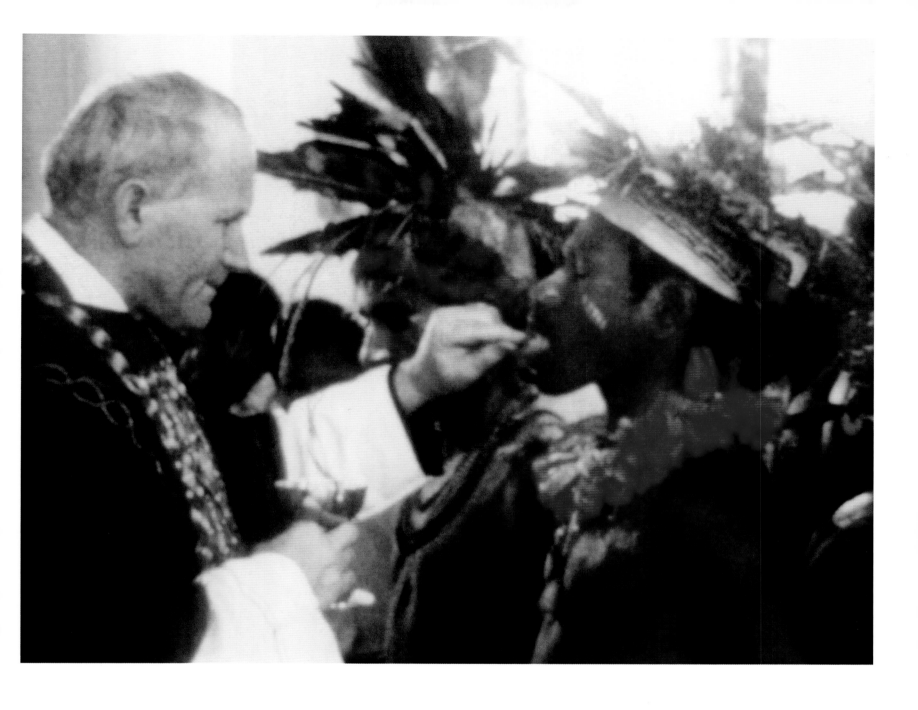

February, 1973 / Port Moresby, Papua New Guinea / Cardinal Wojtyla gives communion during a trip that took him to the Philippines, New Zealand, Papua New Guinea, and Australia. It was the first time that a Polish cardinal traveled to these countries.

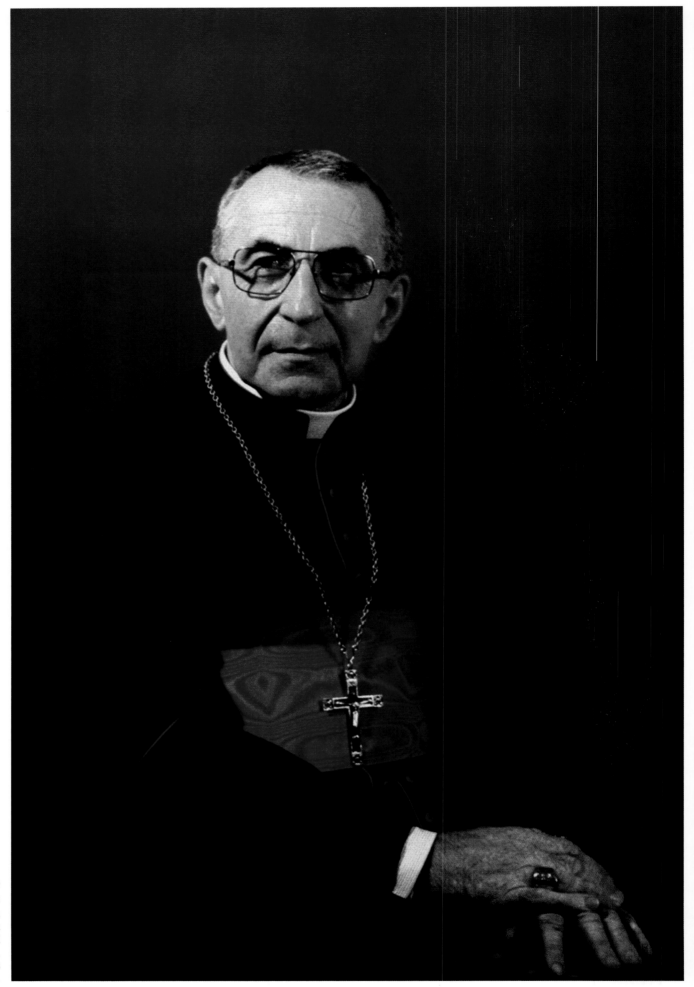

1978 / Rome, Italy /
Cardinal Albino Luciani (1912-1978)
was ordained in 1935, made a
cardinal in 1973, and elected pope in
August 1978 after the death of Paul
VI. He took the name of John Paul I,
and died thirty-three days after his
election.

October 1, 1978 / Rome, Italy / The remains of John Paul I lie in state in Saint Peter's Basilica.

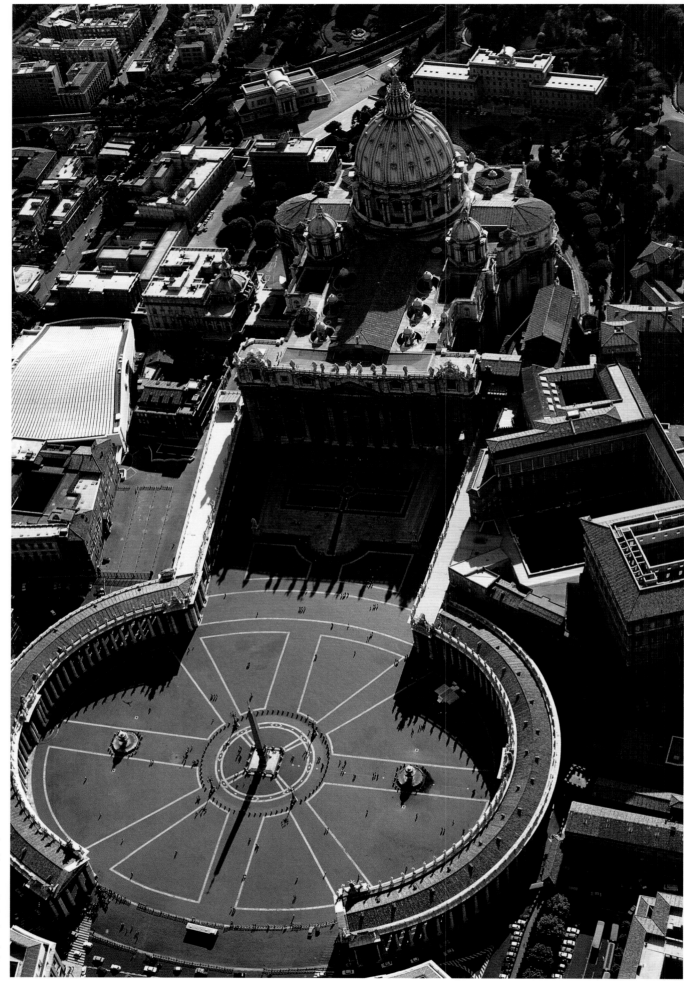

1978 / Rome, Italy /
Aerial view of the Vatican, smallest
state in the world. The State of the
Vatican City is an independent state
with an area of .44 km² and eight
hundred ninety inhabitants. It was
established on February 11, 1929 in
accordance with the Lateran treaties,
signed in the name of the Holy See by
Cardinal Gasparri and on behalf of
Italy by Benito Mussolini.

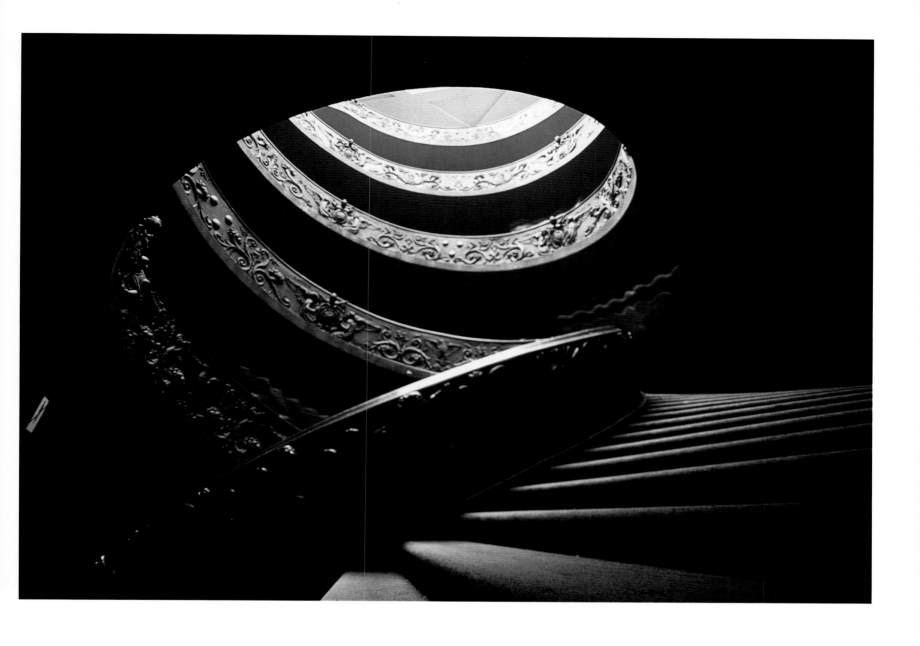

1978 / Rome, Italy / Balustrade leading to the Vatican Museums.

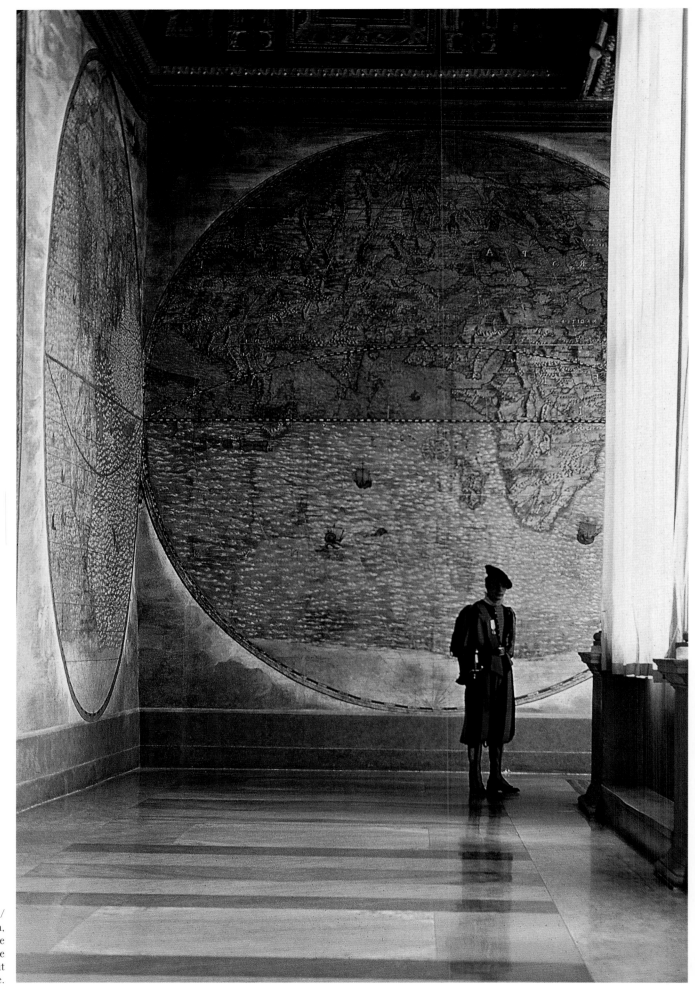

1979 / Rome, Italy /
View of the Loggia della Cosmografia,
main passage into the interior of the
Vatican, decorated with maps of the
world and with windows looking out
on Saint Peter's Square.

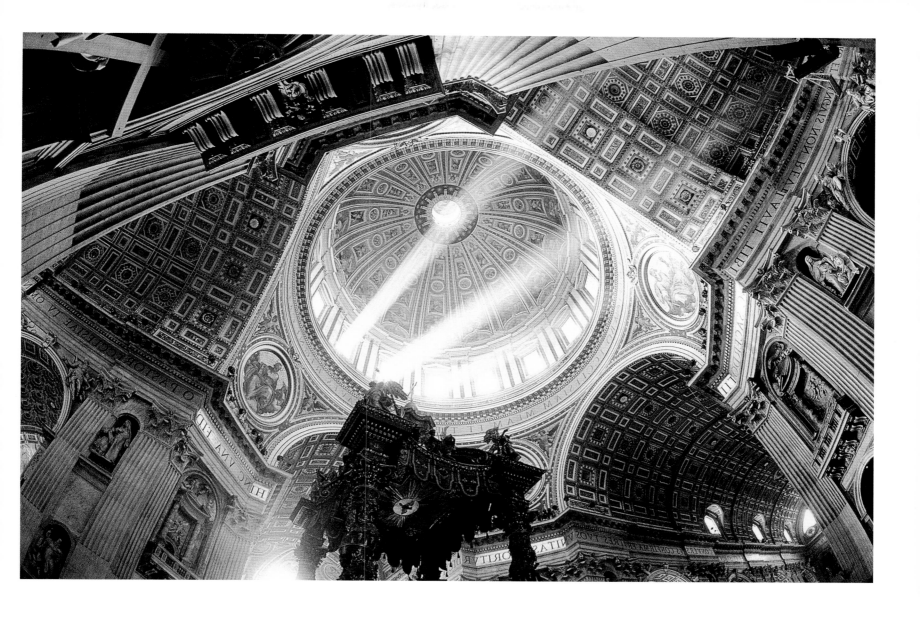

1978 / Rome, Italy / Dome of Saint Peter's Basilica, designed by Michelangelo, who was elevated to the rank of architect of the basilica for life by Paul III in the sixteenth century. The bronze baldachin with twisted columns over the main altar was designed by Gianlorenzo Bernini, the greatest Italian artist of the baroque period.

1978 / Rome, Italy / View of the columns in Saint Peter's Square.

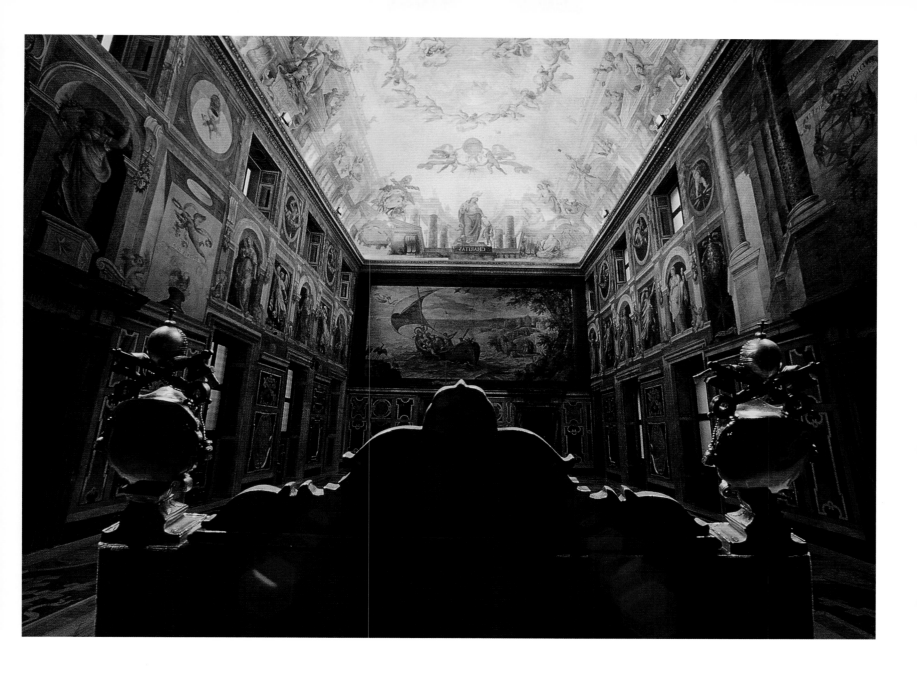

1978 / Rome, Italy / The Clementine Hall, located on the second floor of the Apostolic Palace, where large groups are received during audiences. In the foreground of this baroque setting, the papal throne.

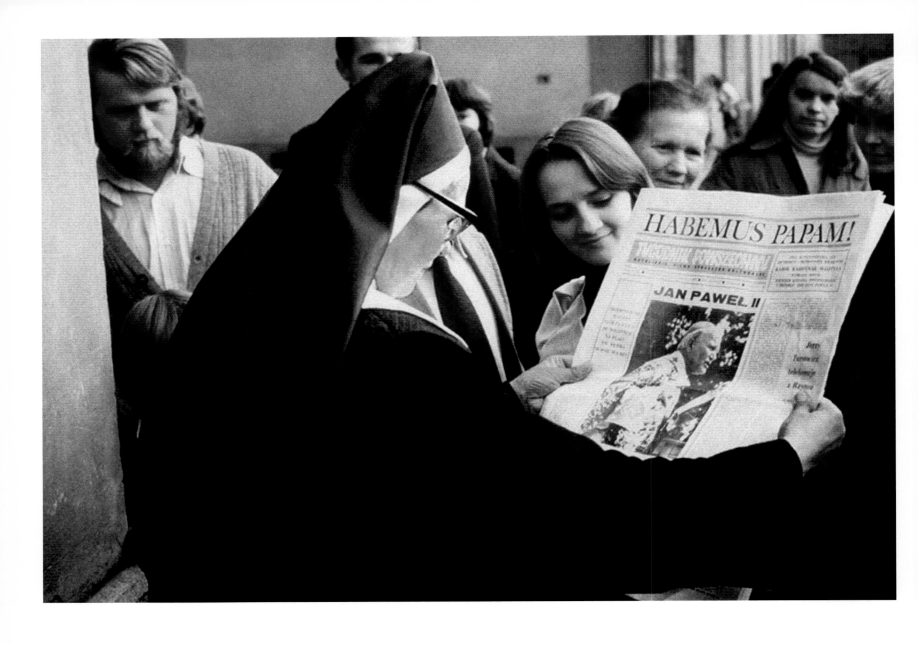

October 16, 1978 / Wadowice, Poland / Announcement of the enthronement of John Paul II in Karol Wojtyla's home town.

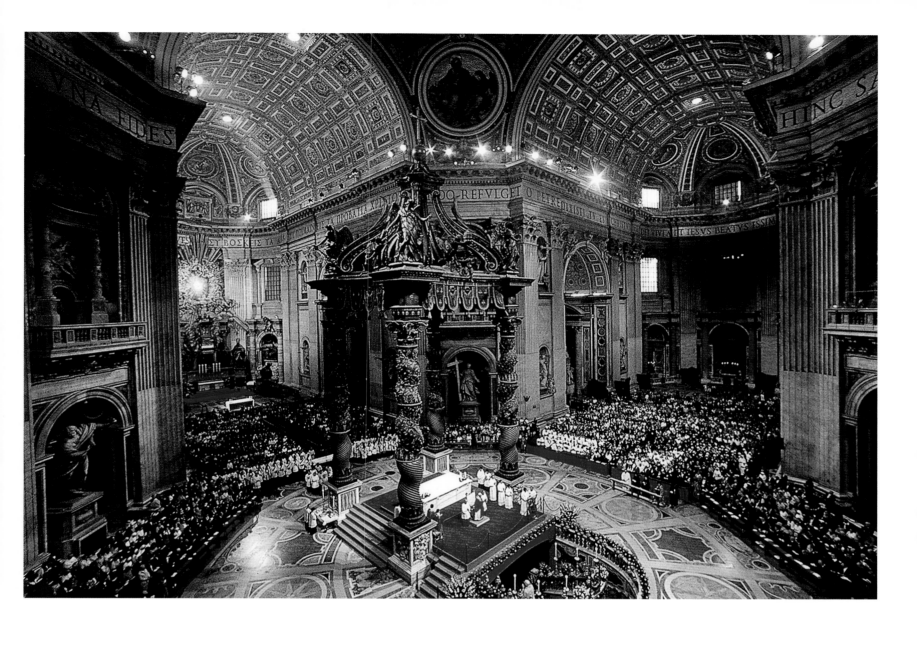

October 22, 1978 / Rome, Italy / Investiture ceremony of Pope John Paul II, the first non-Italian pope in 455 years, in Saint Peter's Basilica.

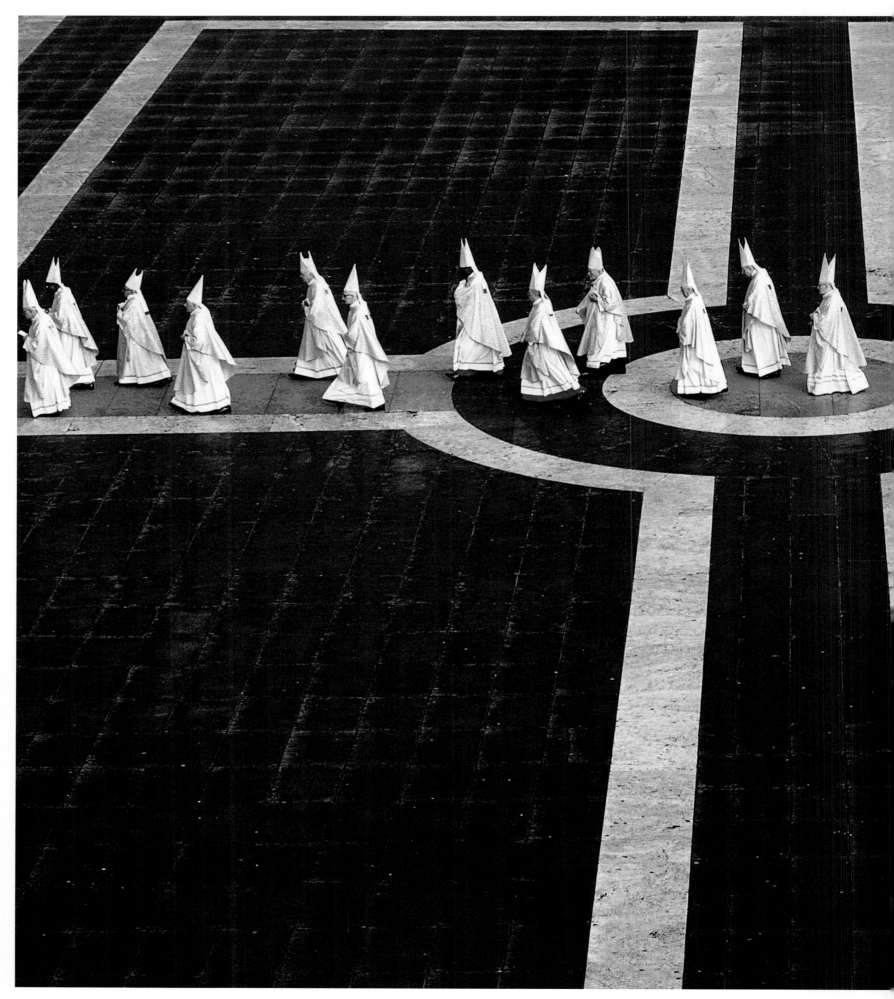

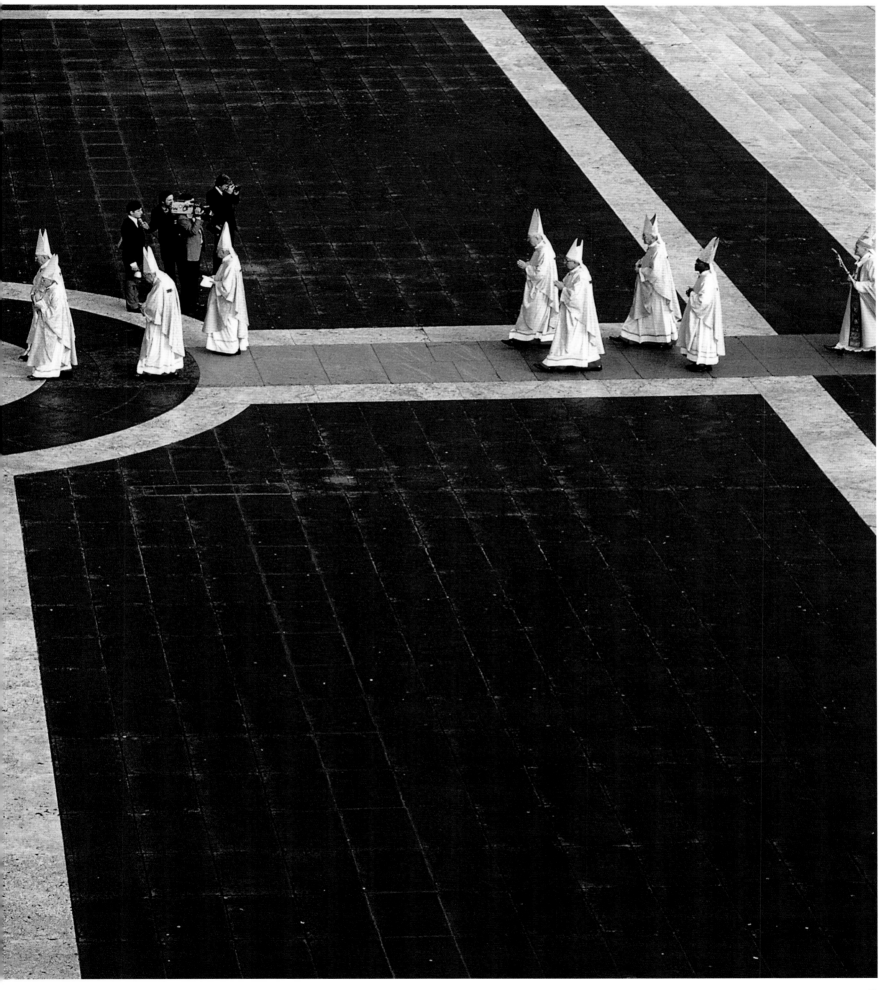

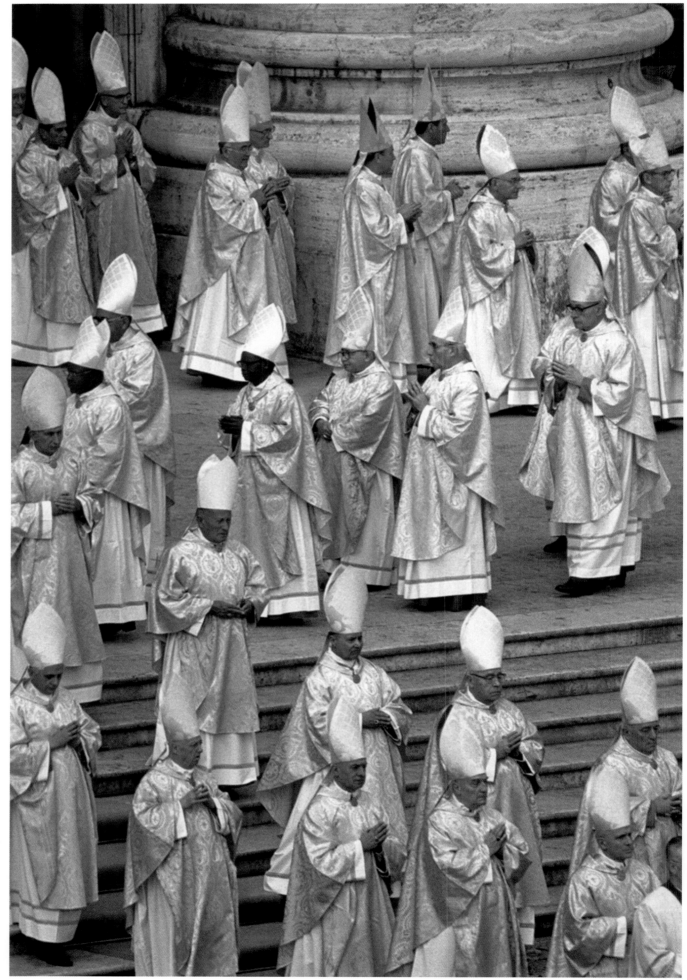

pp. 90–91:
November 24, 1985 / Rome, Italy /
Procession of bishops in Saint Peter's
Square during the extraordinary
synod held for the twentieth
anniversary of the closure of Vatican
II, which gave rise to the creation of a
new universal catechism.

October 22, 1978 / Rome, Italy /
Procession of cardinals during the
investiture ceremony of John Paul II,
the first non-Italian pope
in 455 years.

October 22, 1978 / Rome, Italy / Ceremony inaugurating the pontificate of John Paul II, who was elected by ninety-one out of one hundred eleven votes.

"He proceeds through a huge crowd, without bothering about his creased white cassock or his sleeves soiled with lipstick."

Monsignor Martin, October 23, 1978

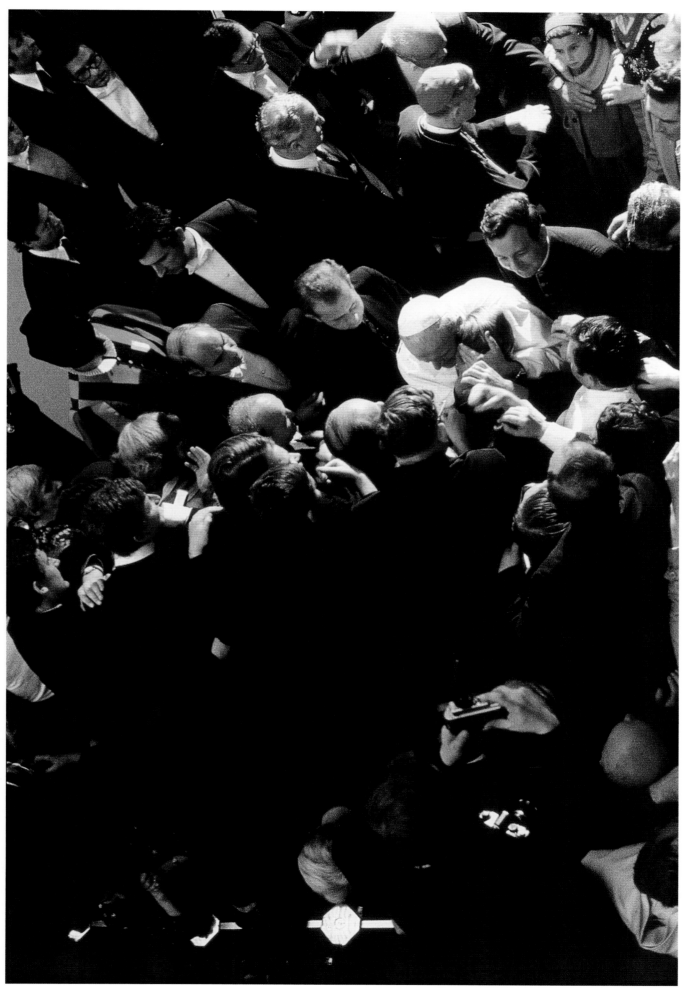

October 30, 1978 / Rome, Italy /
John Paul II at the Vatican, shortly
after his election.

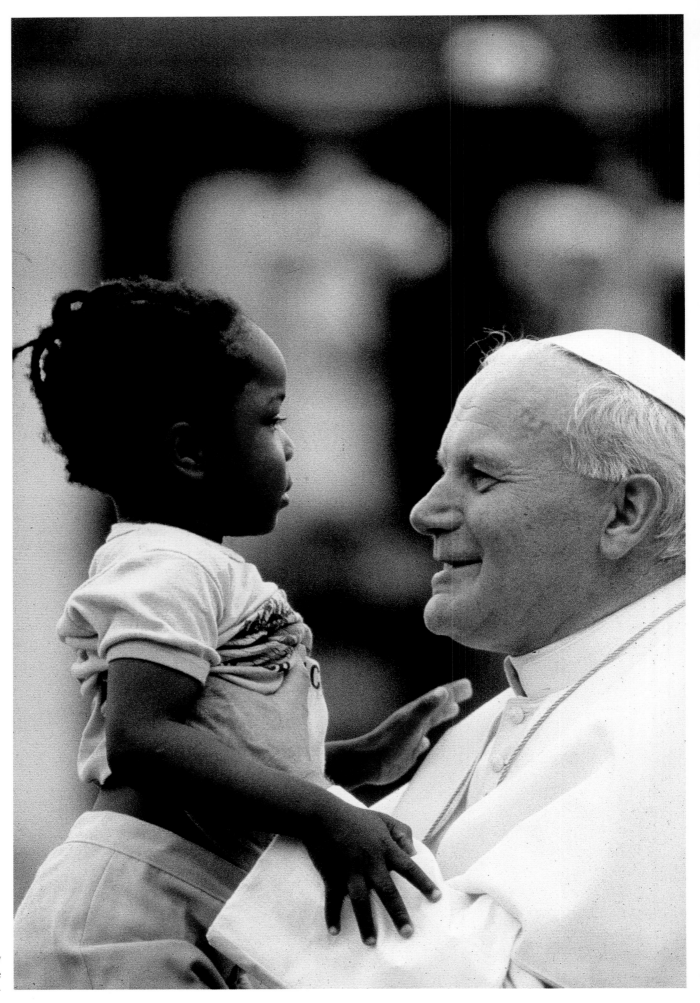

1979 / Rome, Italy /
John Paul II during a public audience
at the Vatican.

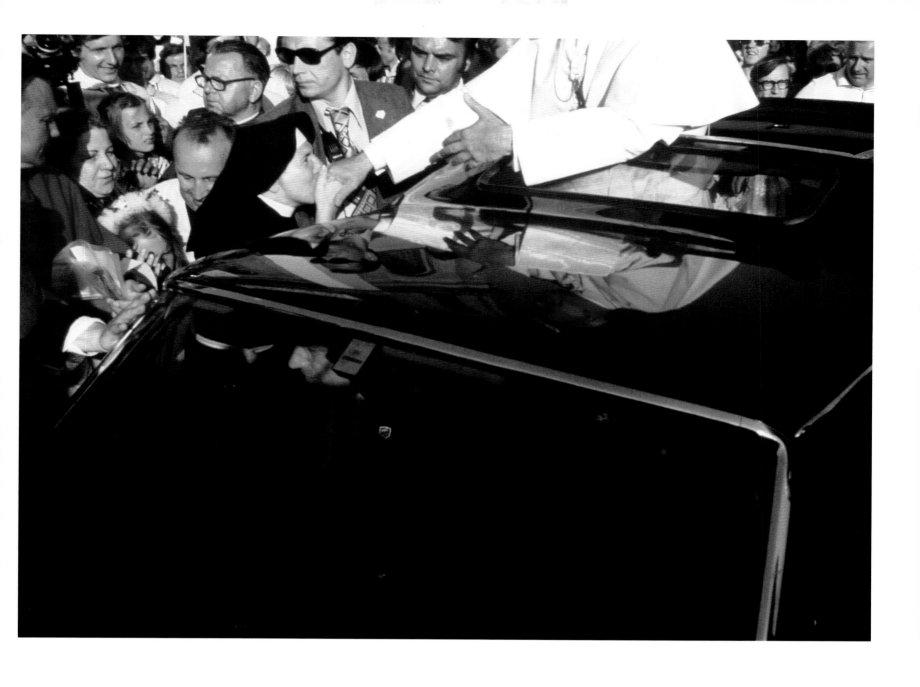

June 3, 1979 / Kraków, Poland / John Paul II during his first trip to Poland as pope, notable for his visits to Kraków, the home of his youth, and to Auschwitz.

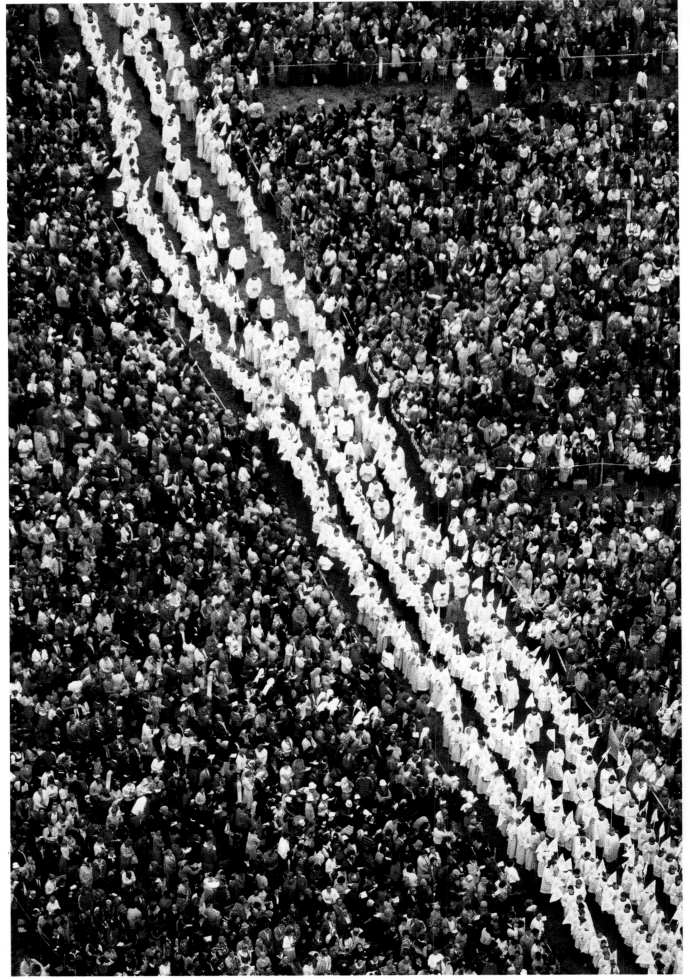

September 10, 1983 / Austria / During his first visit to Austria, in 1983, in his famous speech at the Europa Vesper am Heldenplatz, John Paul II appeals to the common responsibility of nations to preserve the Christian future of Europe.

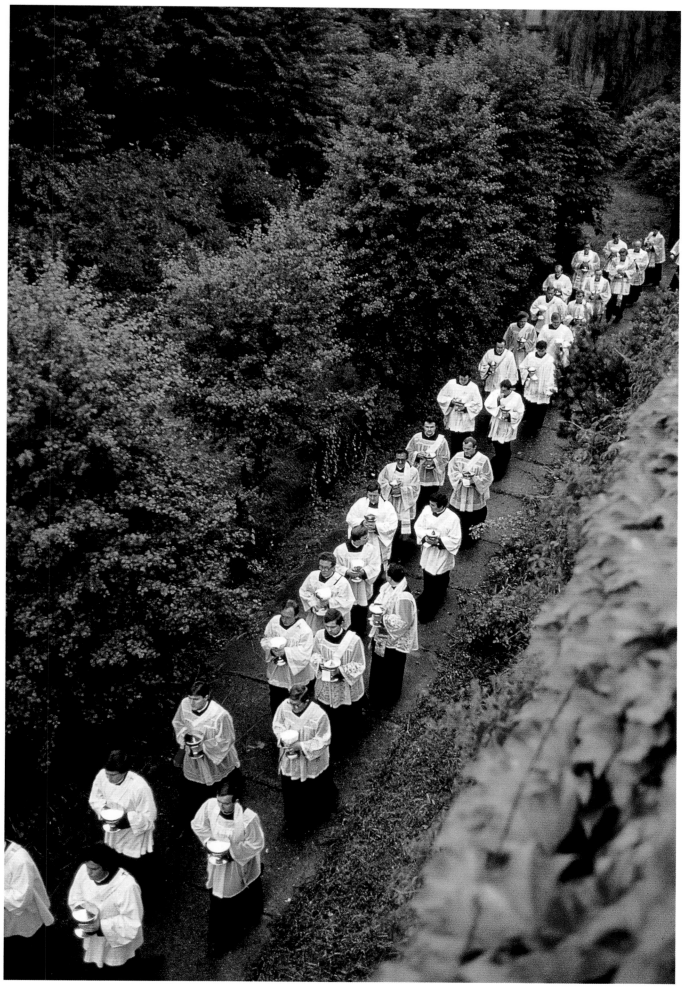

June 6, 1979 / Czestochowa, Poland / During John Paul II's first trip to Poland, a procession of monks heads towards the sanctuary of Our Lady of Jasna Gora. The chapel of the monastery of Jasna Gora houses the famous icon of the Black Virgin, revered by the pope. This miraculous icon is the patron saint of a free and democratic Poland.

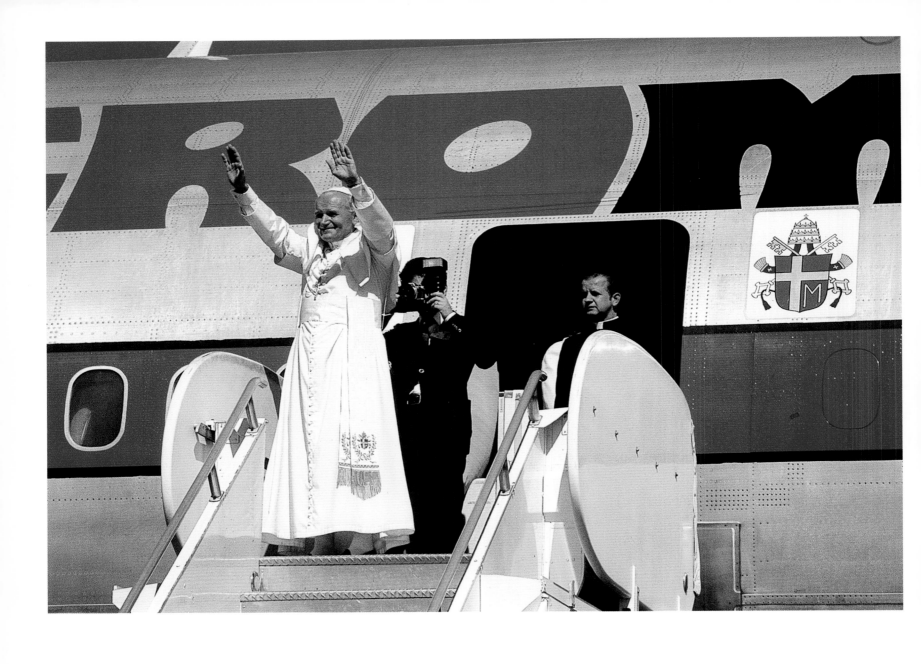

January 27, 1979 / Mexico City, Mexico / Karol Wojtyla chooses Mexico as the first country he visits upon becoming pope, in order to show his veneration for the Virgin of Guadalupe, the patron saint of indigenous peoples.

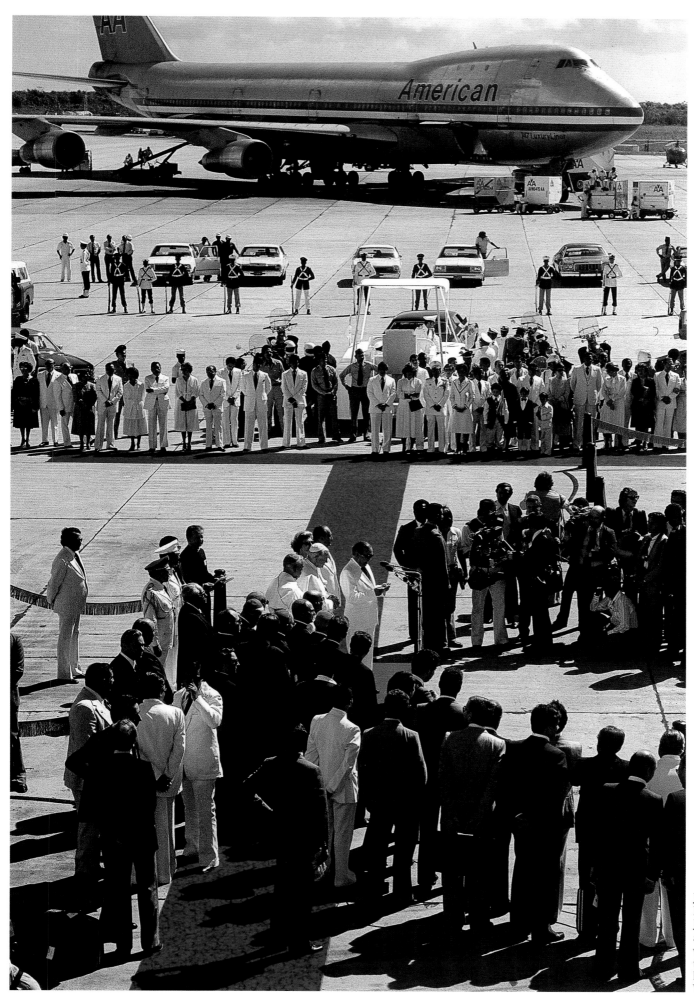

January 27, 1979 / Mexico City, Mexico / On his arrival in Mexico, John Paul II is welcomed at the airport by President Lopez Portillo, who shakes his hand. At that time, the Mexican government did not yet have diplomatic relations with the Vatican.

January 28, 1979 / Puebla, Mexico / John Paul II receives a warm welcome during his first trip abroad. Here he visits the Basilica of Our Lady of Guadalupe, to celebrate mass and to inaugurate the Third General Conference on the Latin American Episcopate.

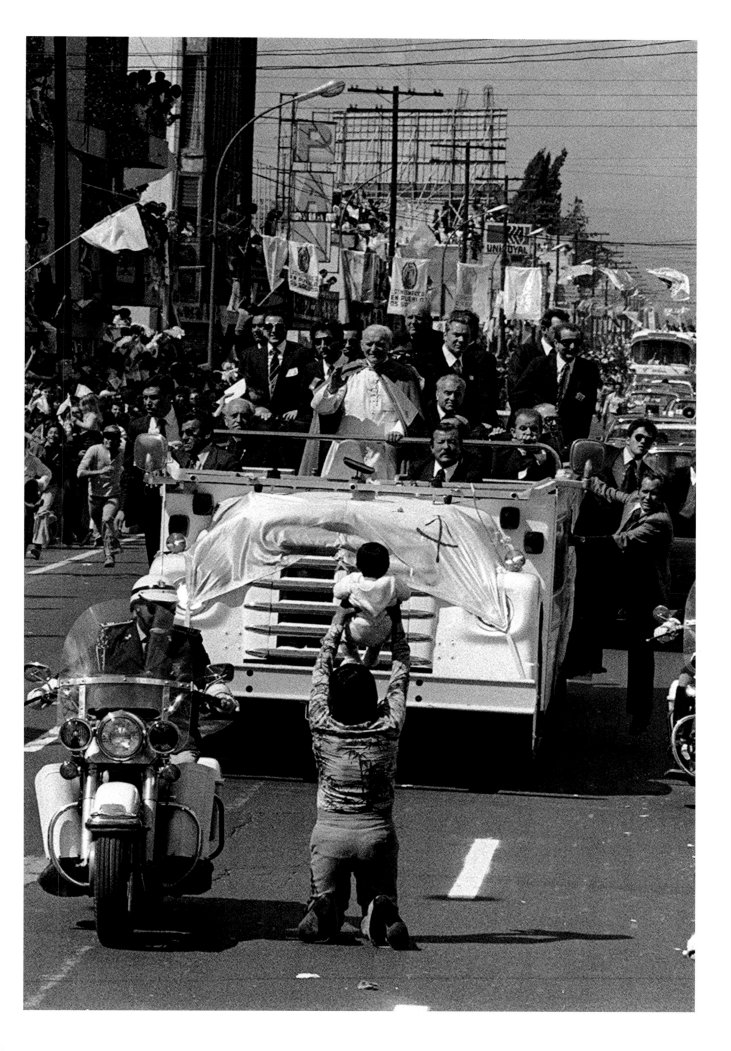

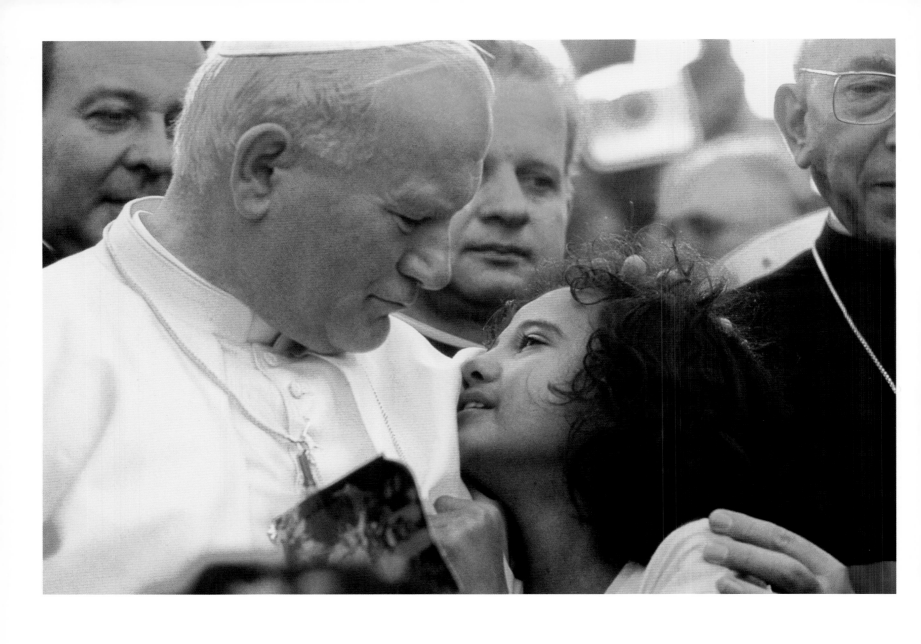

July 1, 1980 / Rio de Janeiro, Brazil / John Paul II visits the favela of Rio. Brazil is thought to be the nation with the most Catholics in the world, with 125 million faithful making up nearly 74 percent of the population in 2000.

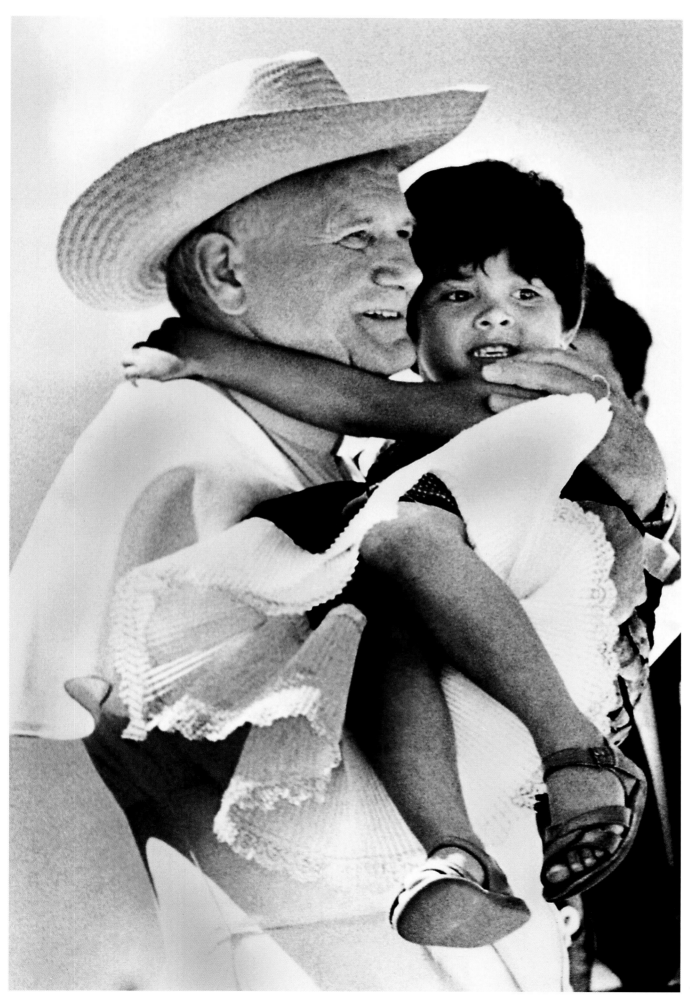

January 29, 1979 / Oaxaca, Mexico / Pope John Paul II embraces a young Indian girl. He was welcomed by thousands of Indians in the State of Oaxaca, home to 20 percent of the Indian population of Mexico, many of whom speak little Spanish.

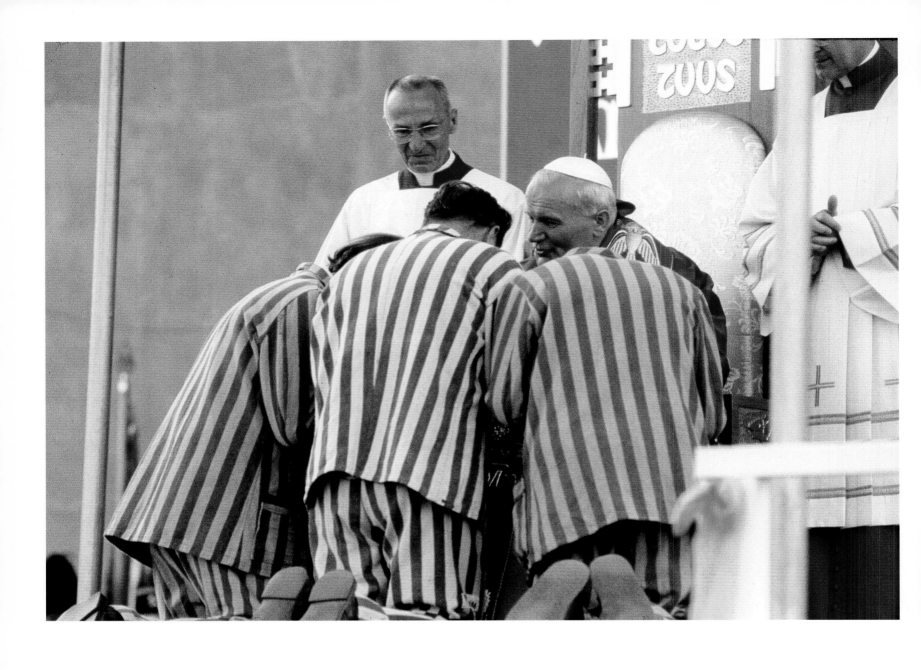

June 7, 1979 / Auschwitz, Poland / During his first trip as head of the Catholic Church to his native Poland, John Paul II becomes the first pope to visit the site of a concentration camp, a place where, in his words, the "triumph of evil" took place.

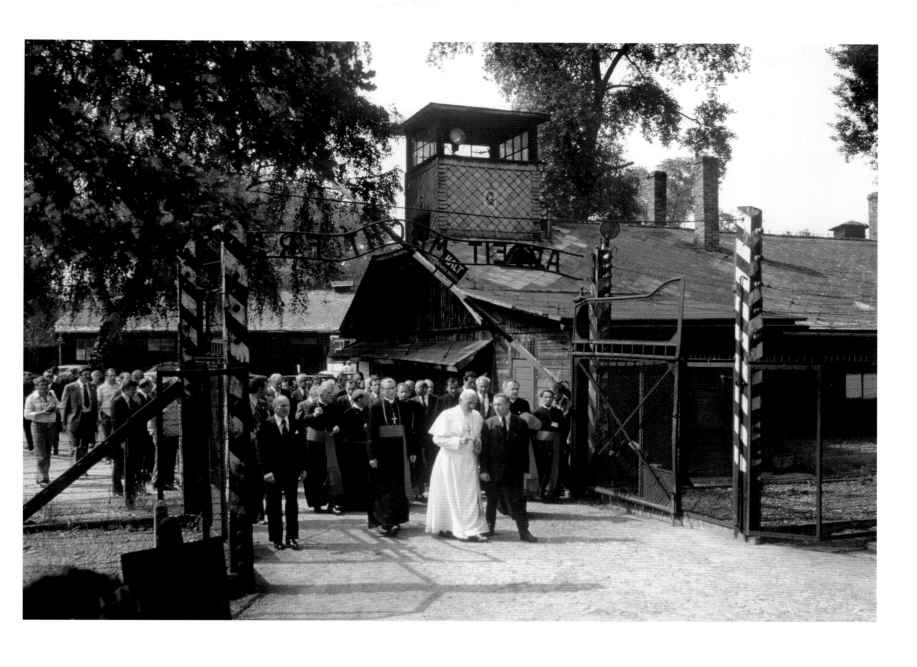

June 7, 1979 / Auschwitz, Poland / "When, as pope, I visited Auschwitz, I stopped before the monuments dedicated to the victims. I stood a bit longer before the stone bearing an inscription in Hebrew and said, 'This inscription invites us to remember the people whose sons and daughters were doomed to total extermination. This people has its origin in Abraham, who is our Father in faith. This, the very people who received from God the commandment thou shalt not kill, has itself experienced in a special measure what killing means. No one is permitted to pass by this monument with indifference.'" John Paul II, January 15, 2005

"The older I grow,
the more the youth demand
I stay young." John Paul II

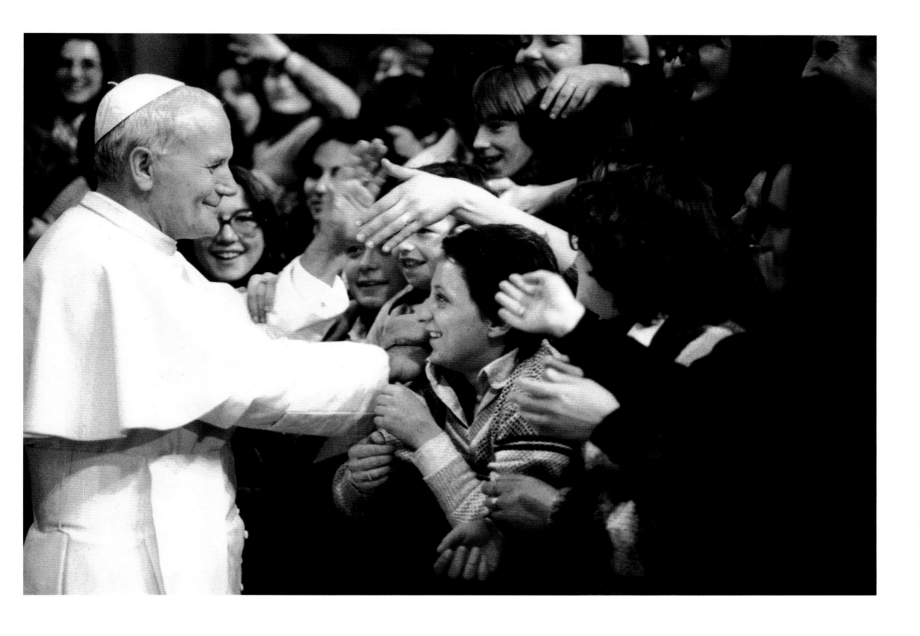

October 30, 1978 / Rome, Italy / John Paul II during a weekly public audience.

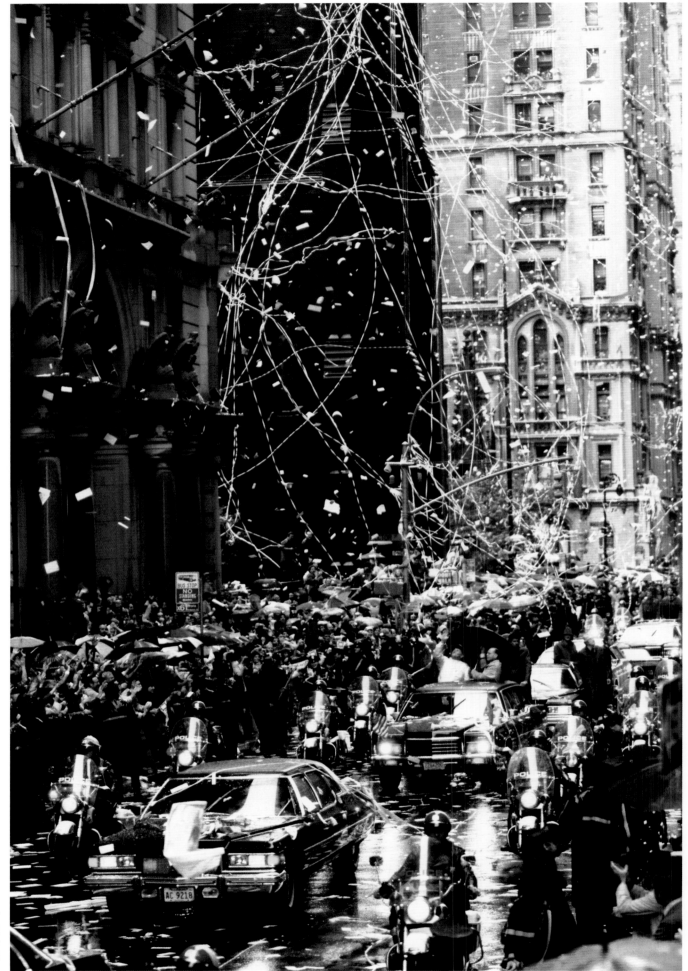

October 1, 1979 / New York City /
John Paul II is cheered by the crowd
during his trip to New York, shortly
before addressing the General
Assembly of the United Nations.

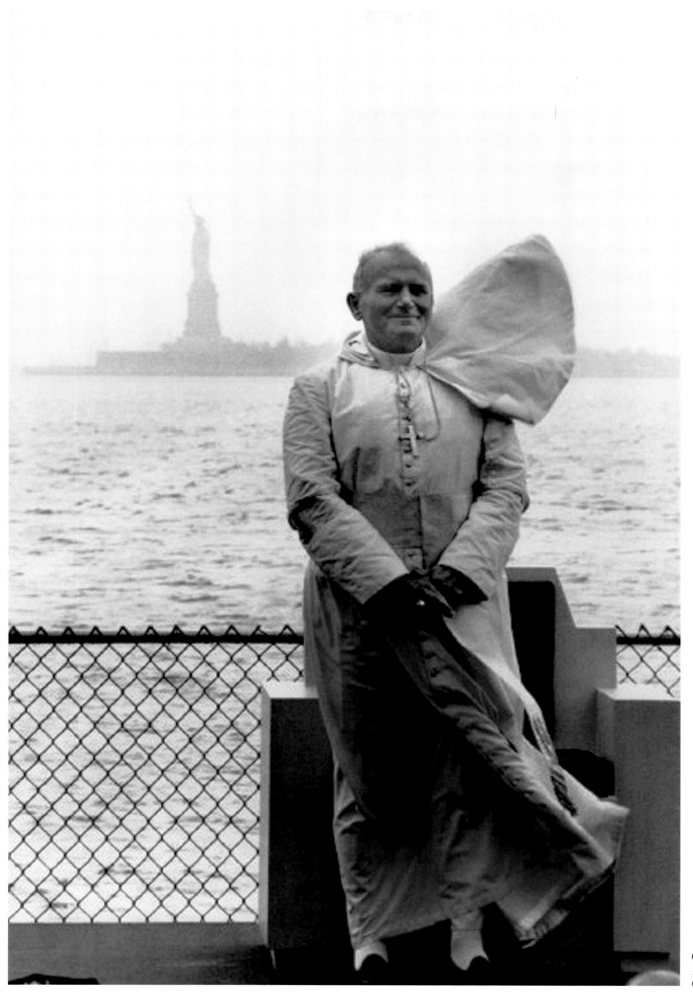

October 3, 1979 / New York City /
John Paul II visiting Battery Park
during his trip to New York.

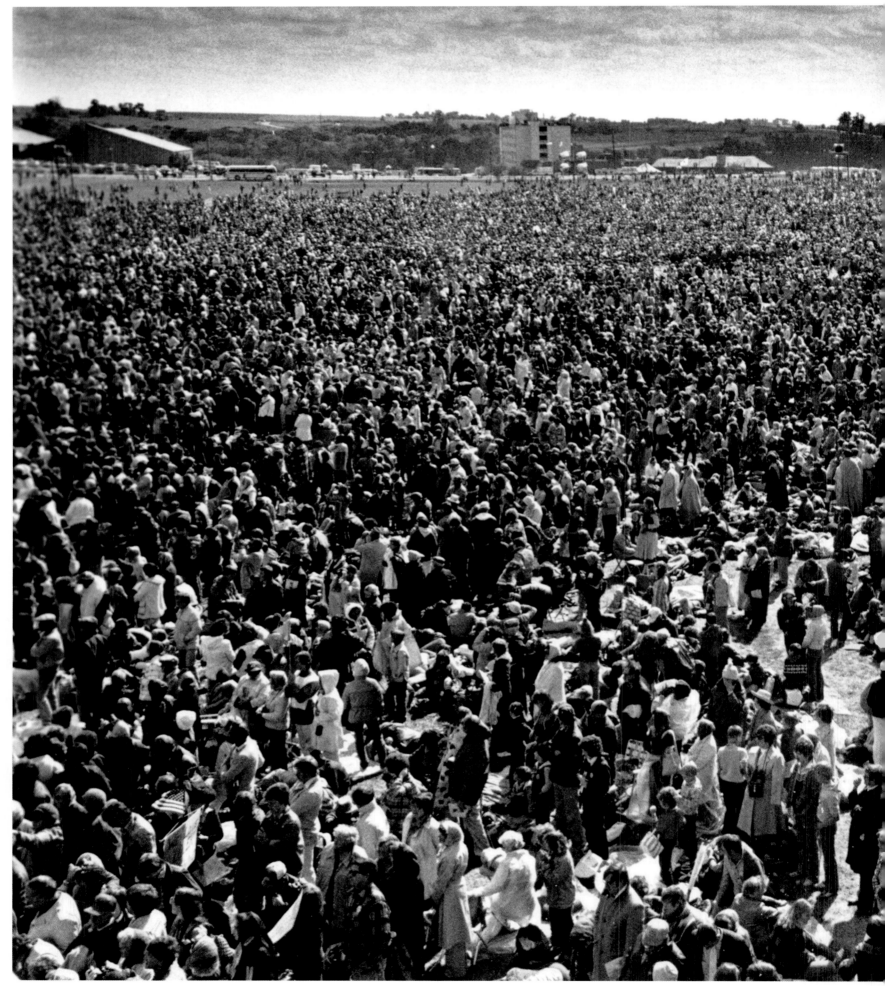

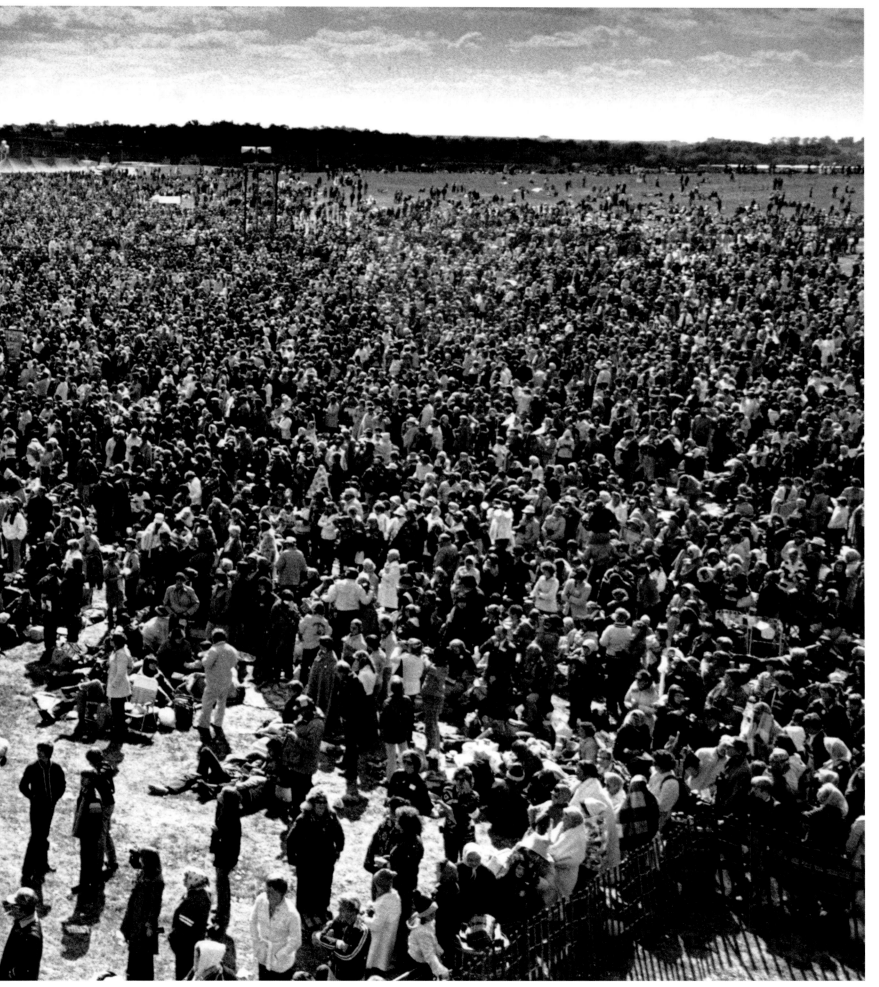

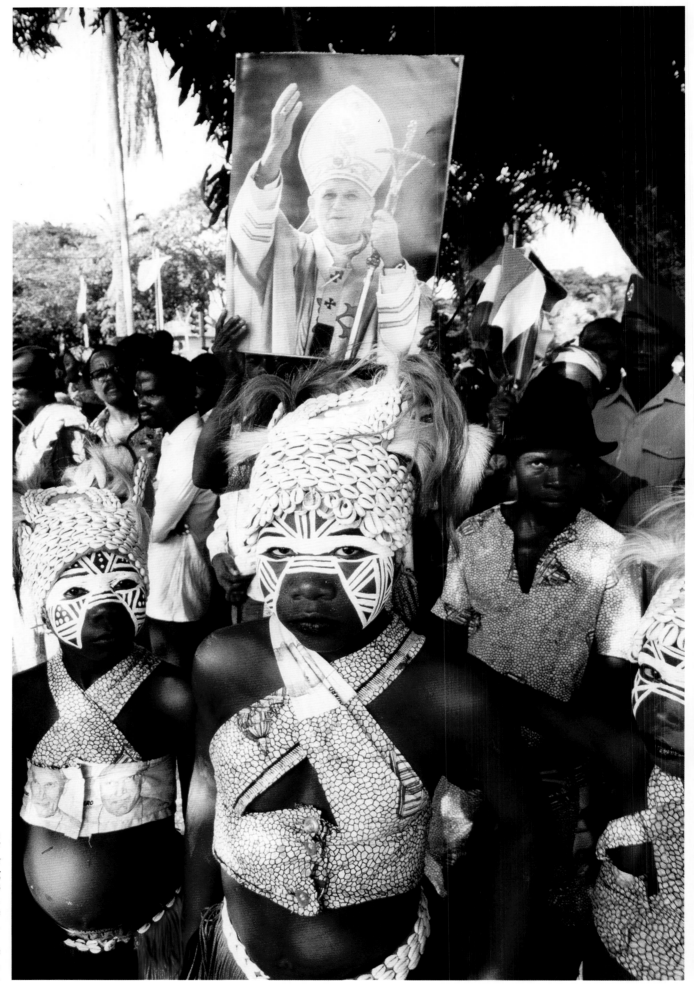

pp. 112-113:
October 4, 1979 / Des Moines, Iowa /
John Paul II visits the Living History
Farms, a few days after addressing
representatives of the member states
of the United Nations in New York.
There were nearly two million people
awaiting him at the farm.

May 11, 1980 / Ivory Coast / The
faithful, in local traditional dress,
await the arrival of John Paul II.

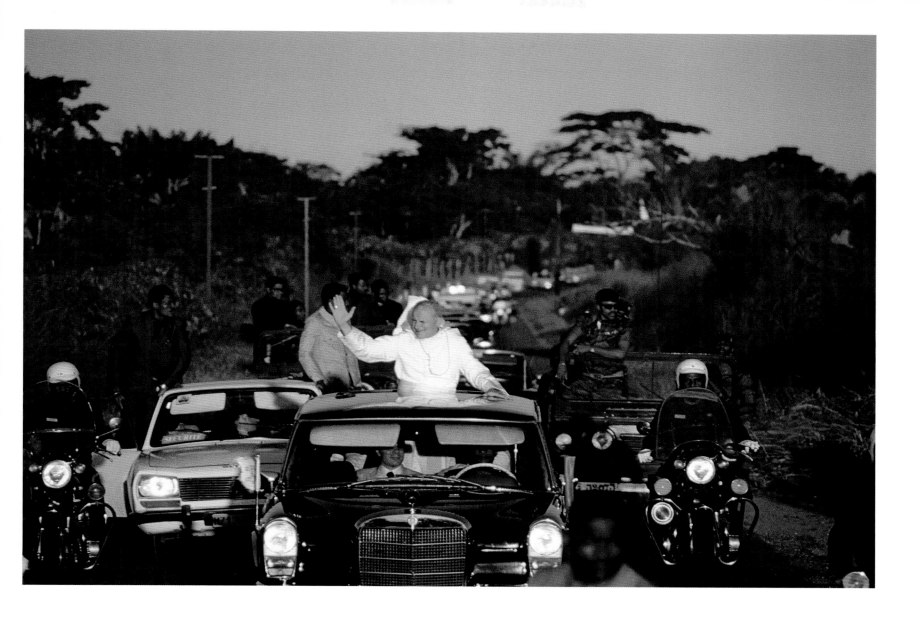

May 2, 1980 / Kisangani, Zaire / John Paul II's first trip to Africa. The jostling of the crowd gathered to greet him caused nine deaths.

"The pope has a style of his own. He is not afraid of confronting issues or people. We will soon feel the strength of his personality."

Monsignor Villot, 1979

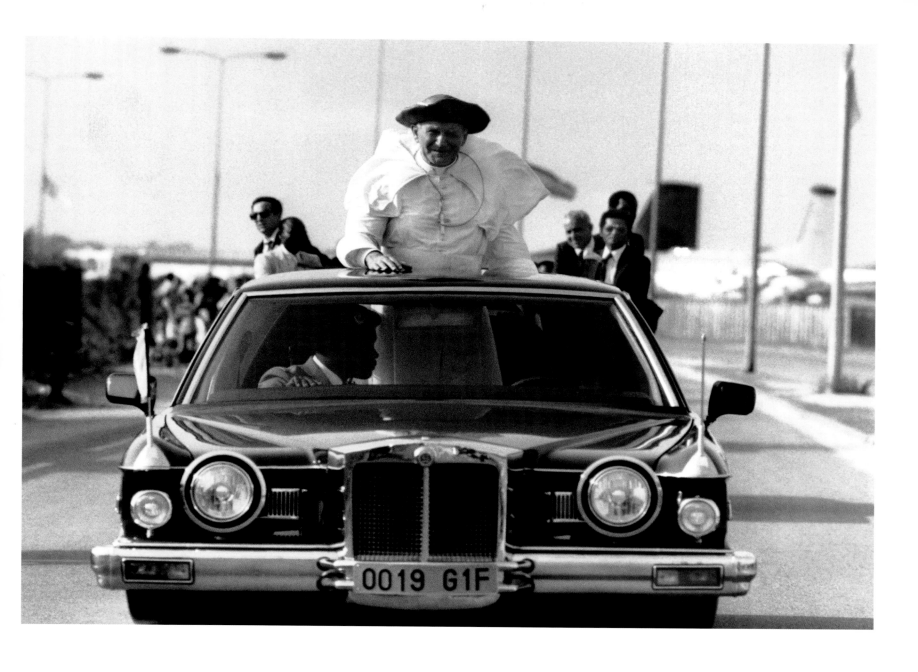

February 7, 1982 / Libreville, Gabon / John Paul II passing through Gabon during a tour of Africa.

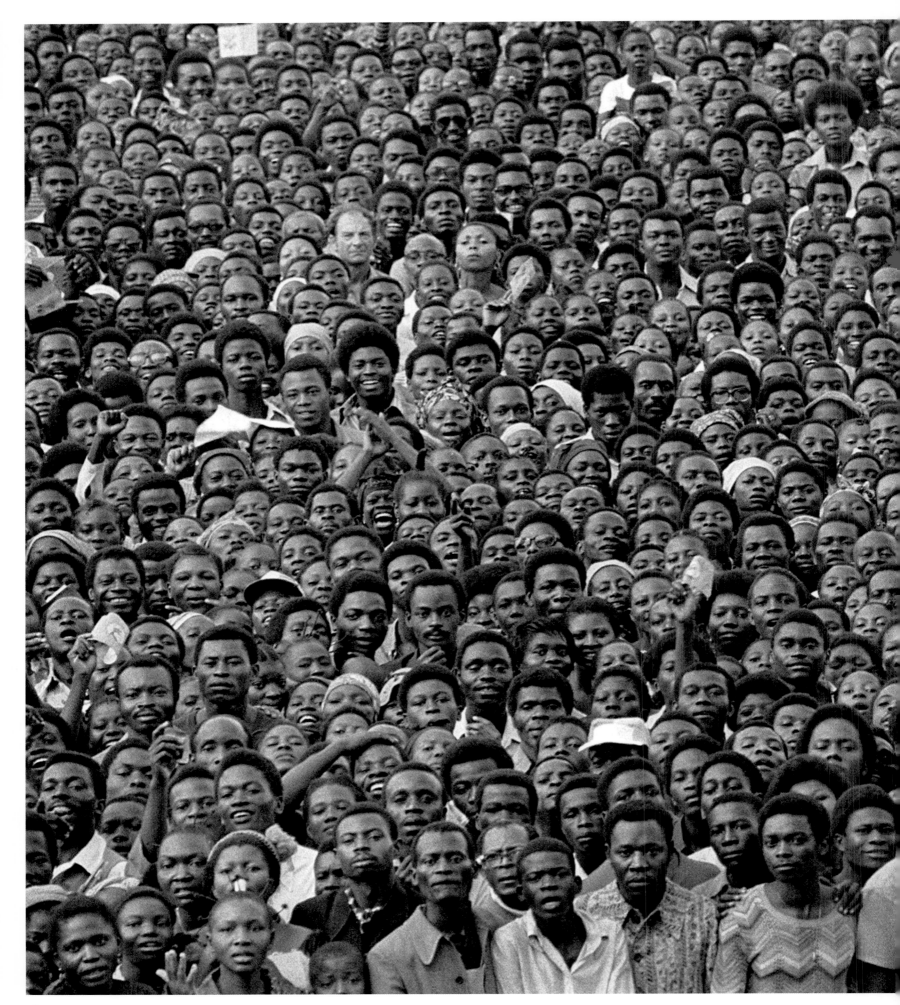

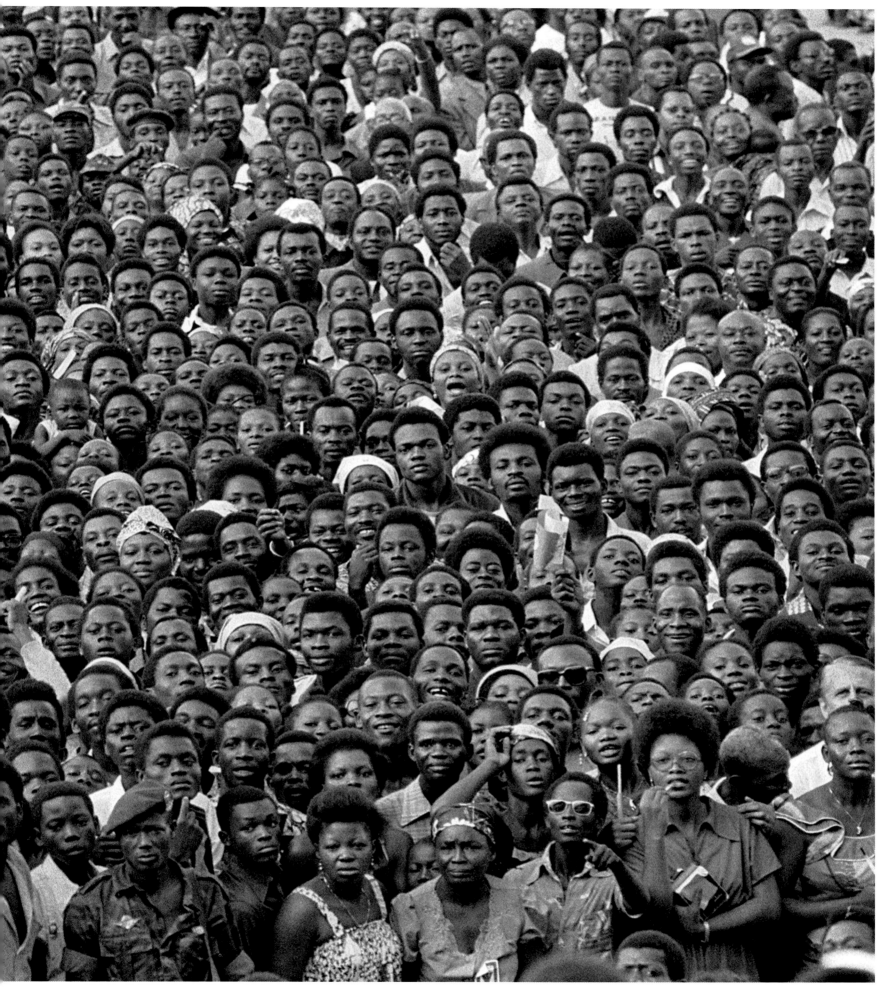

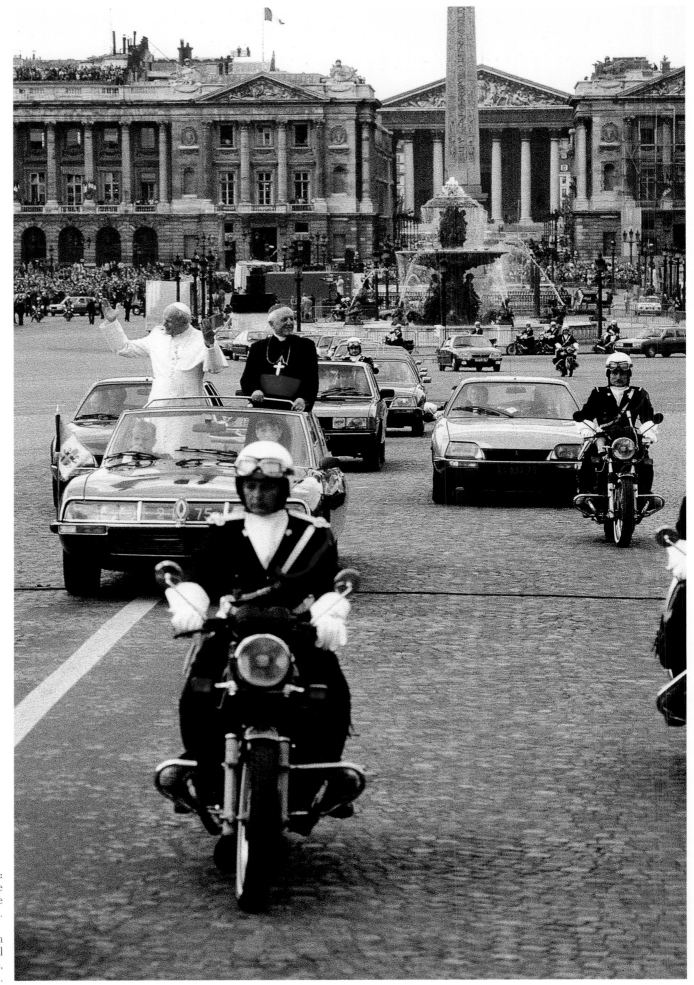

pp. 118–119:
May 3, 1980 / Kinshasa, Zaire / More than a million Zaireans attend the mass celebrated by John Paul II.

May 30, 1980 / Paris, France / John Paul II, accompanied by Cardinal François Marty, archbishop of Paris, at the Place de la Concorde.

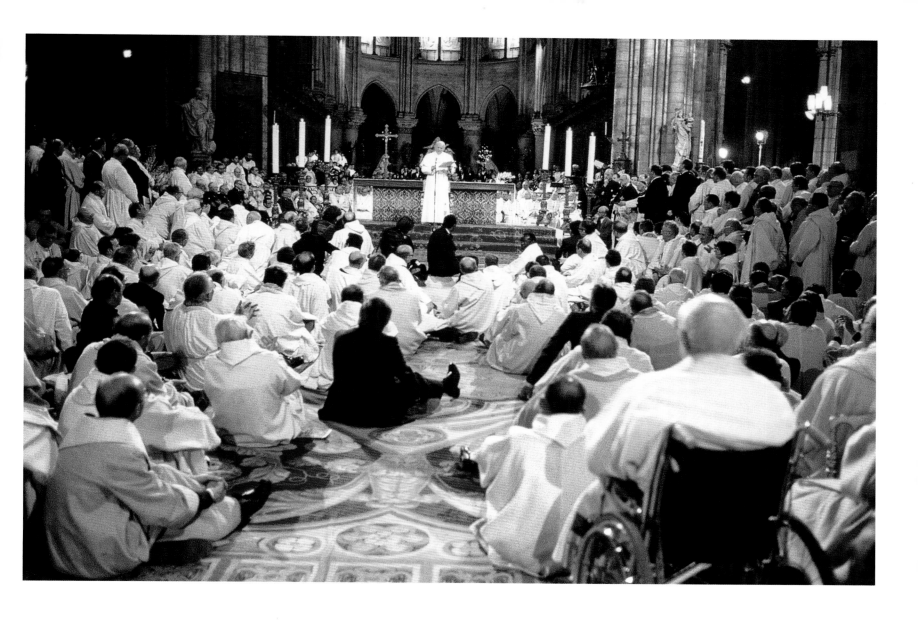

May 30, 1980 / Paris, France / John Paul II celebrates mass at the Cathedral of Notre Dame in Paris.

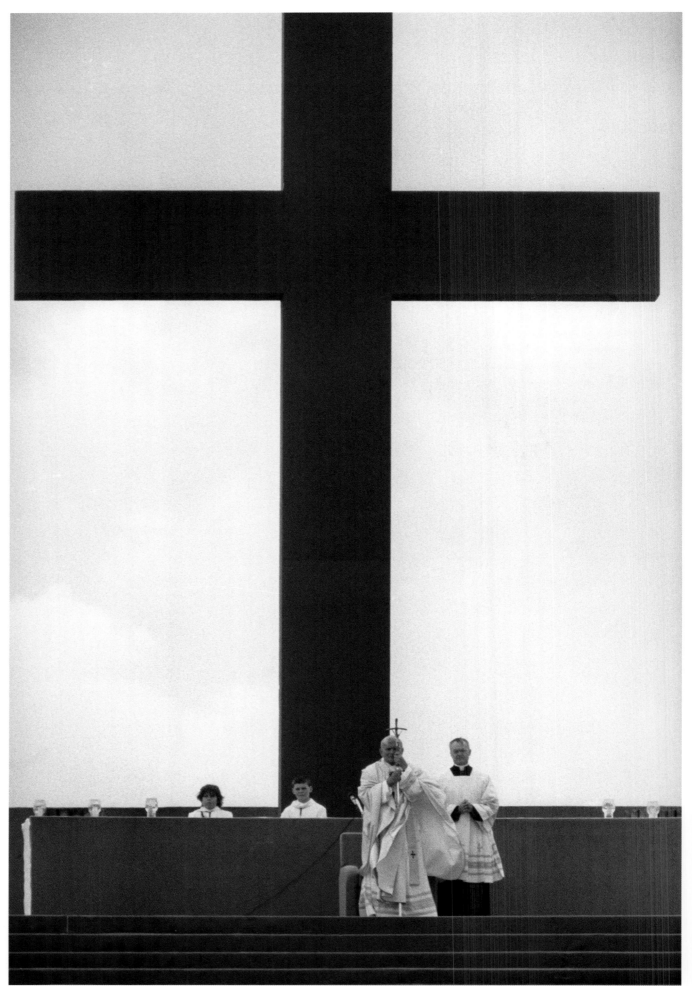

June 1, 1980 / Le Bourget, France / John Paul II celebrates mass in the suburbs of Paris. During this celebration, he calls upon the nation to remember its spiritual roots. "France, what have you made of your baptismal promises?"

June 1, 1980 / Le Bourget, France / An enthusiastic nun immortalizes the Pope's visit to France.

"Our world is not split between the good and the bad, but rather the rich and the poor." John Paul II

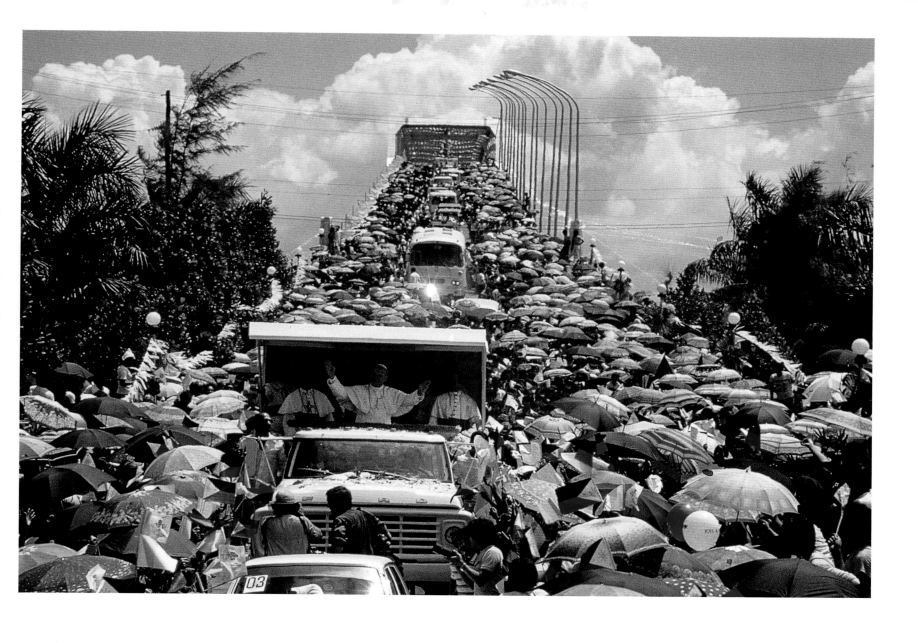

February 19, 1981 / Cebu, Philippines / In the tropical heat, hundreds of thousands of Filipinos come to welcome the pope during his tour of Asia. John Paul II took the opportunity of this visit to meet with Islamic leaders in Davao, in the Mindanao region, and to encourage them to seek out sincere dialogue between Muslims and Christians.

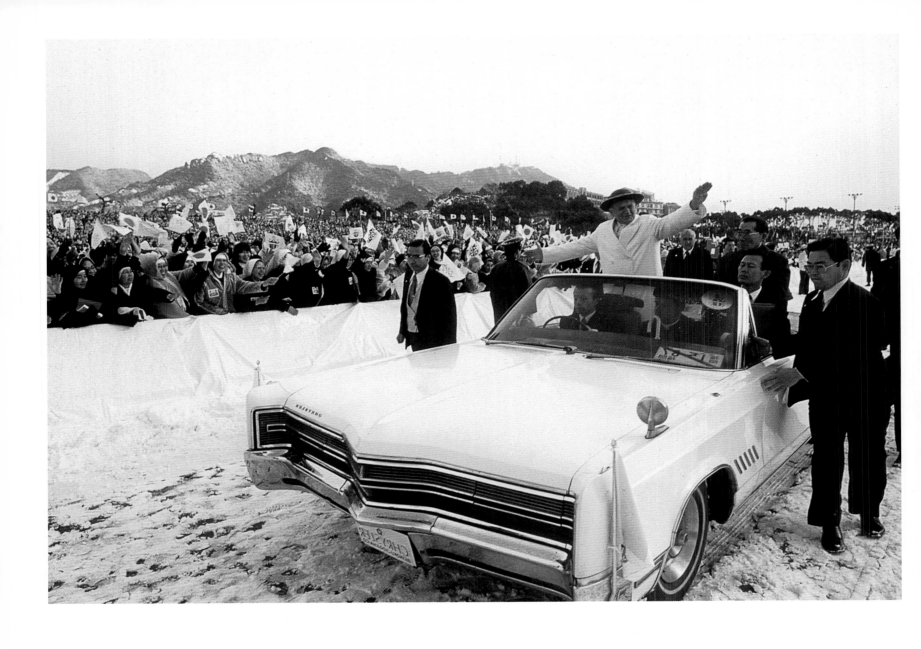

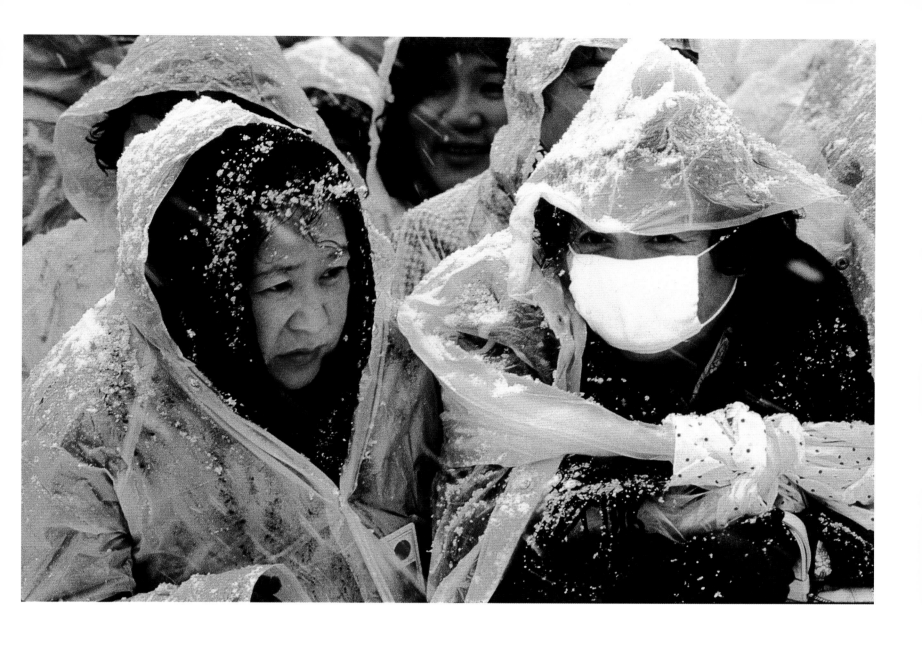

February 24, 1981 / Nagasaki, Japan / Pope John Paul II continues his tour of Asia with a stop in Japan, notably to pray in Hiroshima and Nagasaki, the sites struck by atom bombs in 1945.

May, 1979 / Rome, Italy / John Paul II strolls pensively in the Vatican gardens.

1982 / Rome, Italy / John Paul II in the Vatican gardens.

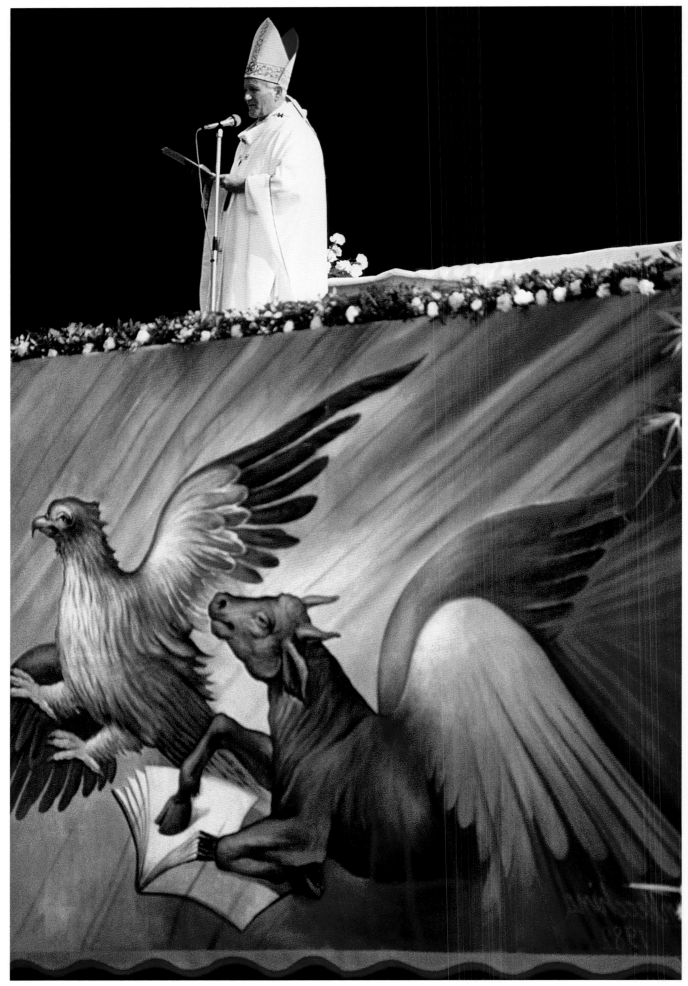

November 20, 1982 / Sicily / John
Paul II addresses the faithful.

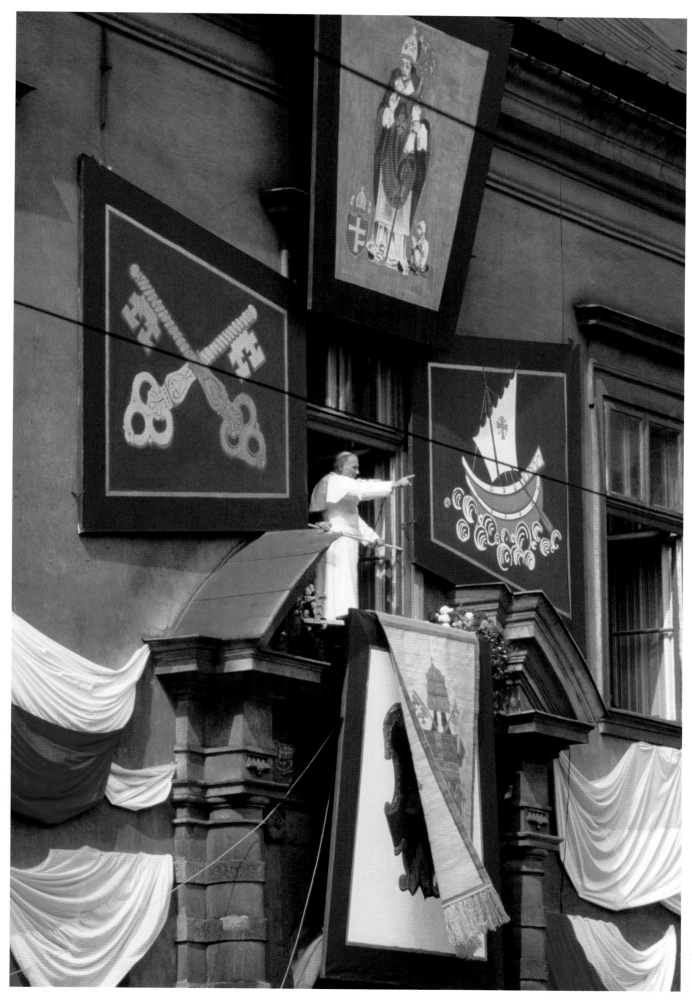

June 9, 1979 / Kraków / The pope at the window of the residence he occupied when he was the cardinal of Kraków.

131

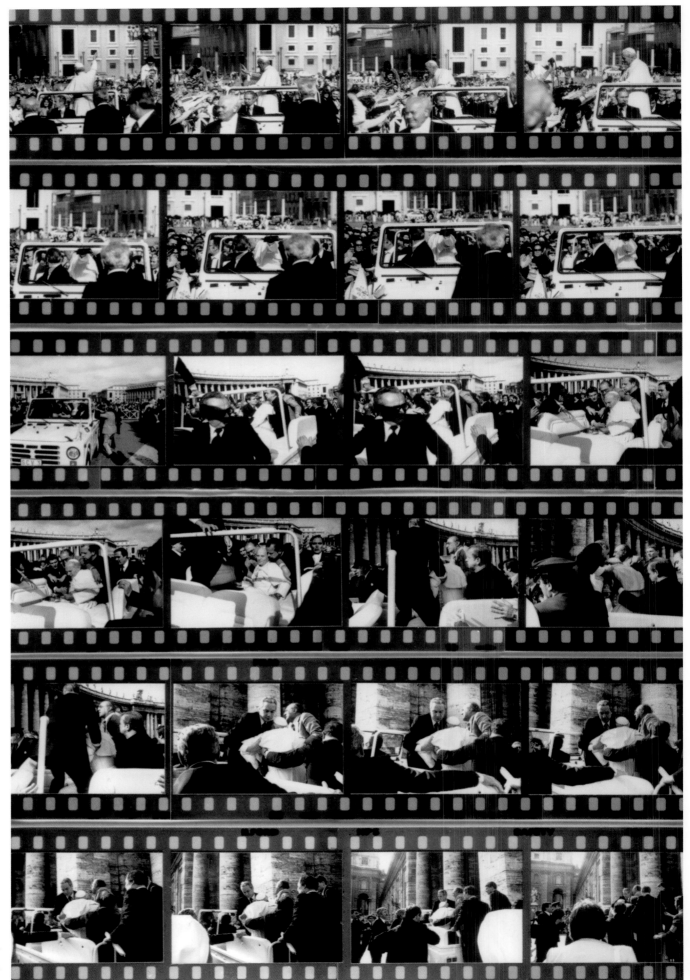

May 13, 1981 / Rome, Italy /
Assassination attempt on Pope John
Paul II.

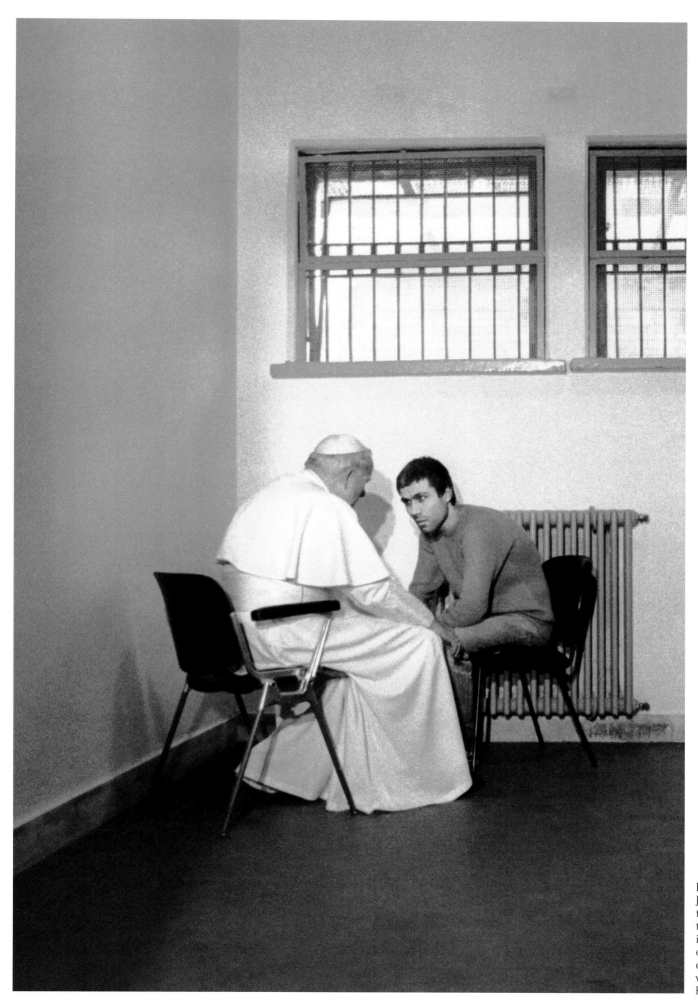

December 27, 1983 / Rome, Italy /
John Paul II meeting with the Turkish
terrorist Mehmet Ali Ağça, who tried
to assassinate the pope in May, 1981,
in his cell in Rabibbia Prison. A few
days earlier, the supreme pontiff had
celebrated a Christmas mass in this
very prison for more than five
hundred prisoners.

"There is no love without responsibility." John Paul II

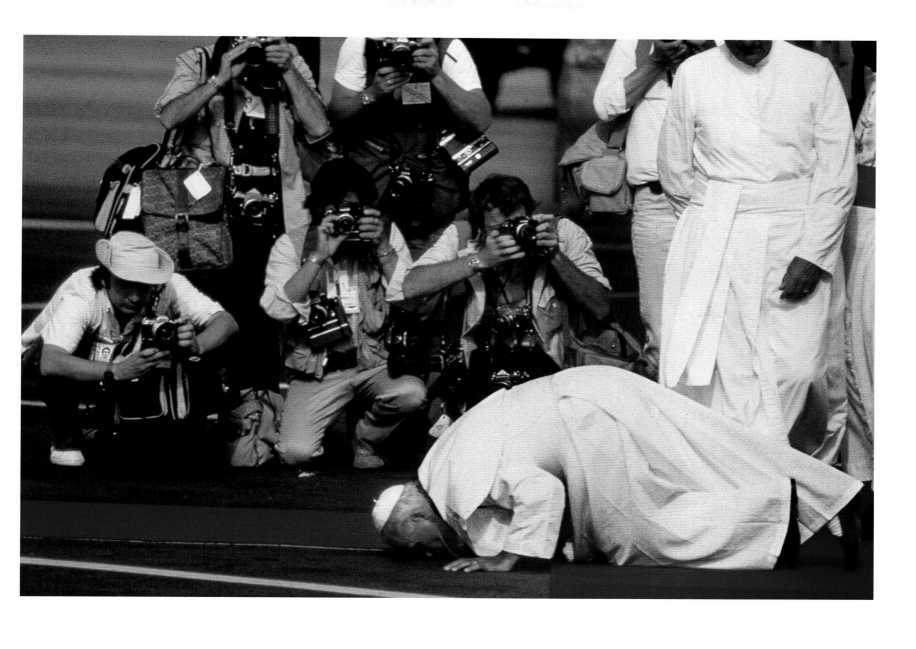

May 2, 1980 / Kinshasa, Zaire / After his plane lands, John Paul II kneels down and kisses the ground, a gesture that he later said he learned from the example of the curate of Ars (on the Ile de Ré, in France), who was a figure dear to John Paul II.

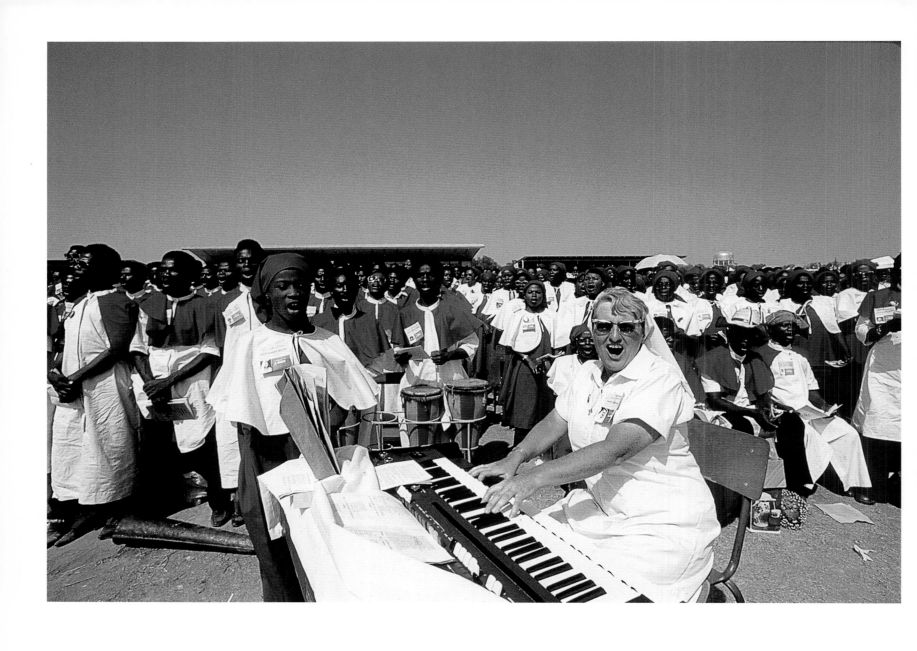

February 12, 1982 / Abuja, Nigeria / Enthusiastic nuns provide musical accompaniment for the pope's apostolic trip to Nigeria. Among its more than 120 million inhabitants, Nigeria counts 20 million Catholics. Interreligious conflicts between Christians and Muslims occur regularly in that country.

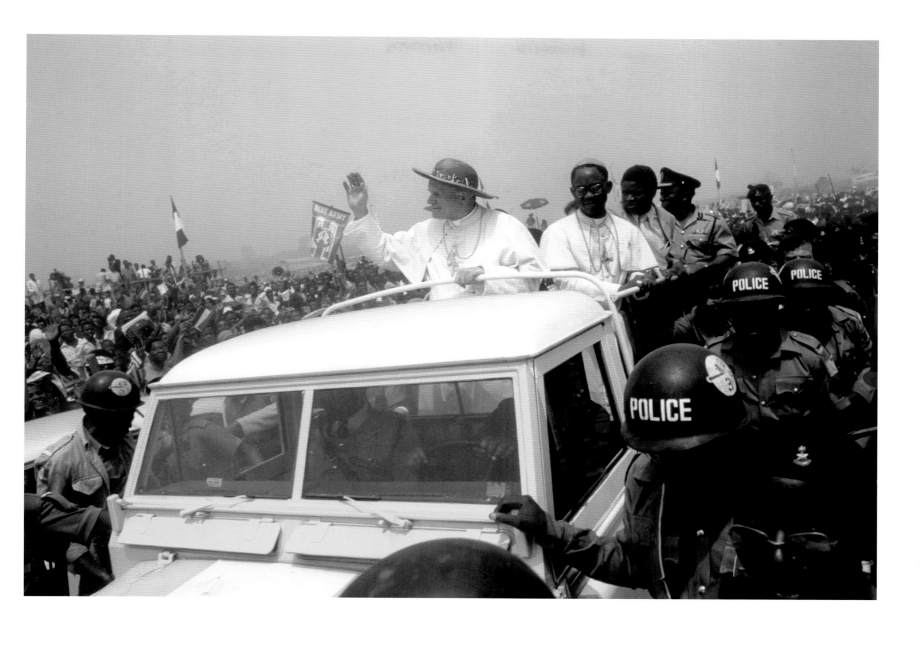

February 18, 1982 / Equatorial Guinea / John Paul II greets the crowd during his second trip to Africa, which includes visits to Benin, Nigeria, and Gabon.

October 5, 1986 / France / Security measures during visits by Pope John Paul II.

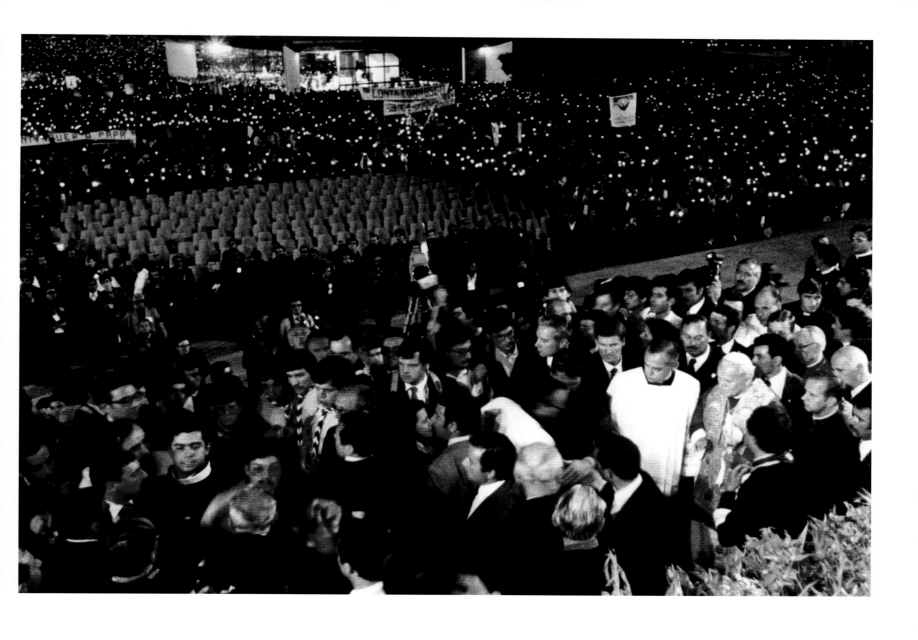

May 12, 1982 / Fatima, Portugal / During a candlelight procession, the crowd stops Juan Fernandez Krohn, left, when he tries to stab John Paul II with a bayonet on the steps of the Basilica of Fatima. Juan Fernandez Krohn is a former Spanish traditionalist priest who disapproved of reforms brought about by Vatican II.

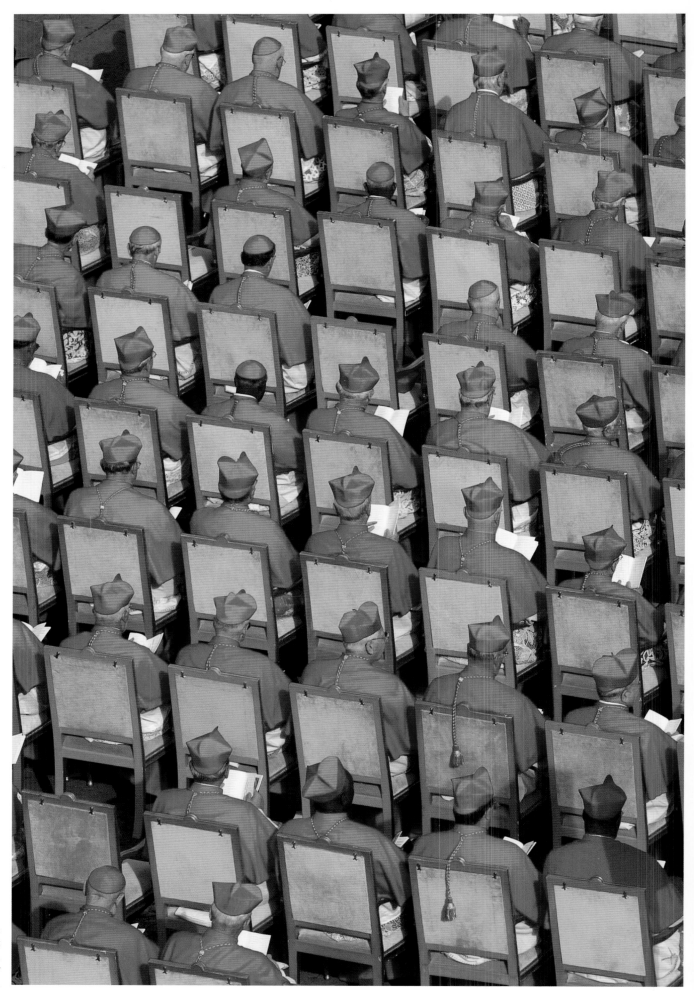

October 21, 2003 / Rome, Italy / The cardinals gather for a consistory at the request of John Paul II. That day, the supreme pontiff creates thirty new cardinals.

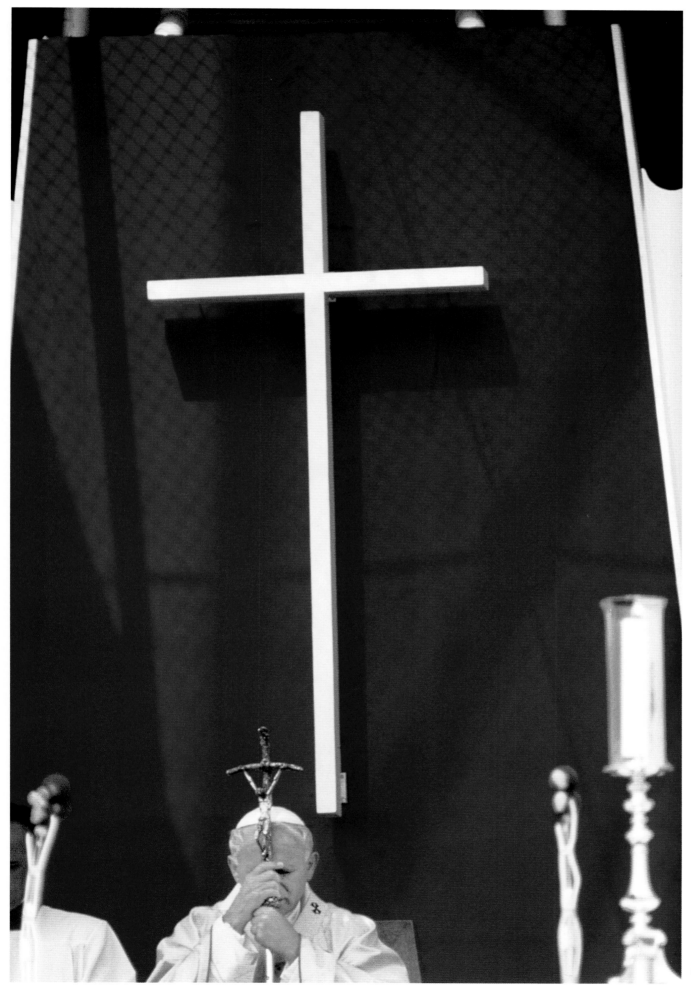

June 1, 1982 / Wales / John Paul II celebrates mass.

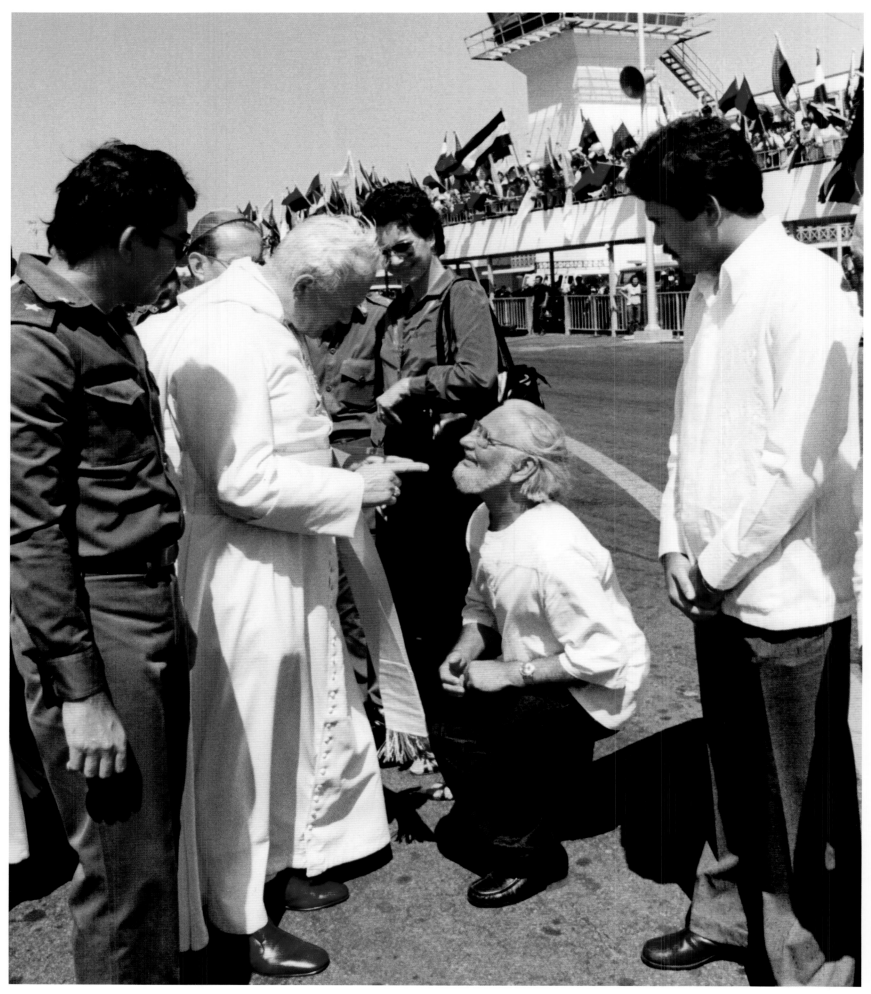

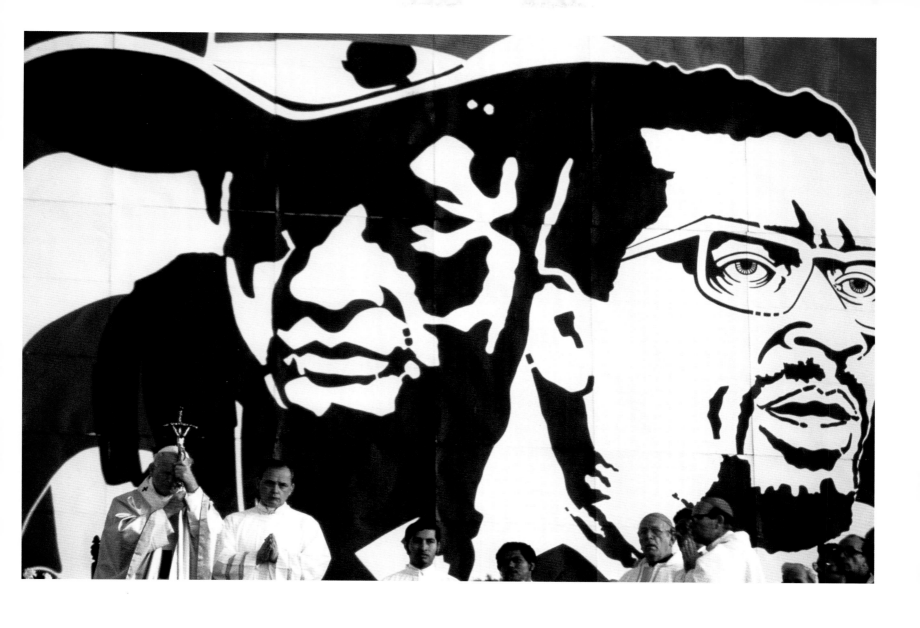

March 4, 1983 / Managua, Nicaragua / During his first visit to Nicaragua, John Paul II shakes his finger at the priest Ernesto Cardenal, because, together with two other priests, he performed ministerial duties in the Sandinista government. Ernesto Cardenal extends his hand to the Pope, who refuses it, and lectures him, his finger raised. "*Arregla tu situacion* (set yourself right)."

March 4, 1983 / Managua, Nicaragua / John Paul II during his first extended visit to Nicaragua. Here again in 1995, the pope would condemn the *Iglesia Popular* (Popular Church) and the false ecumenicalism "of the Christians engaged in the revolutionary process," while at the same time making a cardinal of Archbishop Miguel Obando y Bravo, a fierce opponent of the Sandinistas. This attitude created a feeling of helplessness among the working class Christians who had come to celebrate both their revolution and their pope's visit.

"One cannot understand this man without knowing he spends at least three hours a day in prayer. Key decisions are made not in his office, but his chapel." Monsignor Lustiger

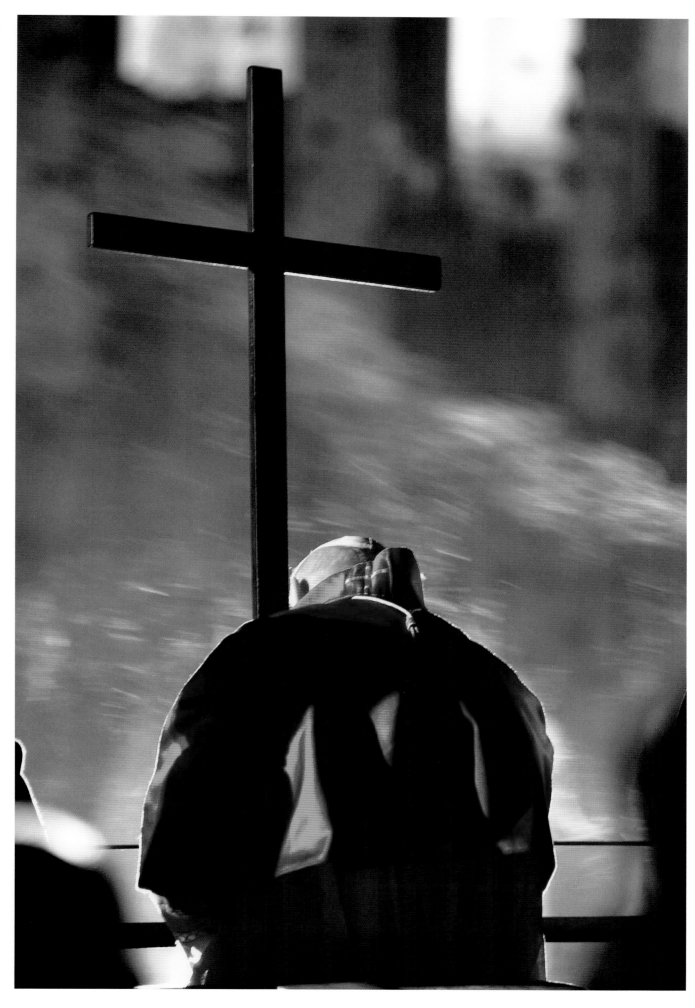

April 13, 2001 / Rome, Italy / Every year on the evening of Good Friday, crowds of pilgrims gather around John Paul II at the Coliseum for religious services commemorating the Way of the Cross. The Way of the Cross is followed from the interior of the Coliseum to the slopes of the Palatine Hill. At the end of the fourteen stations that line the route, the Holy Father improvises a meditation.

145

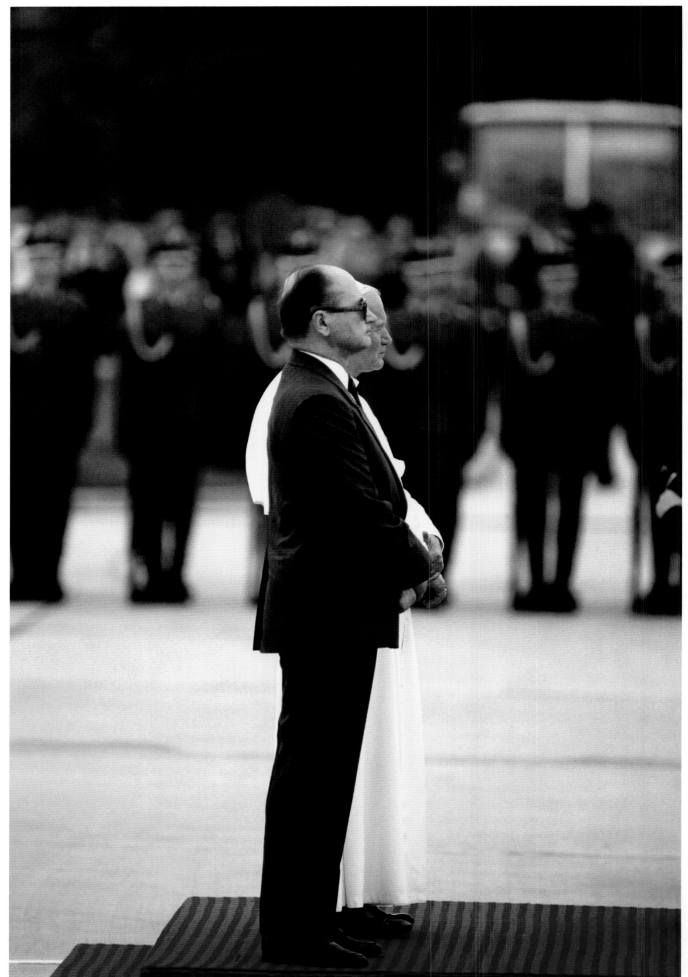

June 17, 1983 / Warsaw, Poland / Pope John Paul II visits communist Poland at the beginning of his pontificate in 1979, then again in 1983 and 1987. This visit in 1983 pushed General Jaruzelski to free Lech Walesa and the members of Solidarity who were still imprisoned.

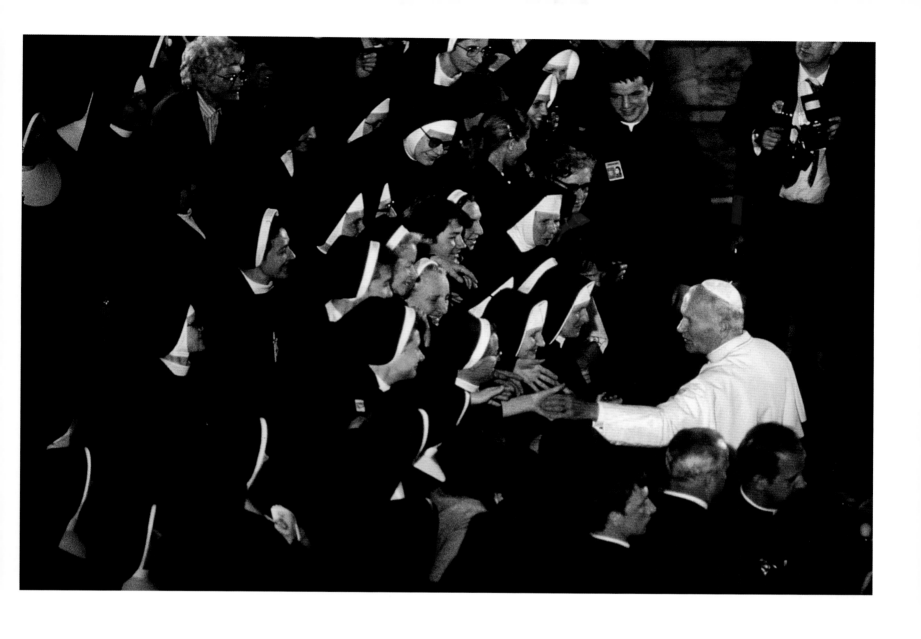

June 18, 1983 / Warsaw, Poland / During John Paul II's travels in Poland, the mass rallies inspired by his visits and his explicit support for the Solidarity union would play a decisive role in the fall of communism in Poland in 1989.

September 22, 1996 / Rheims, France / A nun attends (from a distance) a mass celebrated by John Paul II at an air base.

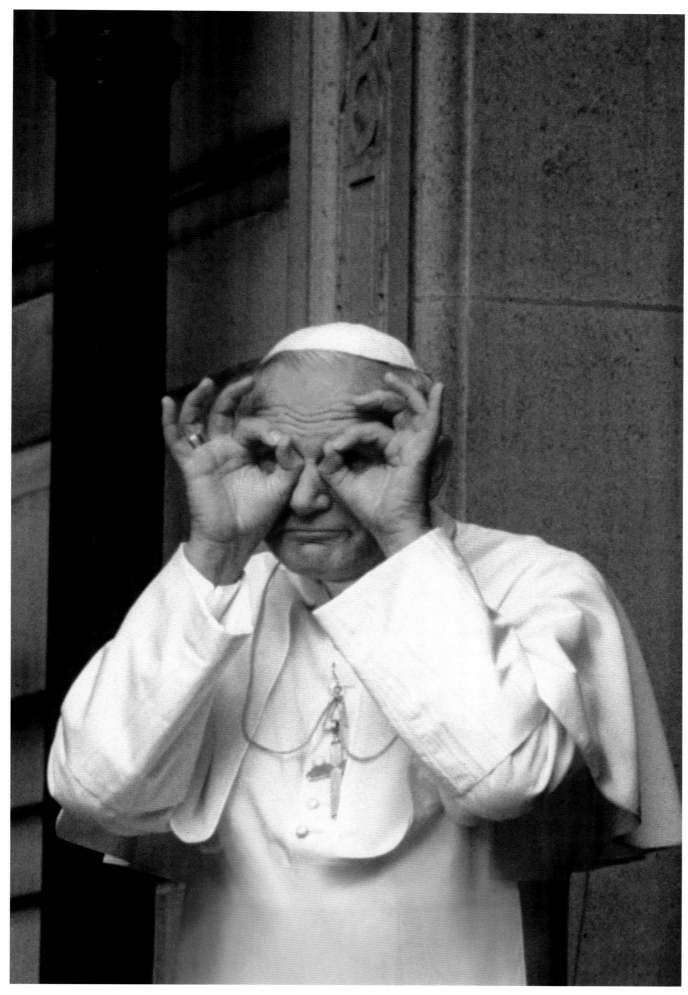

June 1, 1980 / Paris, France / John Paul II watches the crowd that has come to hear him .

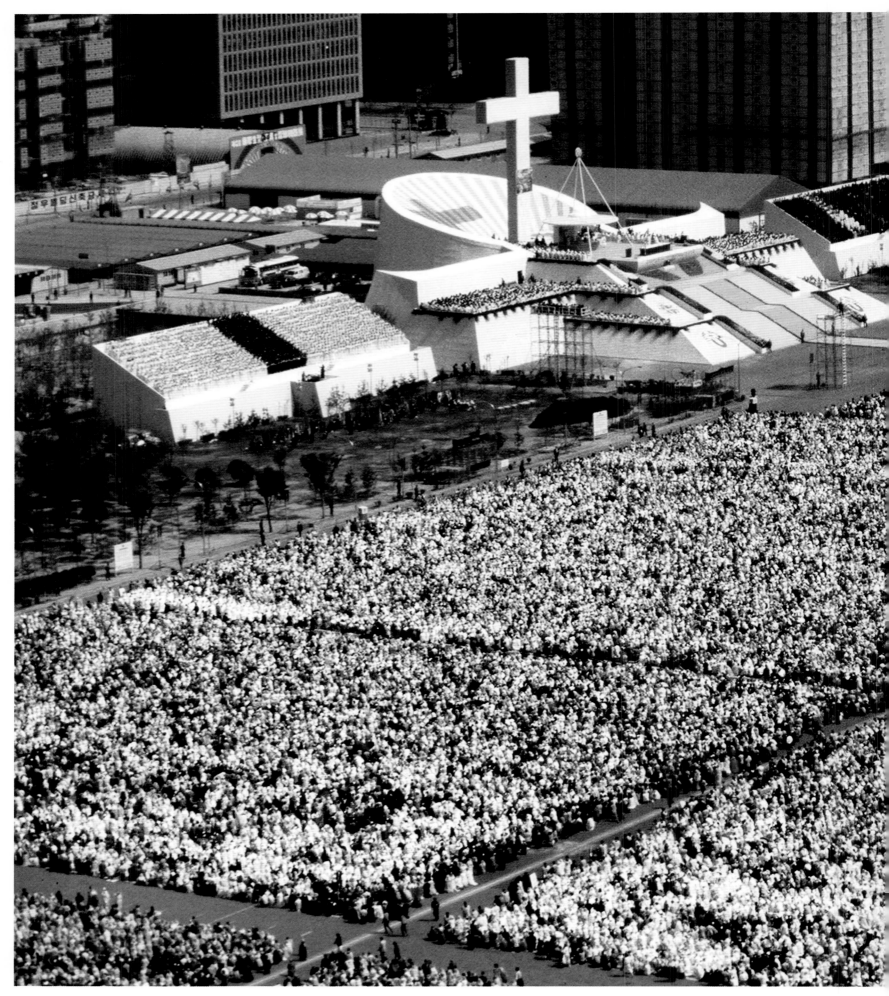

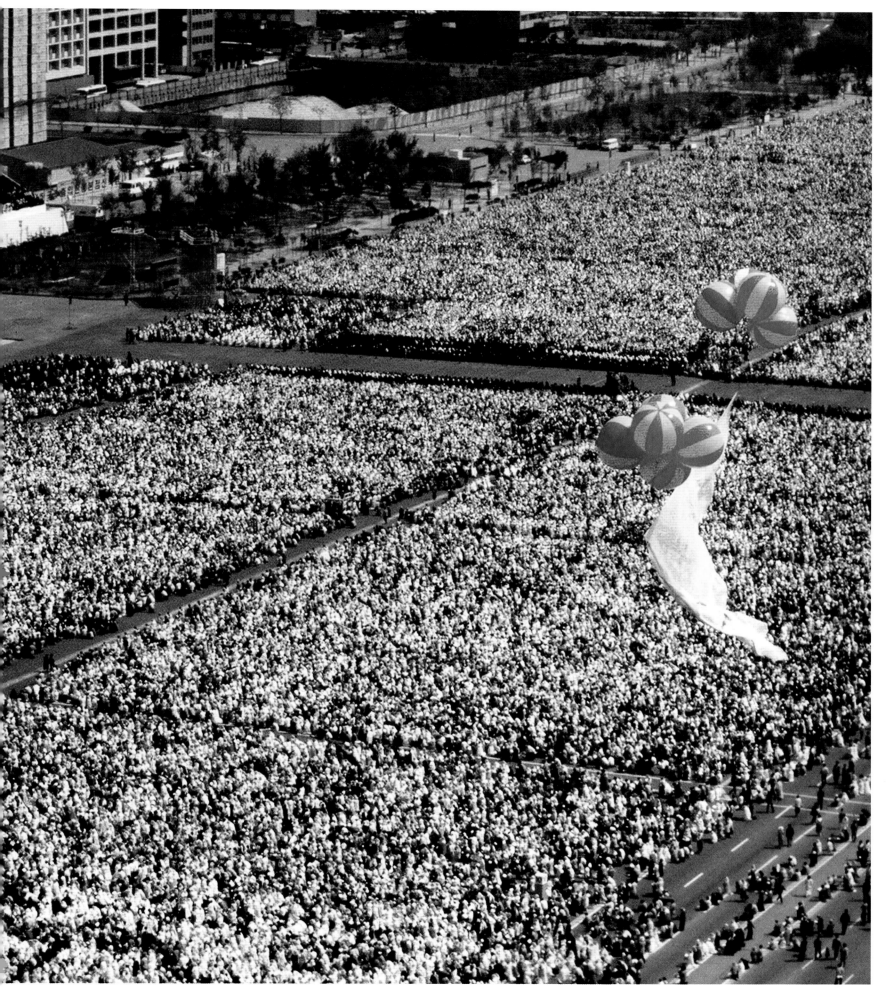

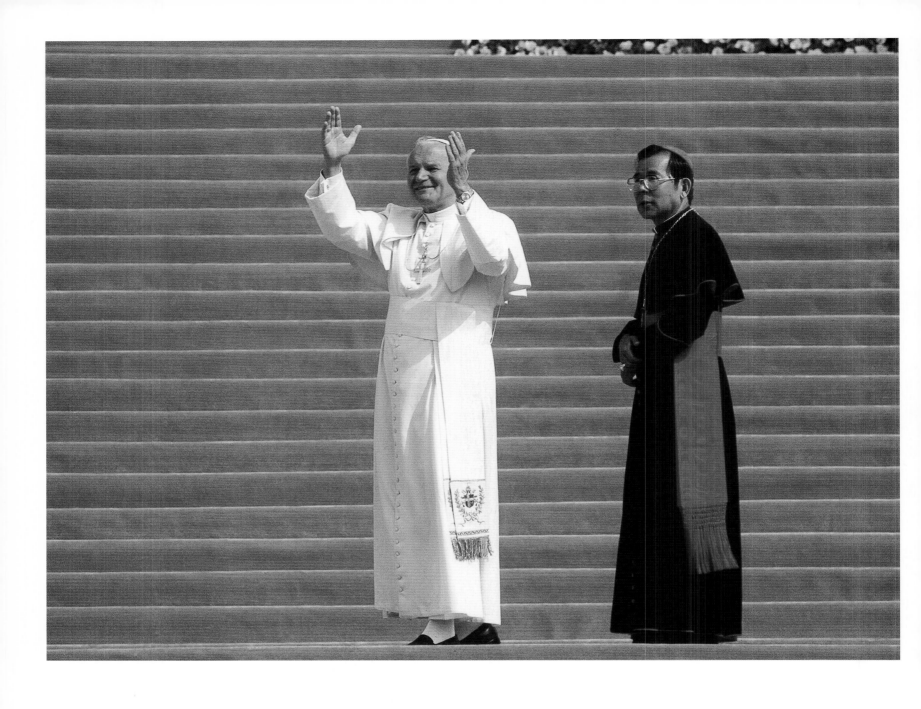

pp. 150-151:
May 6, 1984 / Seoul, South Korea / John Paul II attracts an enormous crowd in South Korea, as he prepares to canonize André Kim Taegon and his one hundred two martyred Korean companions. The pope canonized, among others, eleven martyred priests who belonged to the Foreign Missions of Paris, twenty-four Korean catechists, ten young Korean women, and 6 boys and girls under the age of twenty, all of whom who were executed between 1839 and 1866.

May 5, 1984 / Pansu, South Korea / John Paul II waves to the immense crowd come to cheer him.

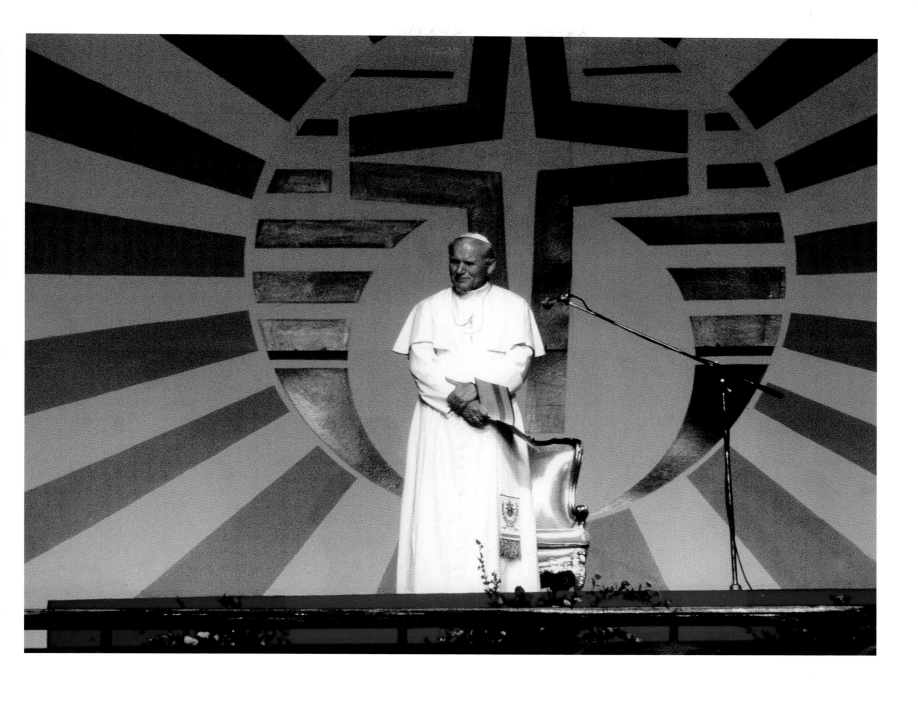

May 5, 1984 / Seoul, South Korea / John Paul II prepares to read a speech to the faithful.

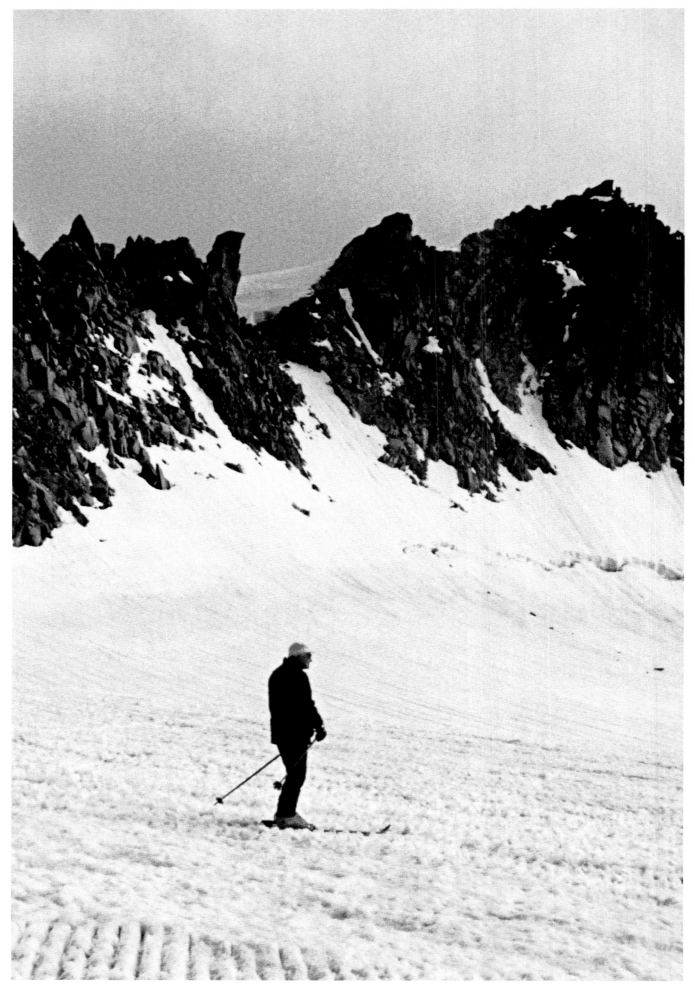

July 17, 1984 / Mount Adamello, Italy / The pope makes the most of an impromptu ski vacation near Pinzolo, in the Dolomites.

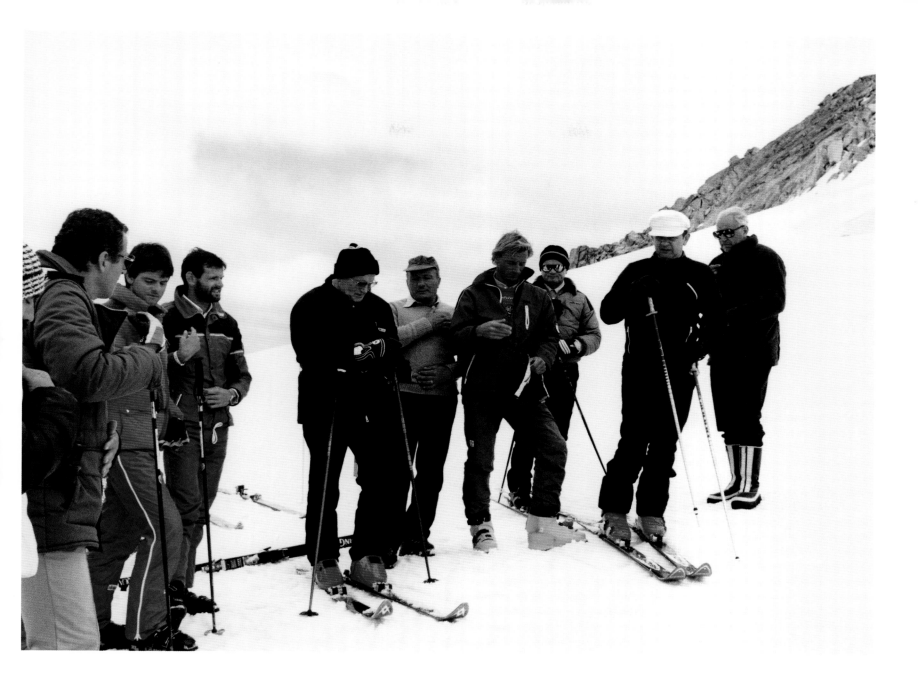

July 17, 1984 / Mount Adamello, Italy / Before heading down the slopes, the pope says a quick prayer, surrounded by members of the ski patrol.

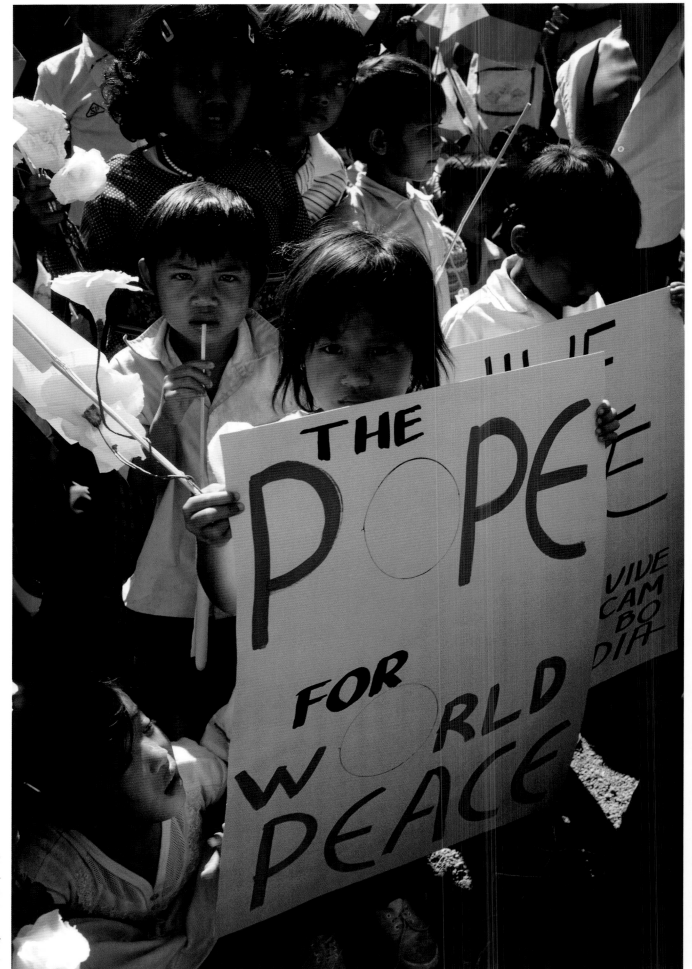

March 22, 1981 / Manila, Philippines / "I don't preach democracy, I preach the Gospel." Such was the message put forward by the pope on this official trip to the Philippines. The campaign of passive resistance led by Cardinal Jaime Sin, with the support of John Paul II, would contribute to the departure of the dictator Ferdinand Marcos in 1986.

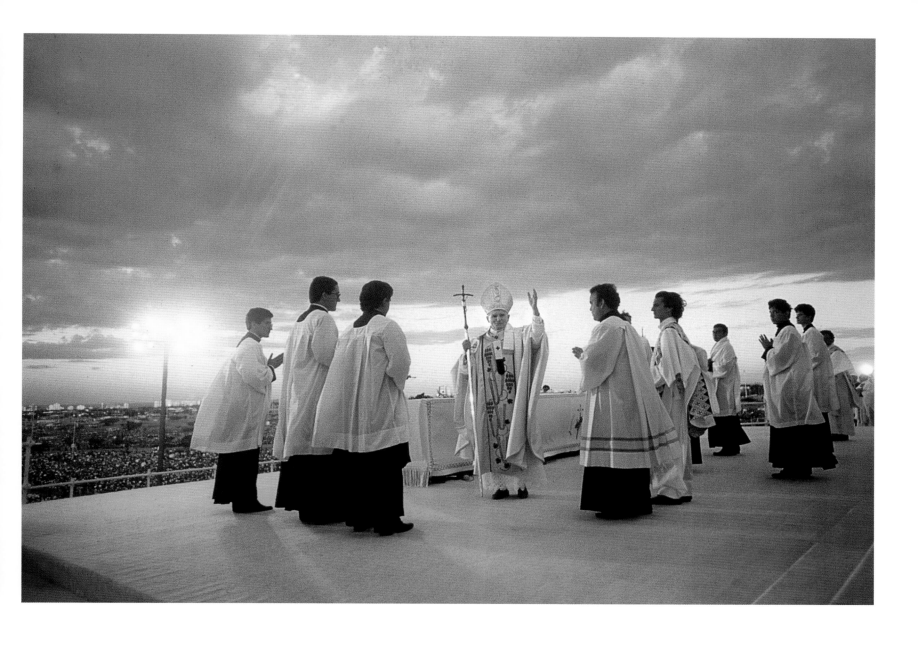

January 27, 1985 / Caracas, Venezuela / John Paul II celebrates an open-air mass during his twenty-fifth trip, which took him to Venezuela, Ecuador, Peru, and Trinidad and Tobago.

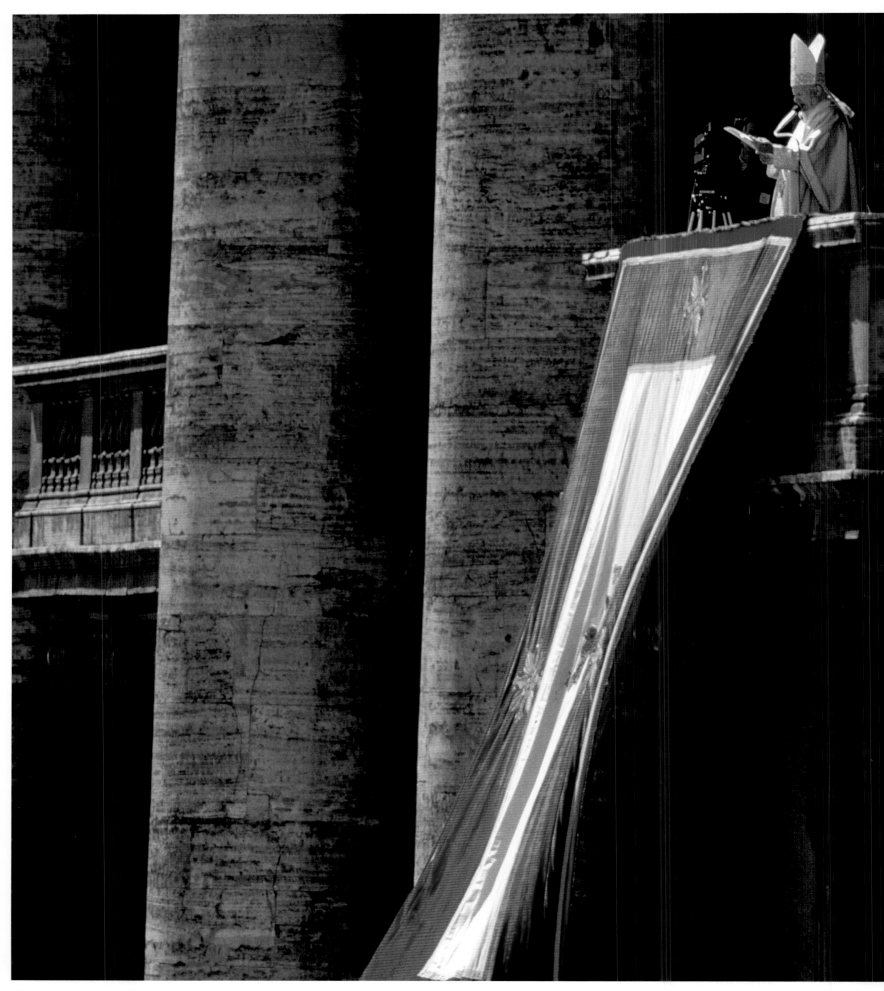

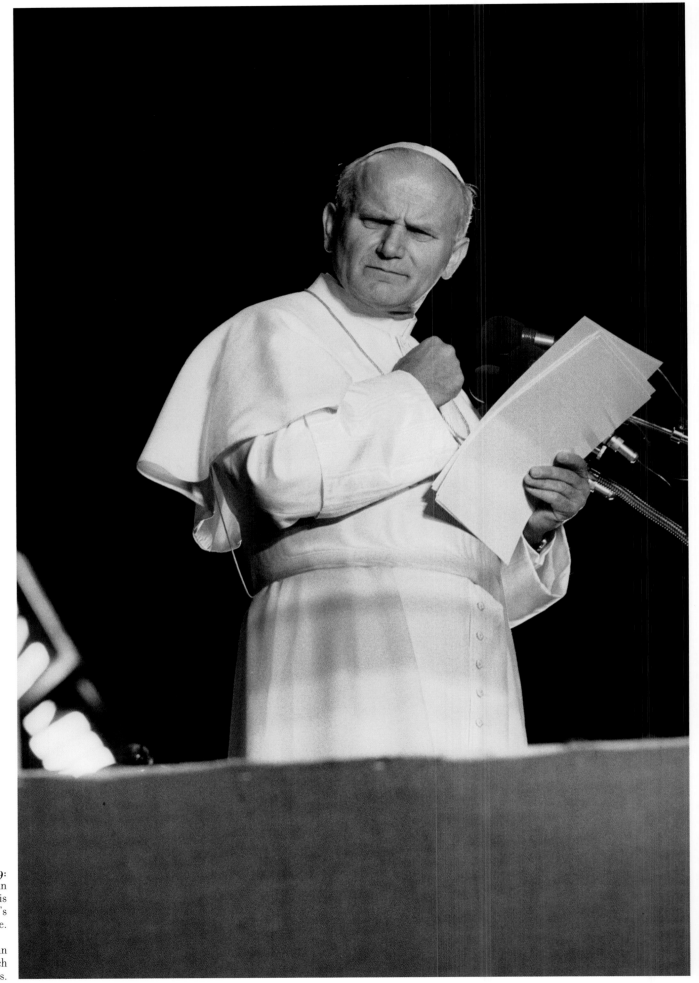

pp. 158-159:
March 31, 1985 / Rome, Italy / John Paul II blesses the crowd from his apartment overlooking Saint Peter's Square.

June 1, 1980 / Paris, France / John Paul II meets faithful young French people in the Parc des Princes.

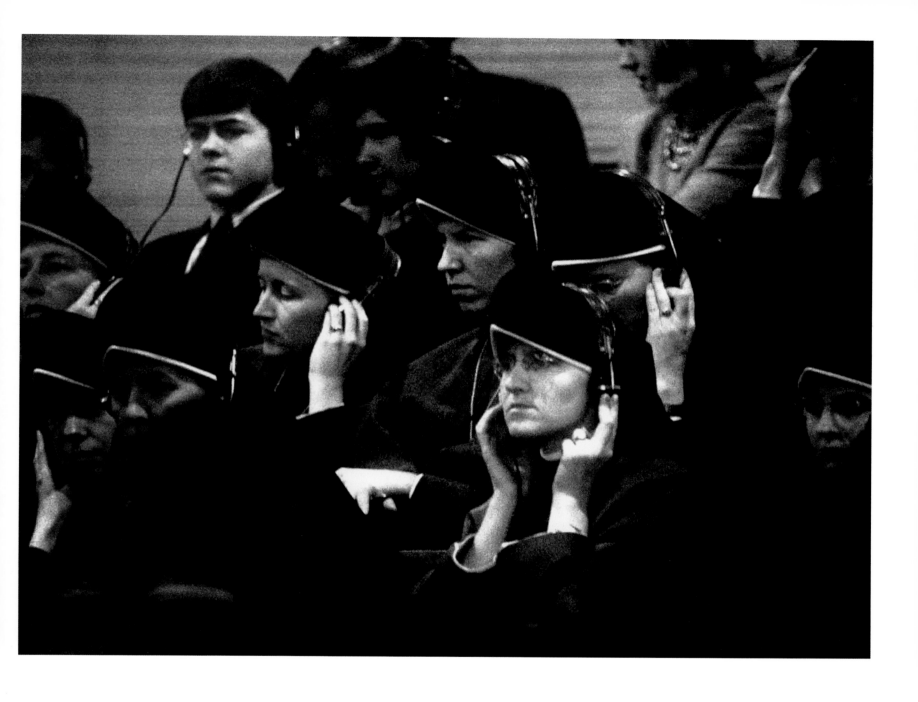

October 5, 1995 / New York City / Attentive nuns listen to a speech by John Paul II.

"Man remains great, even in his weakness." John Paul II

September 17, 1987 / San Francisco, California / In the basilica of Mission Dolores, while celebrating a mass for AIDS patients, John Paul II holds Brendan O'Rourke, a five-year-old child who was infected through a blood transfusion. His father supports him while Archbishop of San Francisco John Quinn watches tenderly. At at time when the AIDS epidemic reached its peak, this gesture from John Paul II drastically changed perception of this disease around the world.

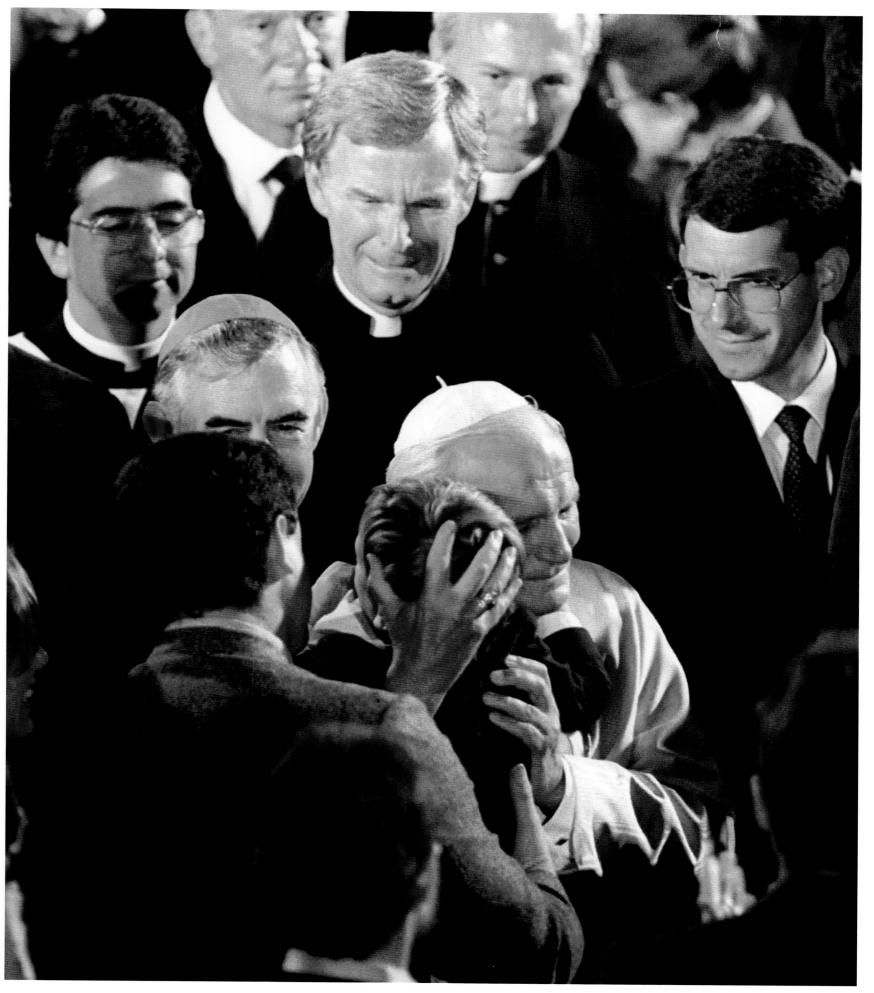

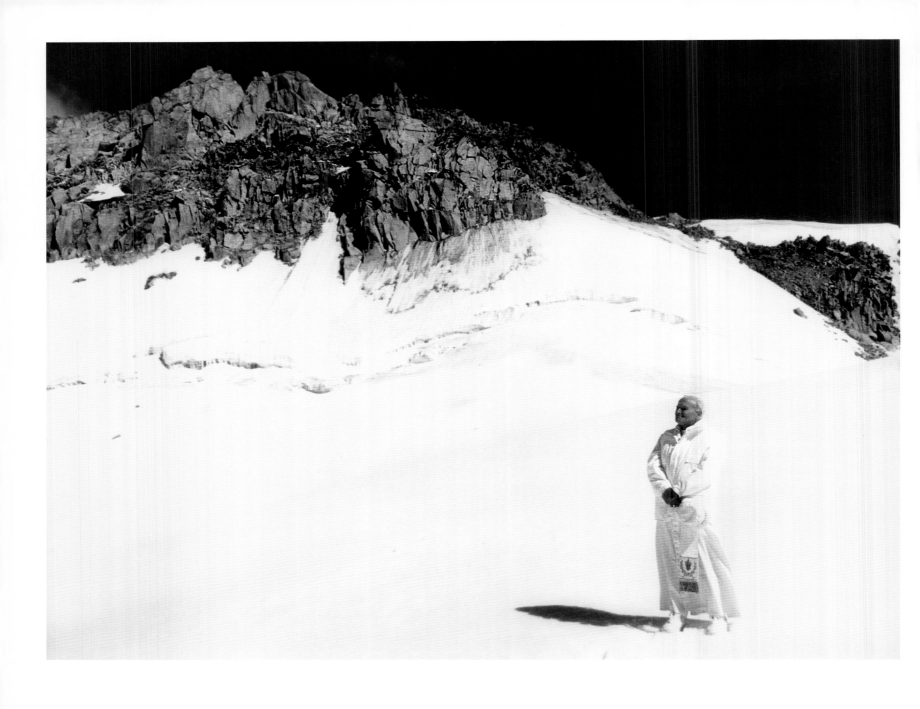

September 7, 1986 / Courmayeur, Italy / John Paul II on a glacier near Mont Blanc, during a two-day expedition.

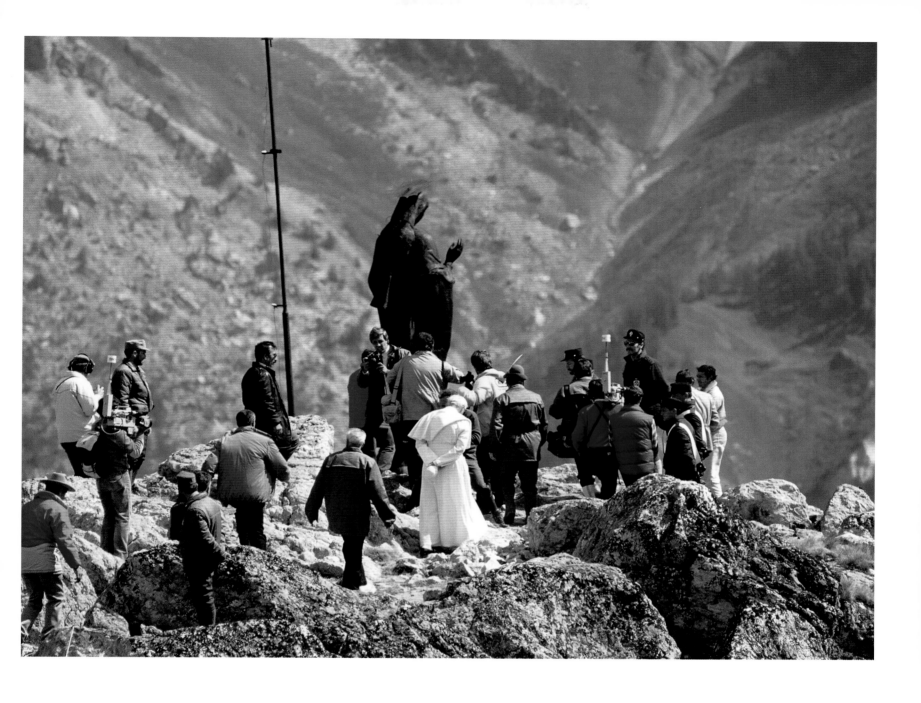

September 7, 1986 / Courmayeur, Italy / John Paul II, on a pastoral visit in the Val d'Aoste. On this occasion he issued a call for the unity of Europe.

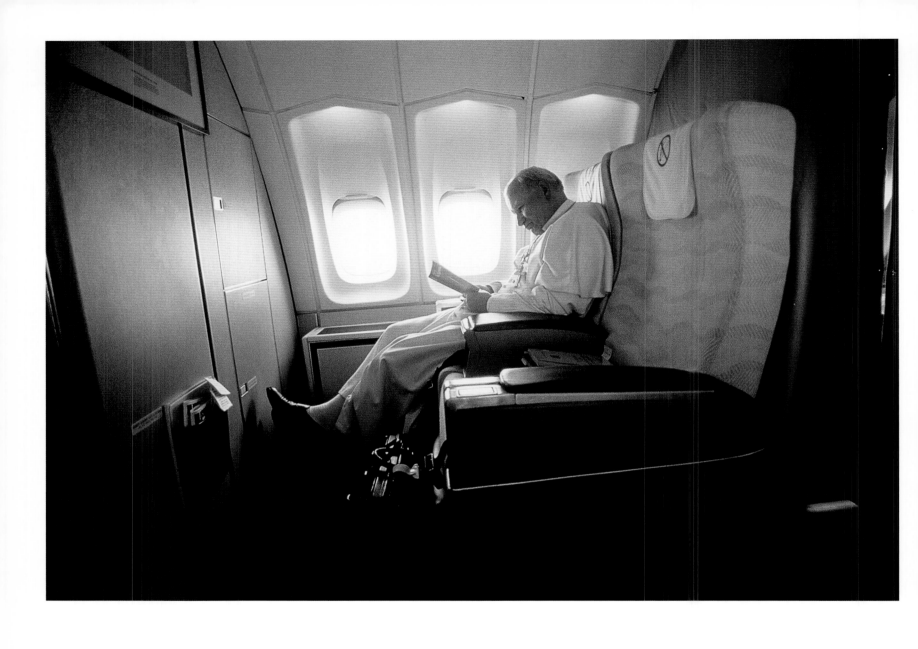

July 1, 1986 / Bogota, Colombia / John Paul II on the flight to Colombia. During his thirtieth trip, he preached a message of peace during a gigantic mass, where 3.2 million of the faithful came to hear him.

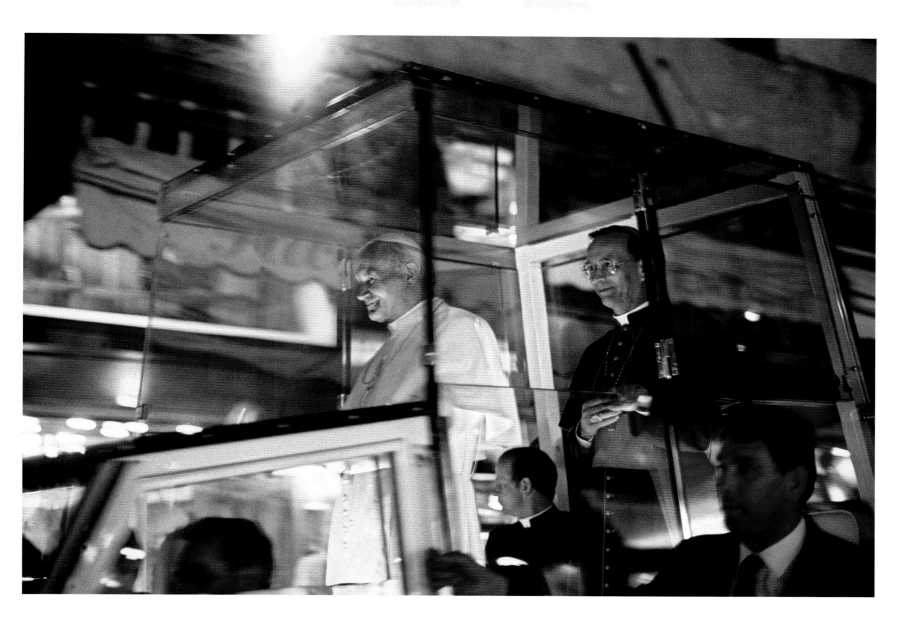

October 27, 1986 / Florence, Italy / John Paul II during the first interreligious meeting in Assisi.

October 6, 1986 / Ars, France / The pope's pilgrimage to France. John Paul II admired the curate of Ars, Jean-Marie Vianney (1786-1859), who heard confession for ten hours a day and who succeeded, at a difficult time in history, in inspiring a sort of spiritual revolution in France. He was canonized in 1925 by Pius XI and proclaimed patron saint of all curates in 1929. Today Ars welcomes more than 450,000 pilgrims a year.

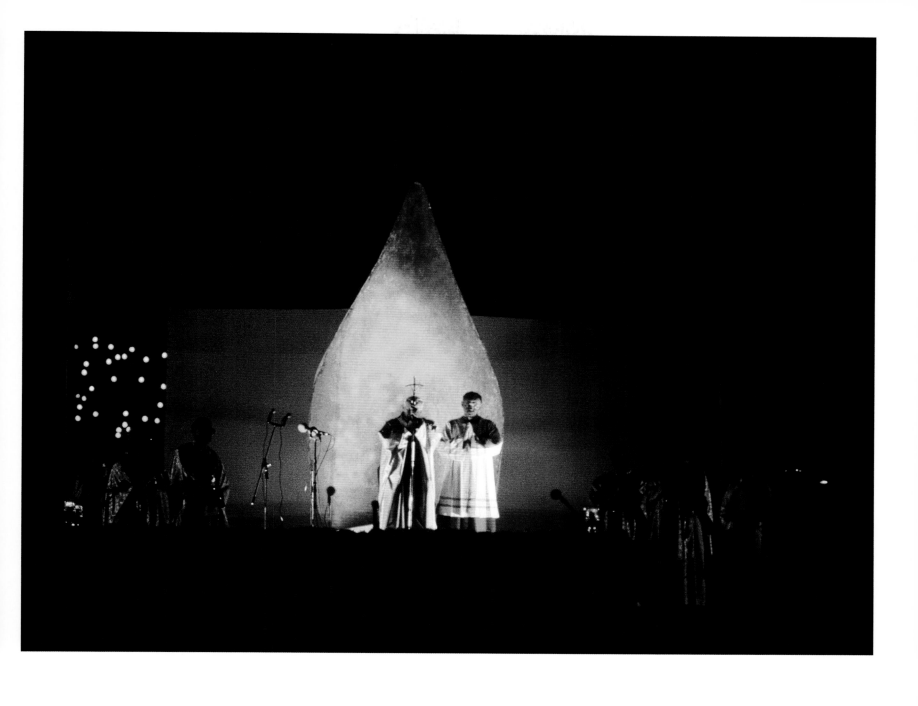

February 3, 1986 / Kalighat, India / John Paul II visits the Nirmal Hriday (Place of the Immaculate Heart) Home for the Dying Destitute, founded by Mother Theresa in 1950, where nuns care for the dying in their final days.

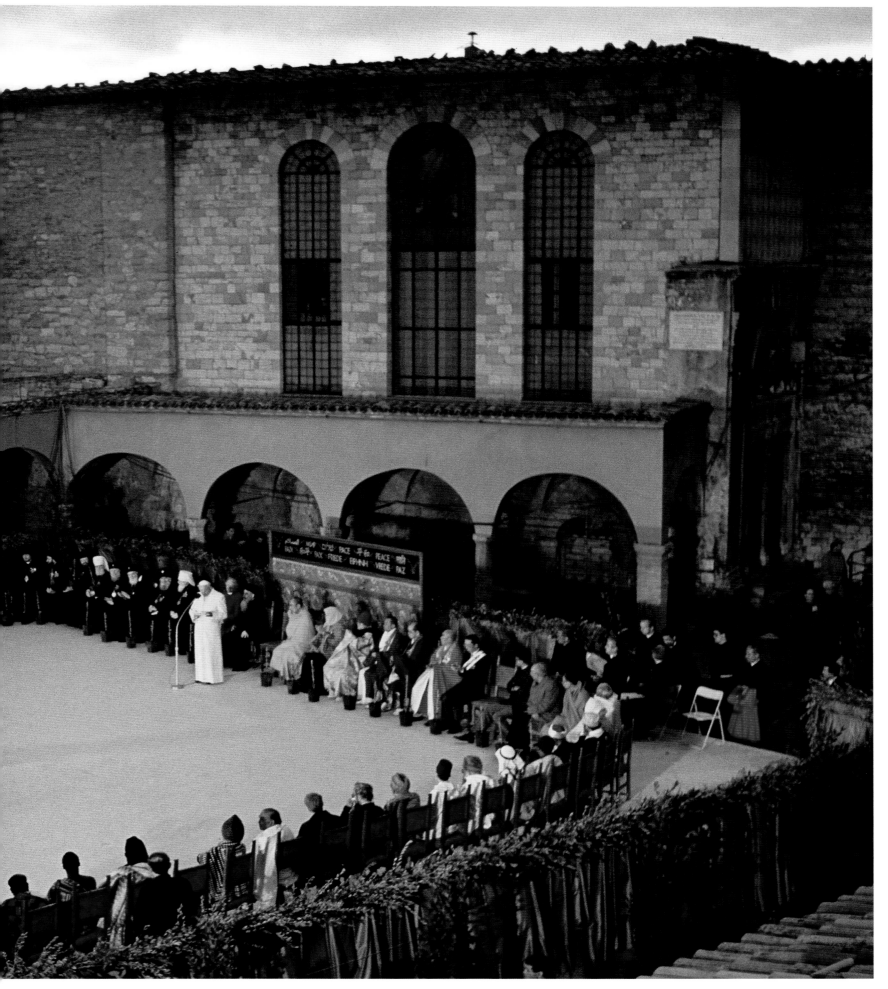

"Do not be afraid! Open, open all doors to Christ. Open borders of countries, economic and political systems…"

John Paul II

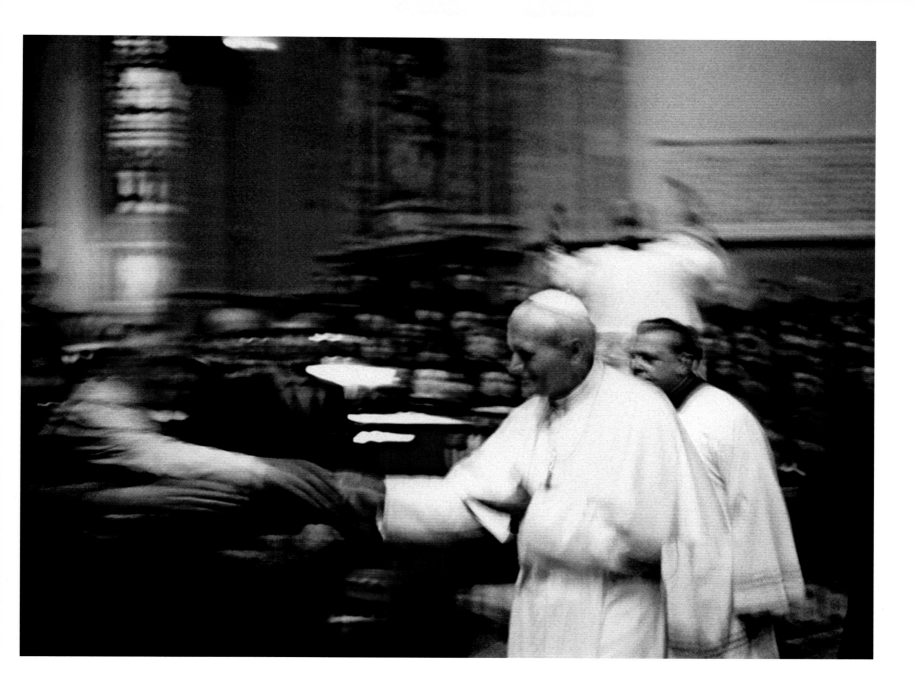

pp. 170-171:
October 27, 1986 / Assisi, Italy / The Assisi meeting, organized by John Paul II, marked a new era in the history of the relations among the religions and is counted among the boldest symbols of John Paul II's pontificate. It brought together in the city of Saint Francis, the universal brother, some five hundred religious leaders representing about forty religions. It was mainly a religious meeting and not the occasion for negotiations, preparations for peace actions, or even doctrinal discussions. On the agenda for the meeting was prayer for peace, pilgrimage, silence, and fasting. Heavily covered by the media, it was greeted by world opinion as an exceptional event without precedent.

June 30, 1986 / Florence, Italy / John Paul II during a mass celebrated in Italy.

October 5, 1986 / Fourvières, France / For John Paul II's trip to Lyon, the security precautions were particularly tight. A wave of terrorist action was sweeping through France, the trial of Klaus Barbie had just been announced in Lyon, a terrorist well known for planting bombs had just been arrested there, and the prophecies of Nostradamus mention the assassination of a pope "between Rhône and Saone" before the end of the millennium.

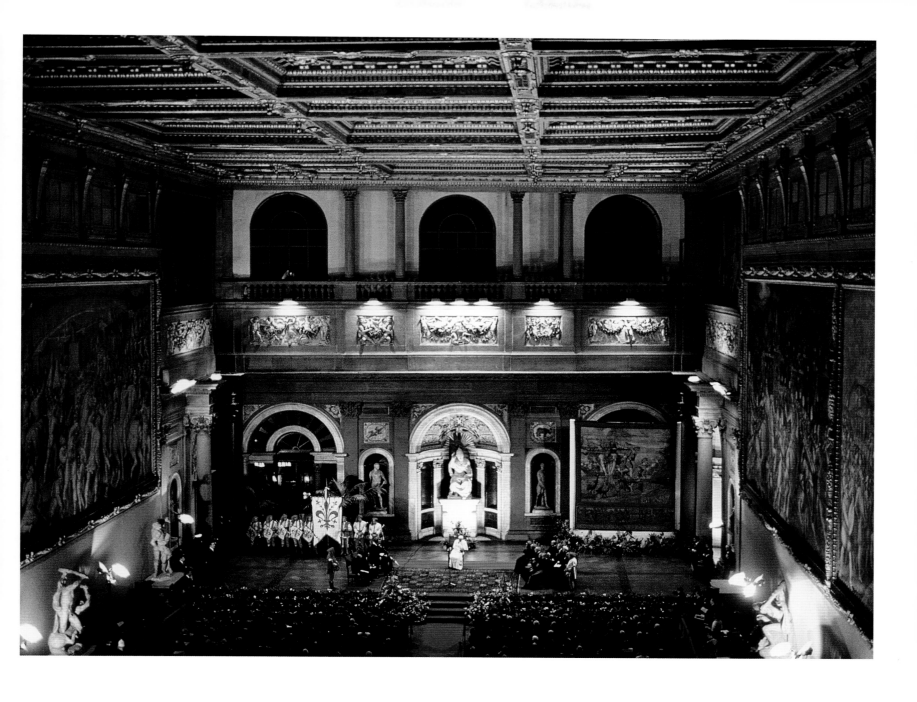

June, 1987 / Florence, Italy / Reception of the pope in the Uffizi Gallery, the most important museum in Florence.

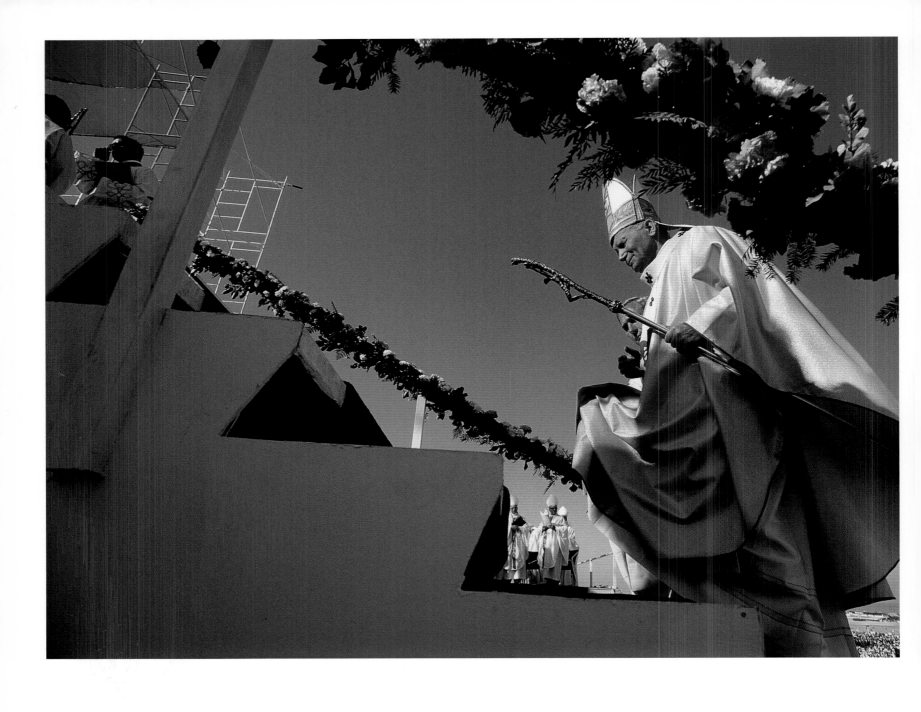

April 7, 1987 / Santiago, Chile / On his thirtieth trip, to Uruguay, Chile, and Argentina, John Paul II meets Augusto Pinochet. His arrival in Chile is disrupted by violent riots.

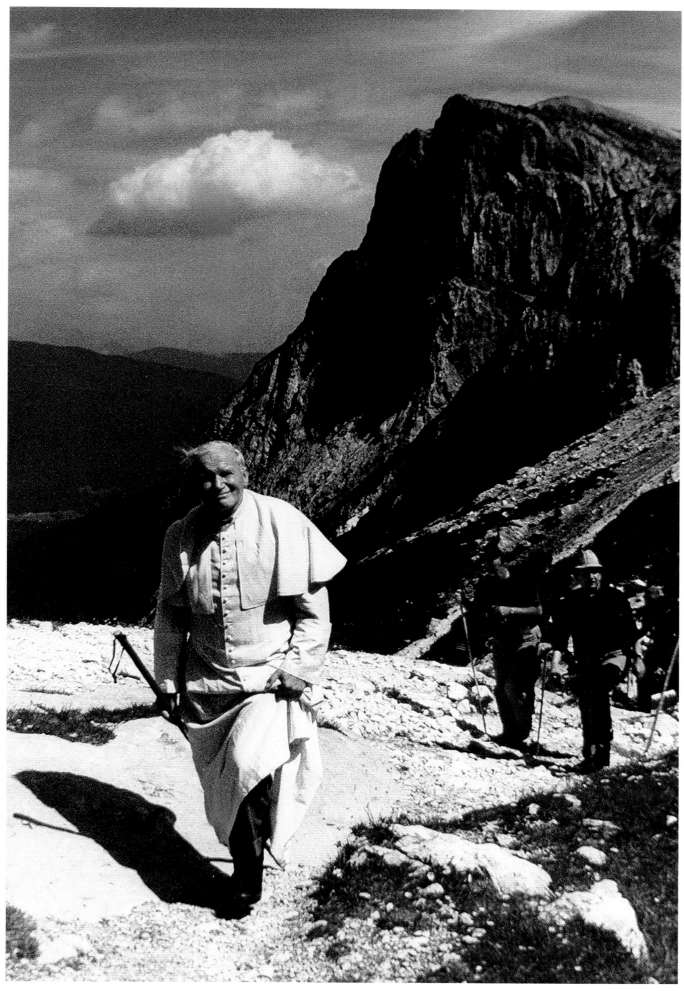

July 12, 1987 / The Dolomites / John Paul II relaxes in the Dolomite region so dear to him.

177

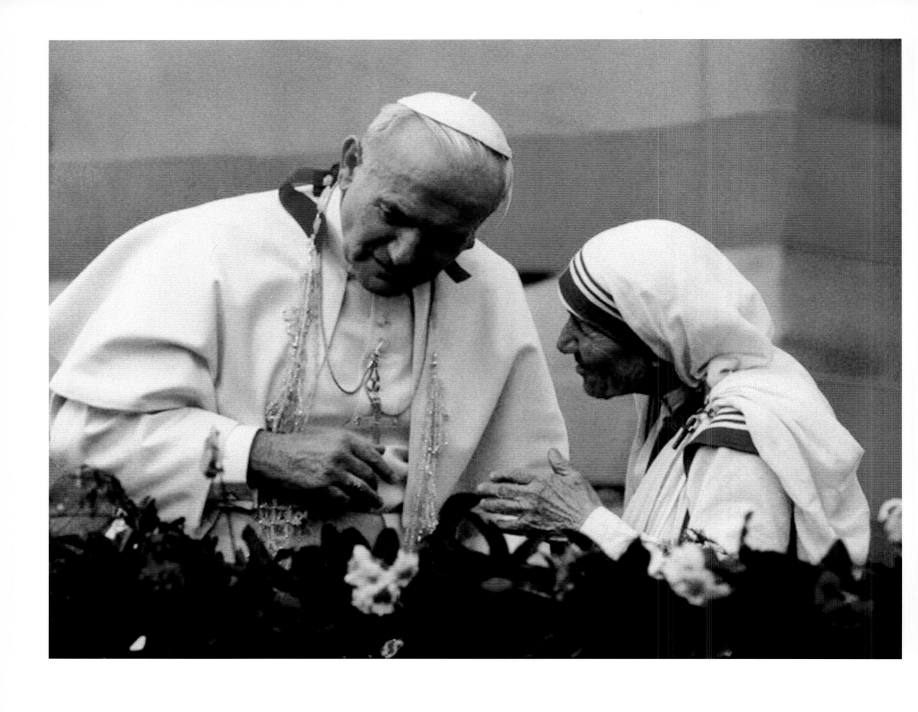

February 3, 1986 / Kalighat, India / John Paul II and Mother Theresa outside the Nirmal Hriday Home for the Dying Destitute.

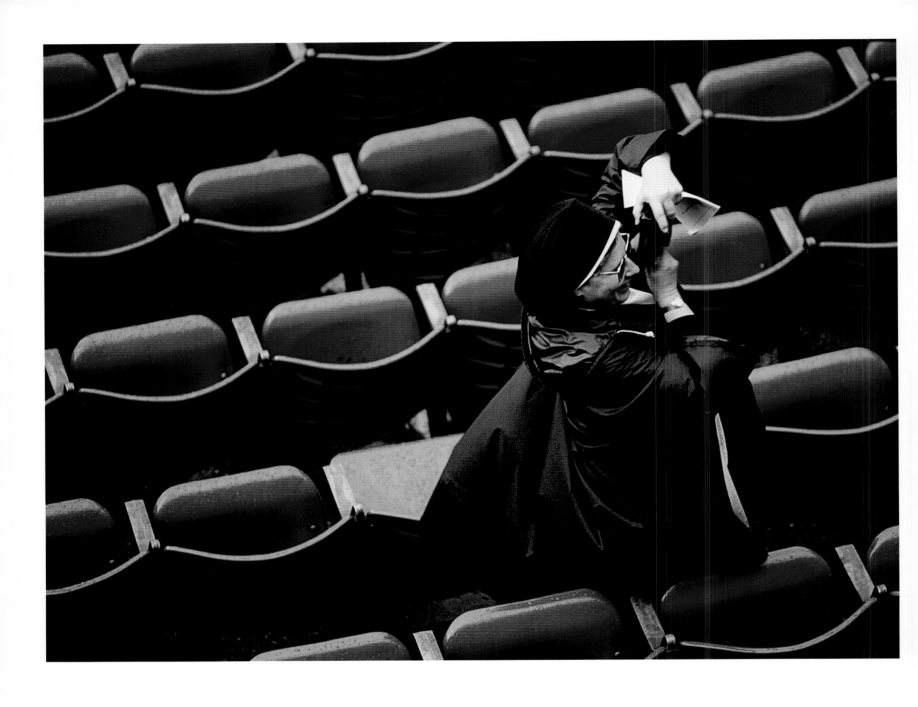

October 5, 1995 / East Rutherford, New Jersey / A nun takes a photo in the bleachers of the Meadowlands Sports Complex during a mass celebrated by John Paul II.

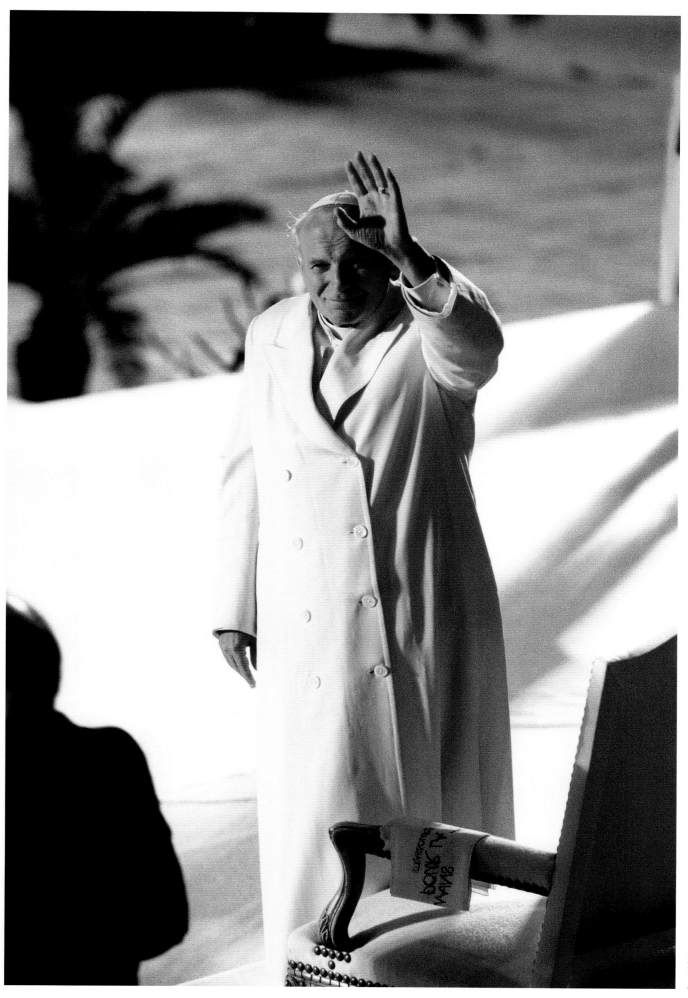

November 15, 1978 / Strasbourg,
France / Portrait of John Paul II at the
age of fifty-eight.

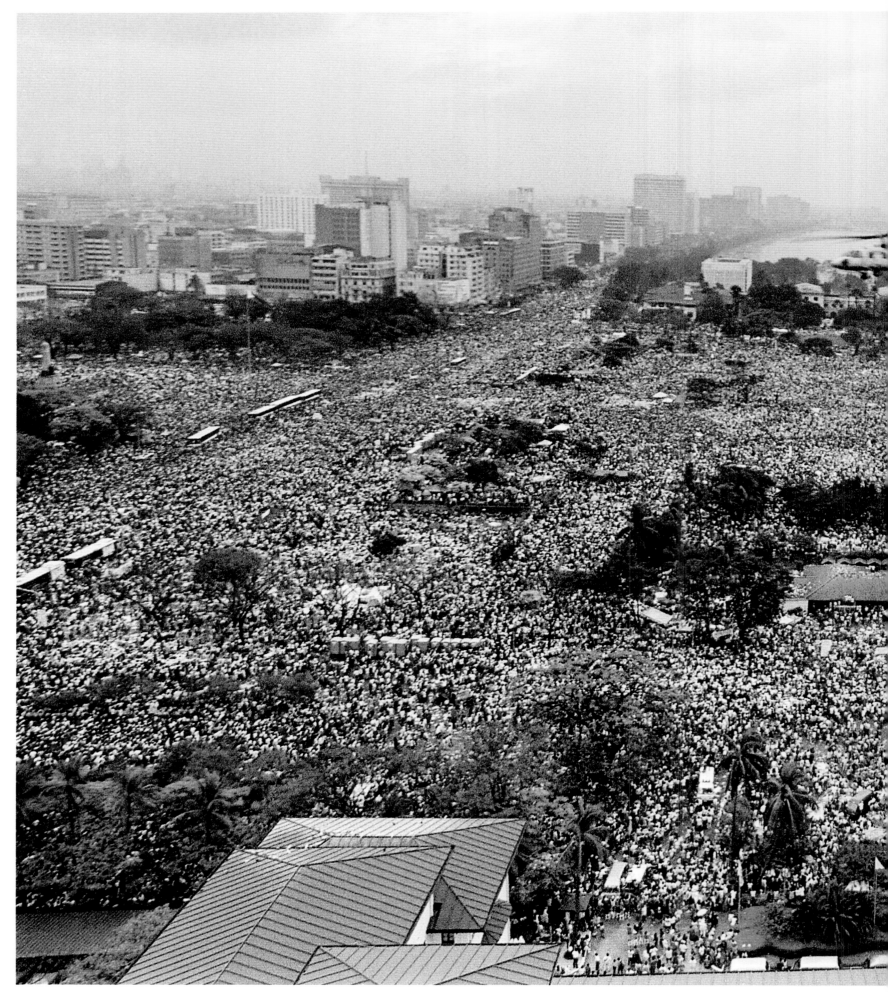

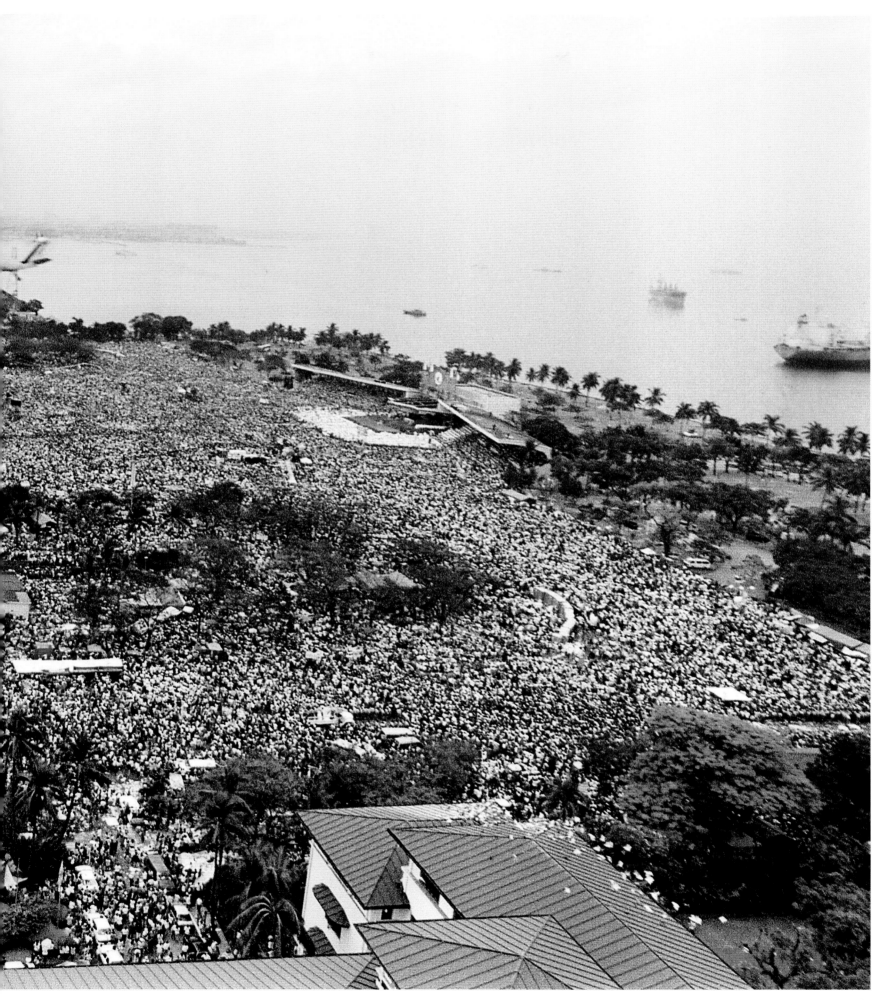

"The freedom of religion must not be simply tolerated. It is a civil and social reality, one that is composed of certain rights–including the right to proclaim one's faith in God without fear of retaliation."

John Paul II, Casablanca, Morocco, August 19, 1984

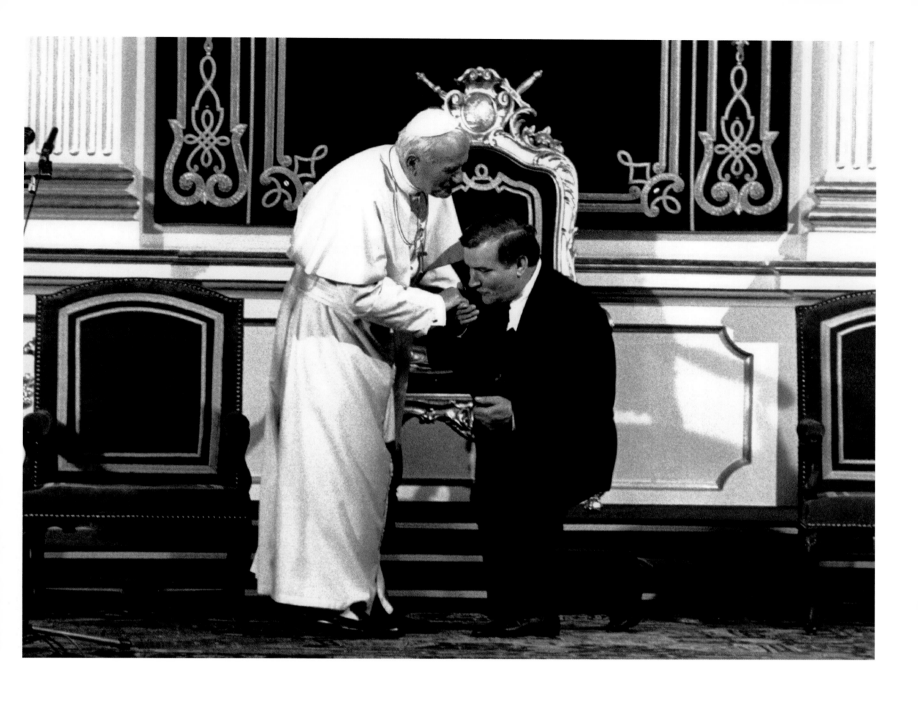

pp. 182-183:
January 15, 1995 / Manila, Philippines / John Paul II's helicopter flies over a crowd of more than two million people gathered in Luneta Park for the tenth World Youth Day.

June 8, 1991 / Warsaw, Poland / In the royal castle, on the occasion of the two hundredth anniversary of the Polish constitution, Polish president Lech Walesa, holding the original copy of the constitution, kisses the hand of John Paul II.

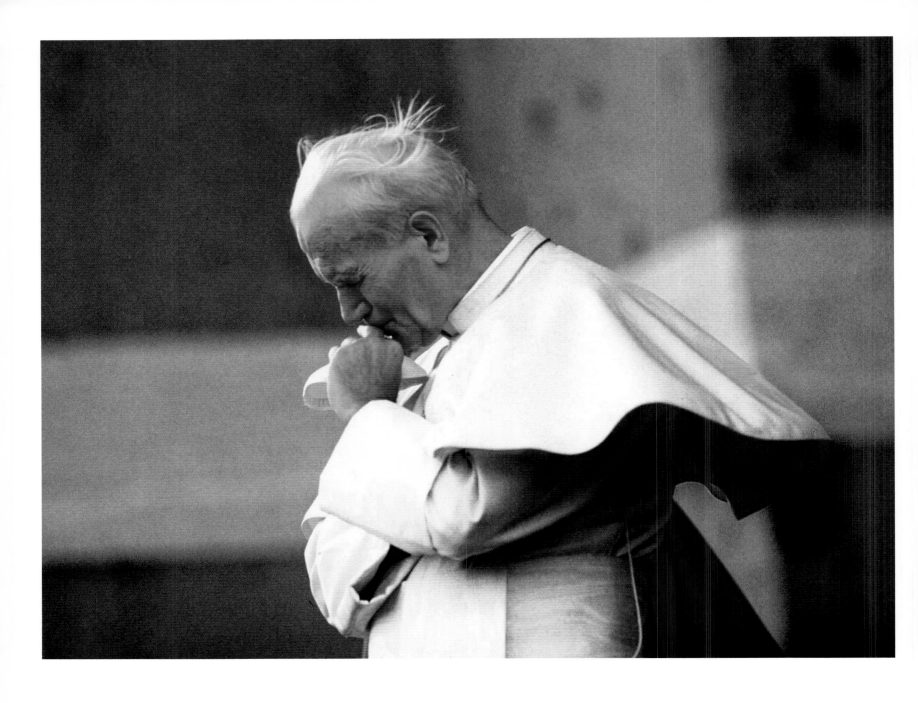

April 24, 1993 / Rome, Italy / John Paul II reflects.

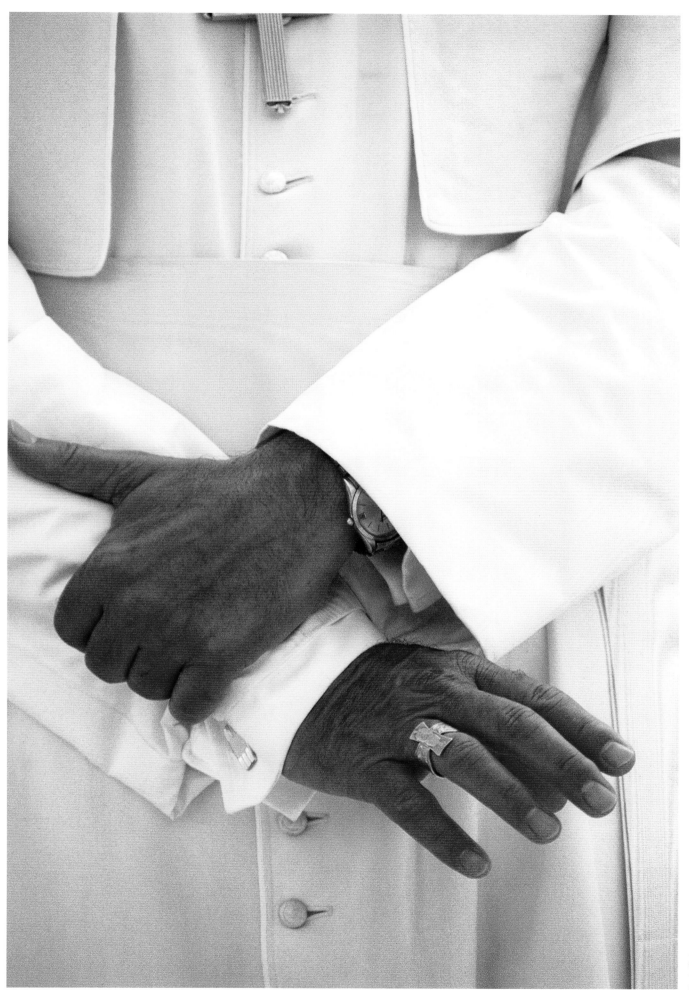

January 17, 1995 / Port Moresby, Papua New Guinea / John Paul II during his sixty-third trip.

187

"I renew before Christ my devotion to serve the Church as long as it will please Him, and I completely surrender to His divine will. I leave to Him the choice of which moment to relieve me of my charge."

John Paul II, May 17, 1995, the day before his seventy-fifth birthday, usually the age limit for bishops

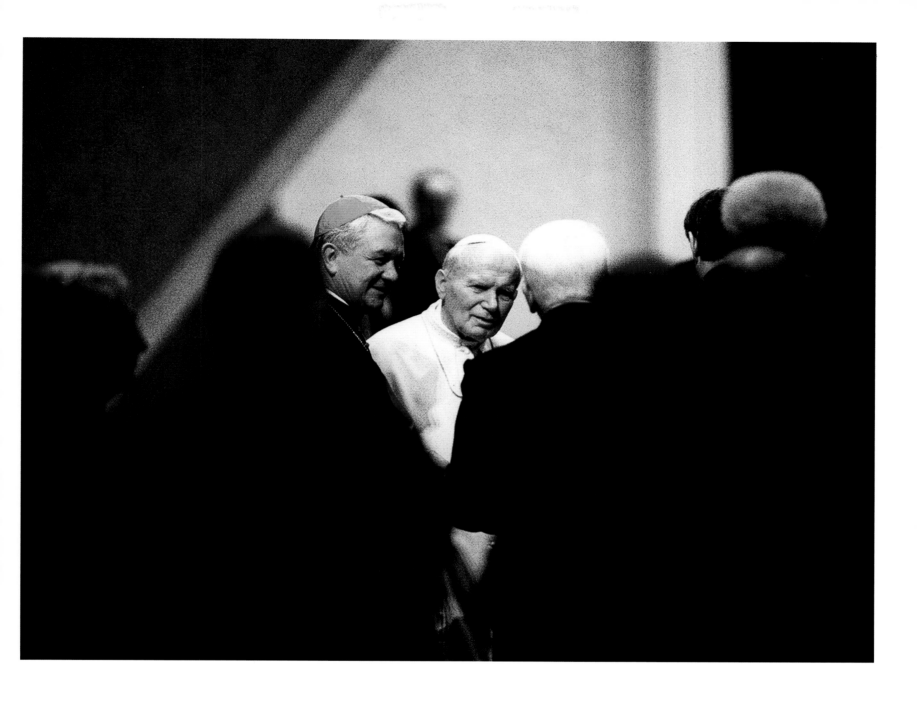

November 28, 1994 / Rome, Italy / John Paul II in conversation with the cardinal of Detroit, Monsignor Maida. Two days earlier, the pope had created thirty cardinals during a consistory.

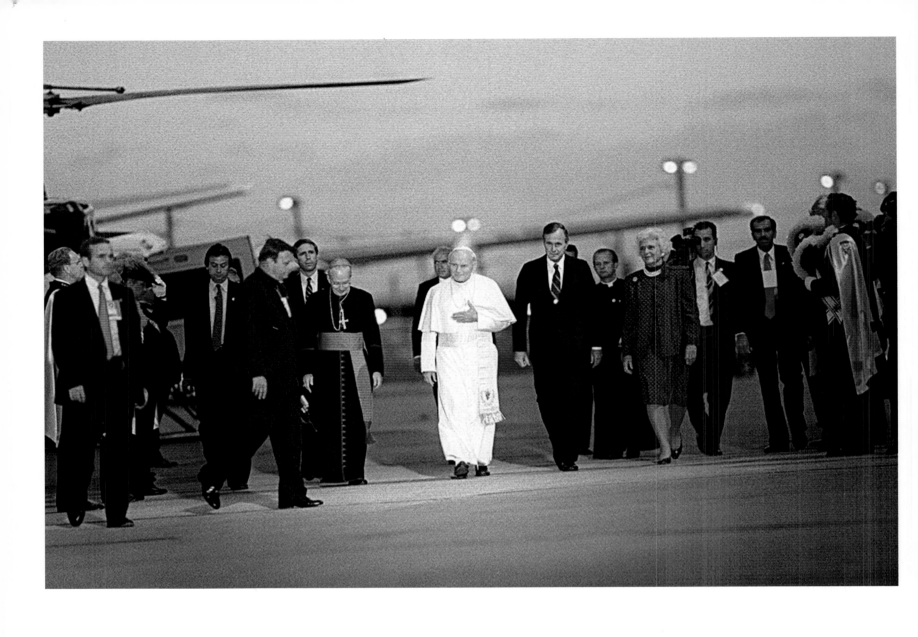

September 19, 1987 / Detroit, Michigan / John Paul II is taken back to the airport in Detroit by President George H. W. Bush and his wife.

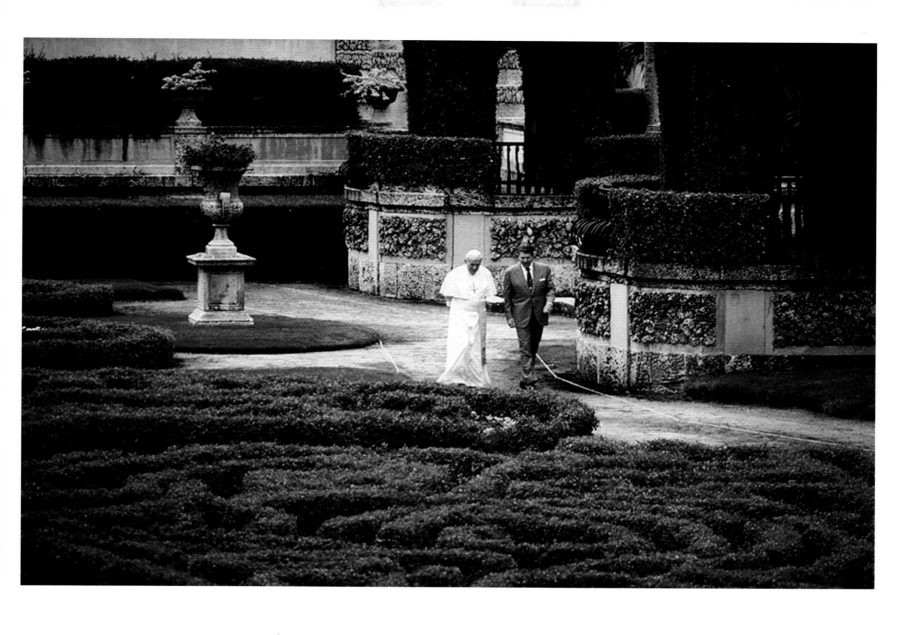

September 10, 1987 / Miami, Florida / President Ronald Reagan and John Paul II stroll in the gardens of the magnificent Villa Vizcaya.

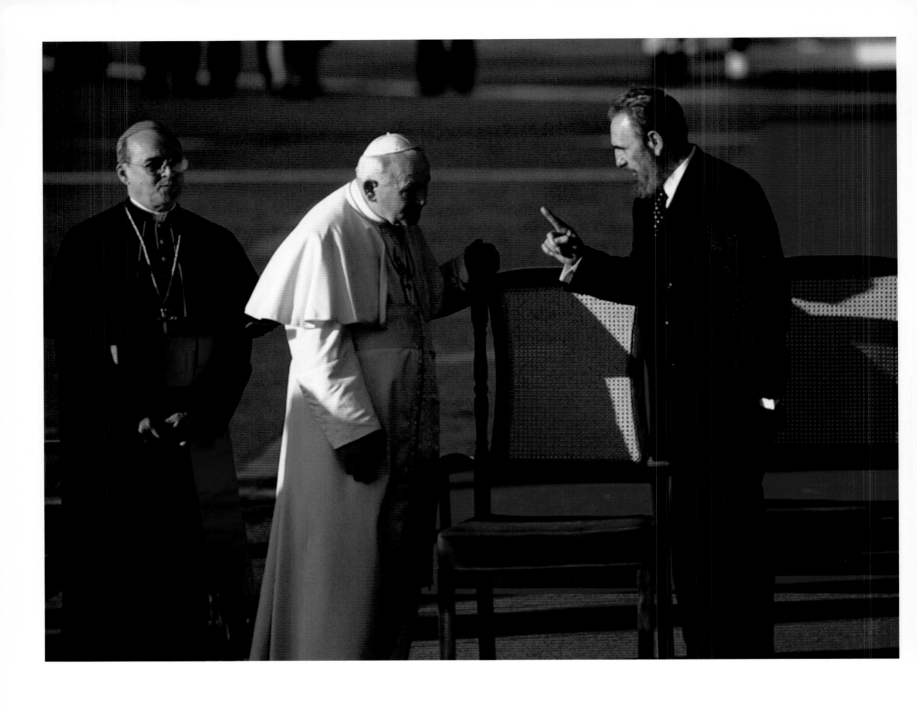

January 21, 1998 / Havana, Cuba / The first official trip of the pope to Cuba. It took years of negotiations to make this trip possible. The Vatican demanded significant concessions from Cuba, including the restoration of the Christmas holiday, which took place in 1997.

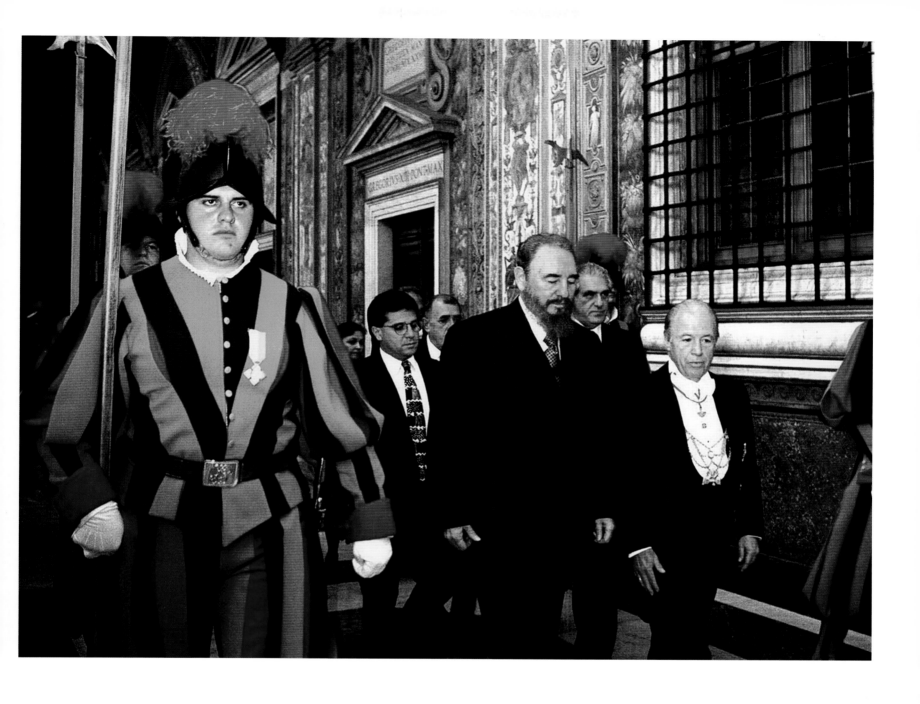

November 19, 1996 / Rome, Italy / Fidel Castro's private audience in John Paul II's private library.

"You have never let those of us who enjoy the benefits of prosperity, liberty, and peace forget our responsibilities"

President Clinton, January 27, 1999

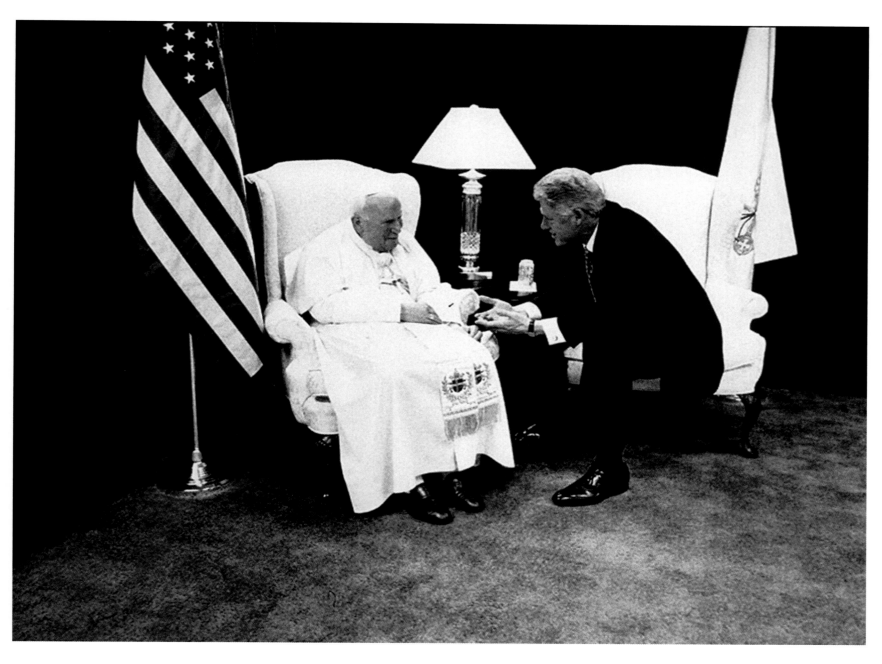

January 27, 1999 / St. Louis, Missouri / Meeting of John Paul II and President Bill Clinton.

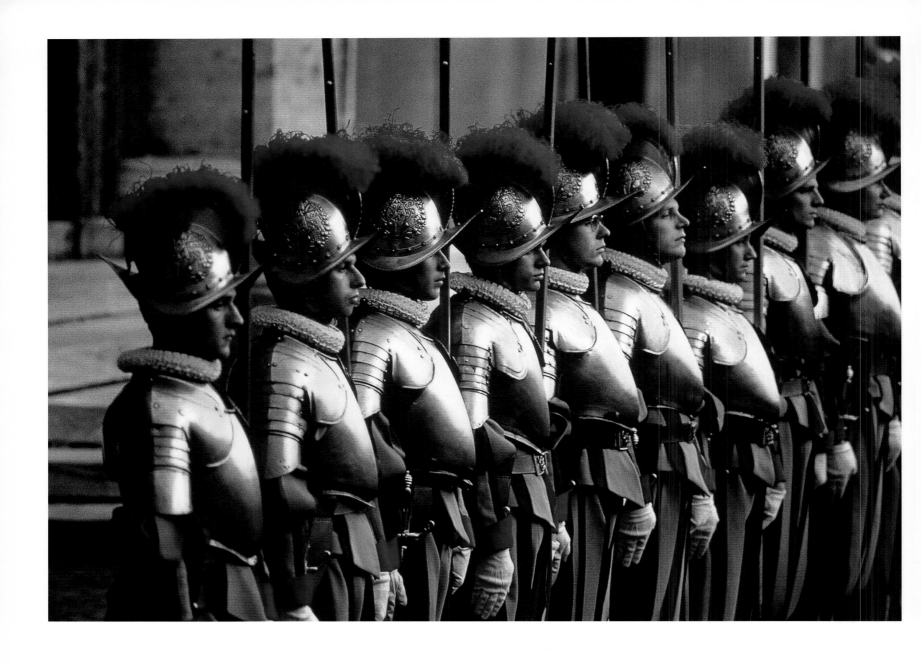

1986 / Rome, Italy / Column of Swiss Guards.

June 1, 1997 / Poland / John Paul II traveling in Poland, when he canonizes Queen Edwige d'Anjou, Dame de Wawel, who caused the Polish-Lithuanian union in the fourteenth century.

"God of our fathers, you chose Abraham and his descendants to bring your name to the nations. We are deeply saddened by the behavior of those who throughout history have caused your children to suffer, and we ask your forgiveness. We wish to commit ourselves to a genuine brotherhood with the people of the Book."
Jerusalem, March 26, 2000
Johannes Paulus II

March 26, 2000 / Jerusalem, Israel / Text of the message written by John Paul II and placed in a crevice of the Western ("Wailing") Wall.

198

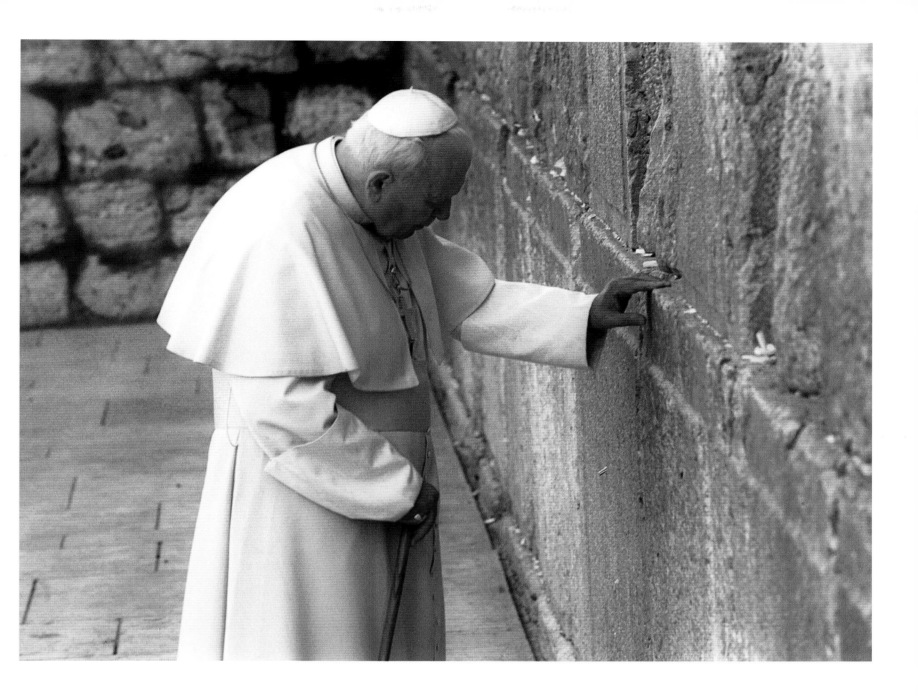

March 26, 2000 / Jerusalem, Israel / John Paul II approaches the Western Wall in order to place a handwritten prayer in it.

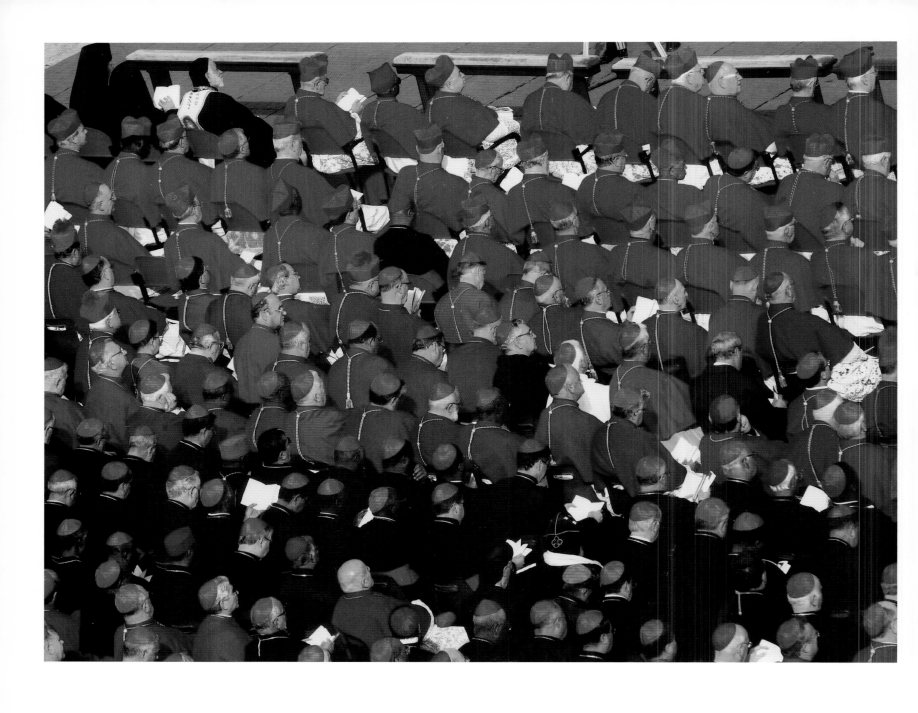

October 19, 2003 / Rome, Italy / The cardinals gather to attend the beatification ceremony for Mother Theresa, winner of the 1979 Nobel Peace Prize. More than 250,000 pilgrims attended this tribute.

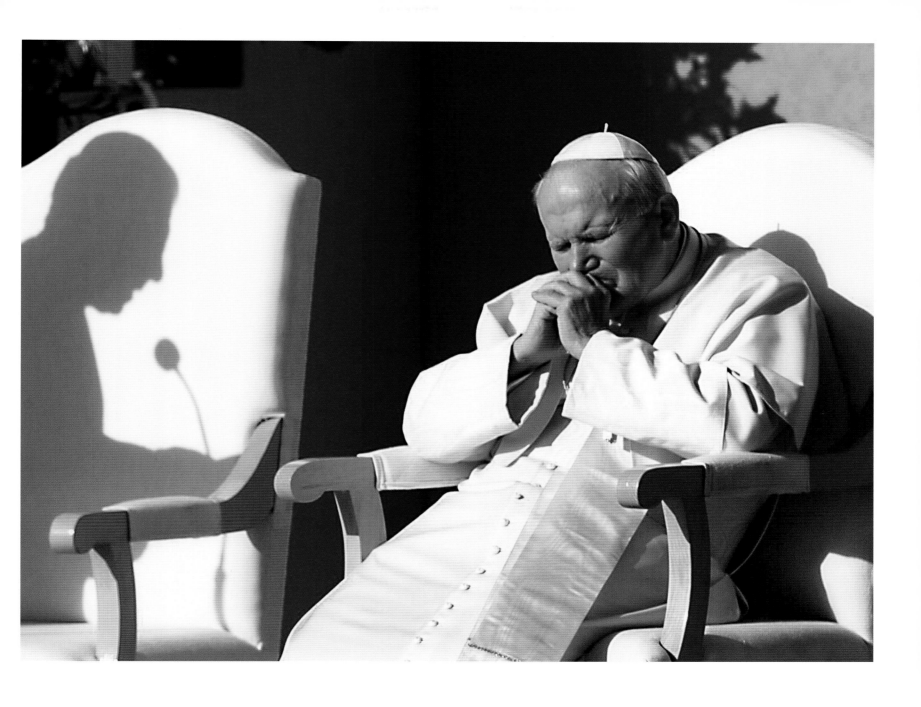

January 26, 1999 / Mexico City, Mexico / John Paul II listens to Mexican president Ernesto Zedillo's speech, shortly before leaving Mexico for a thirty-hour visit to St. Louis, Missouri.

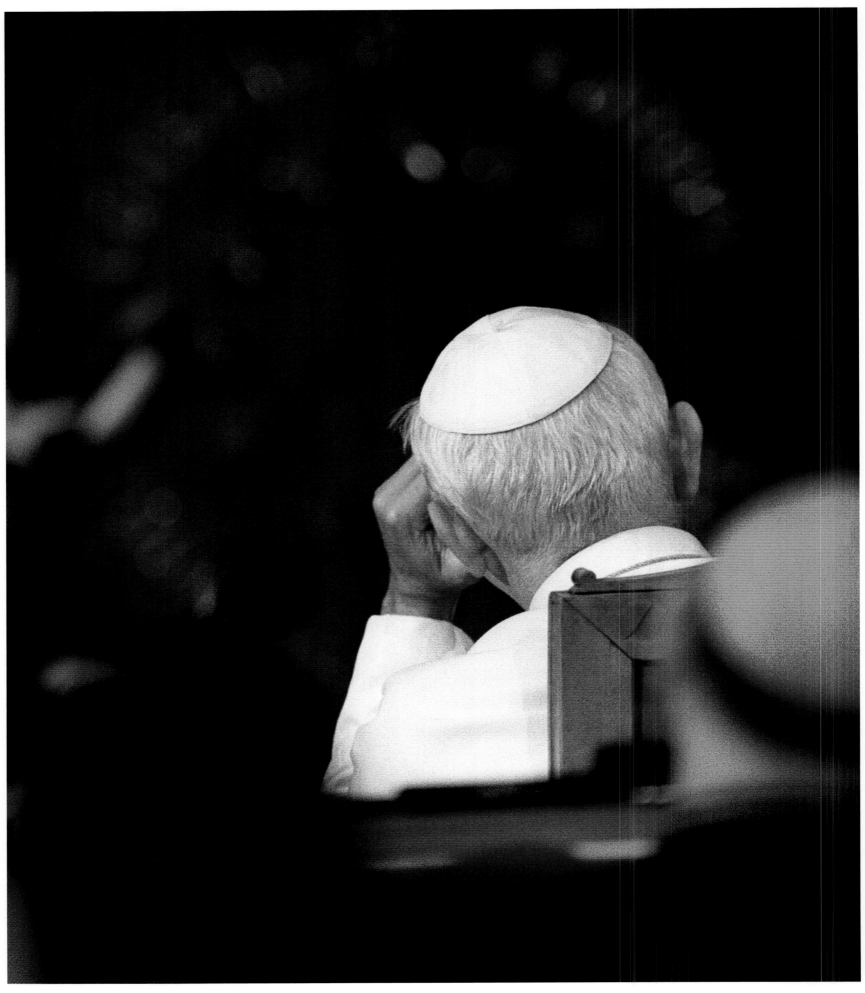

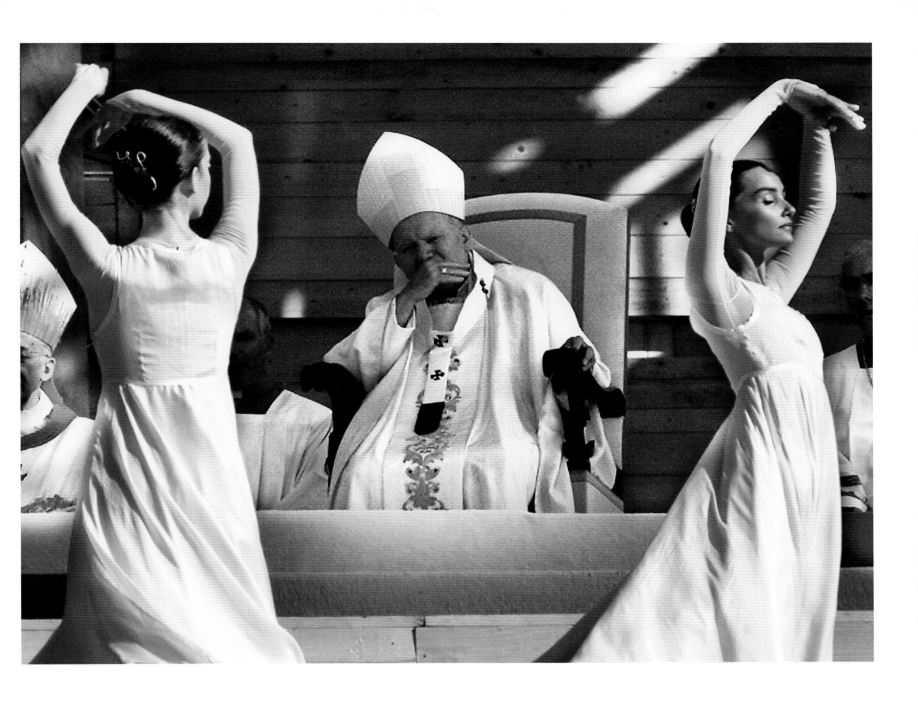

October 9, 1988 / Strasbourg, France / John Paul II hears a mass celebrated in the Strasbourg Cathedral during his fourth trip to France.

August 20, 2000 / Rome, Italy / The Pope attends a performance of *Tor Vergata* on the campus of the University of Rome during the closing of World Youth Day, in which more than two million young people took part.

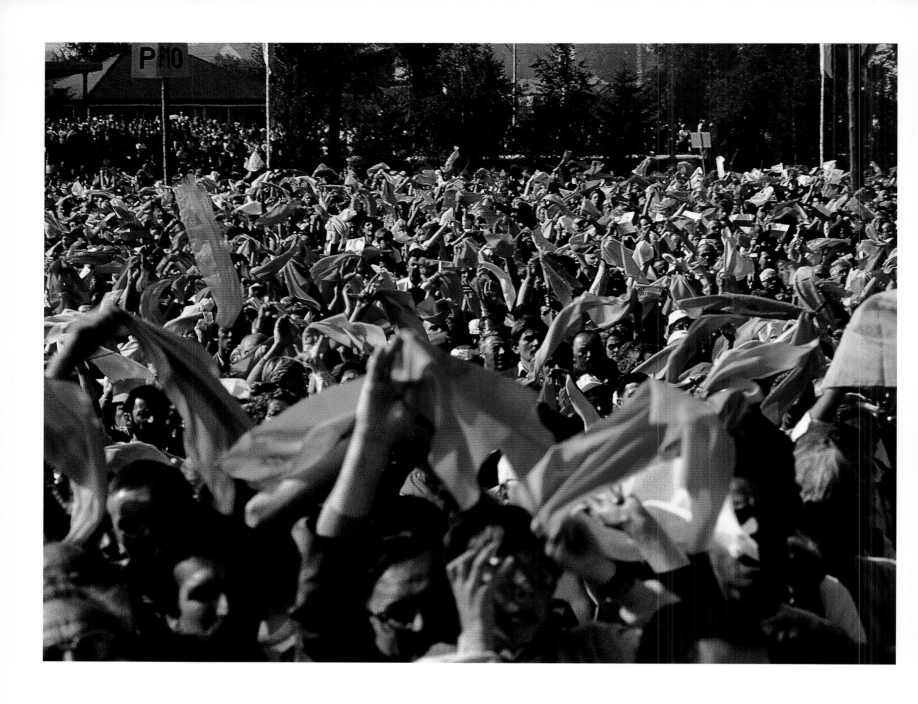

1986 / France / An enthusiastic crowd welcomes John Paul II.

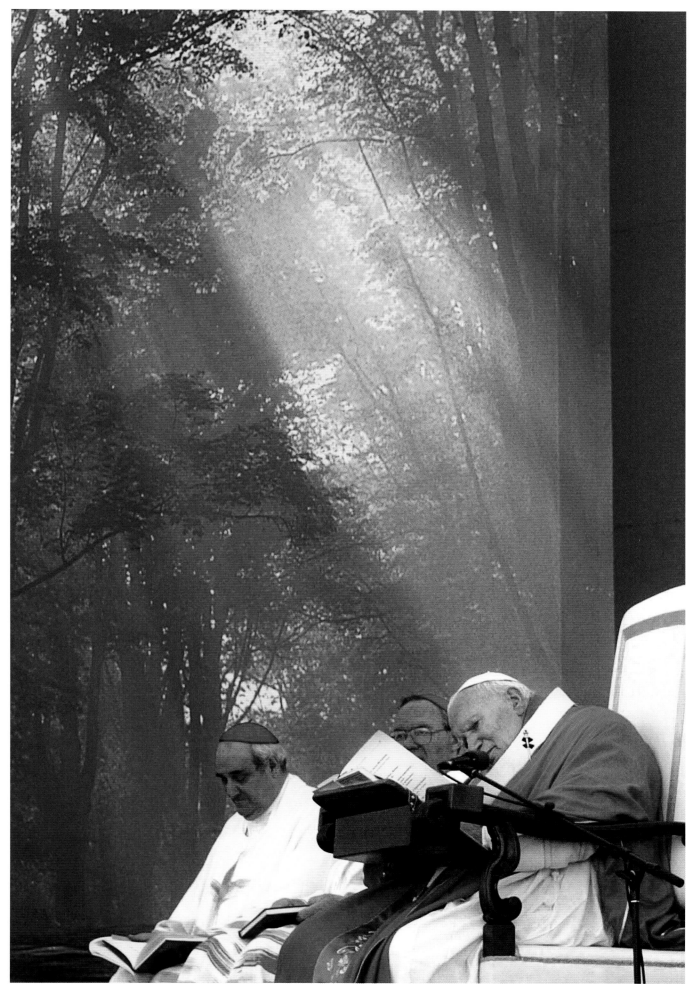

July 28, 2002 / Toronto, Canada / John Paul II addresses more than 800,000 people during the World Youth Day papal mass in Downsview Park, in Canada. More than 210,000 camped out on site so they could attend the event.

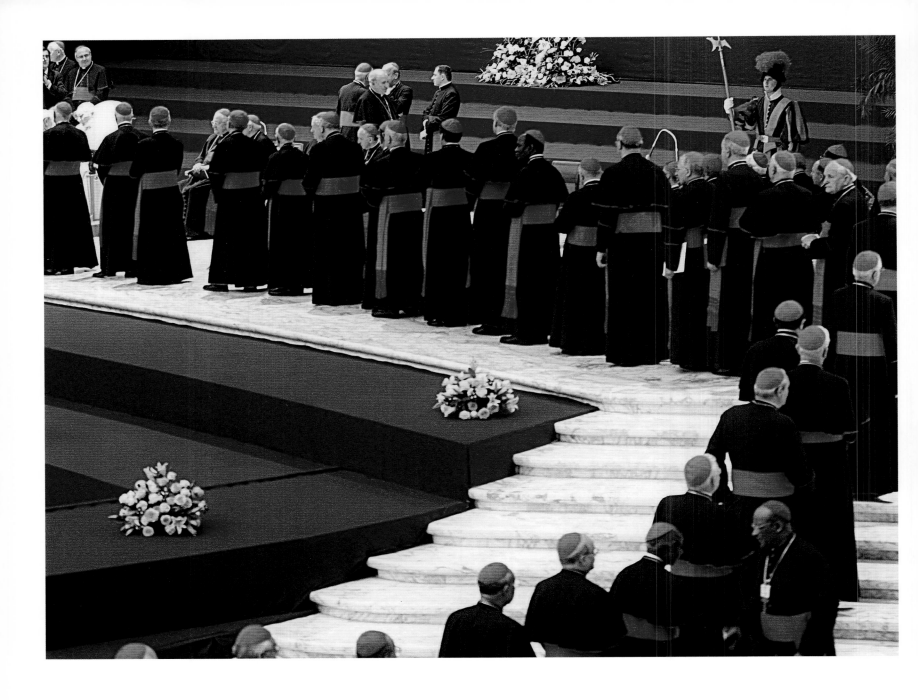

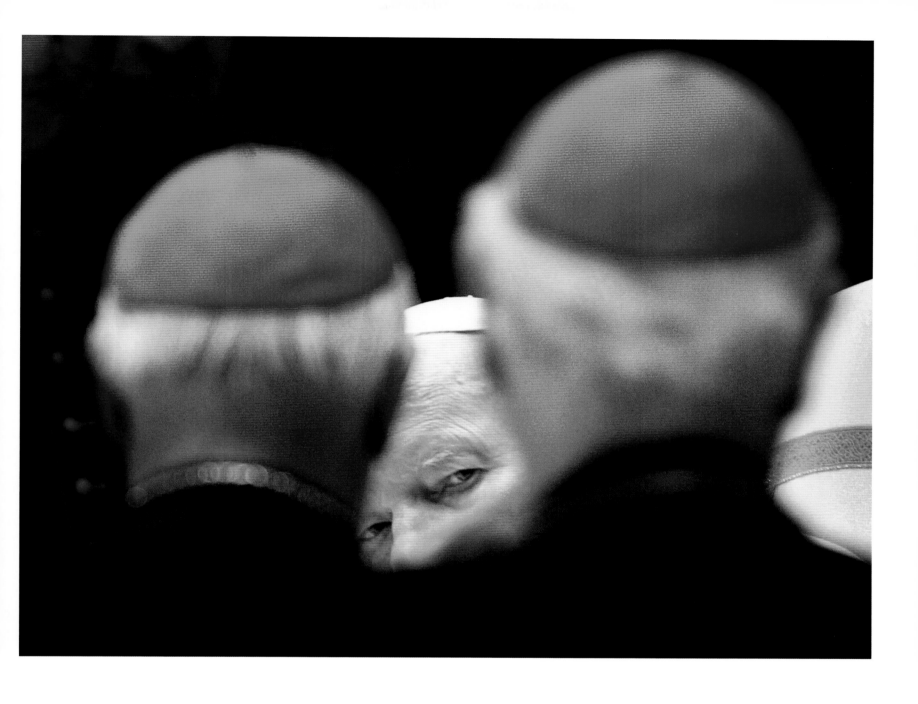

October 16, 2003 / Rome, Italy / The cardinals come to greet John Paul II during ceremonies marking the twenty-fifth anniversary of his pontificate.

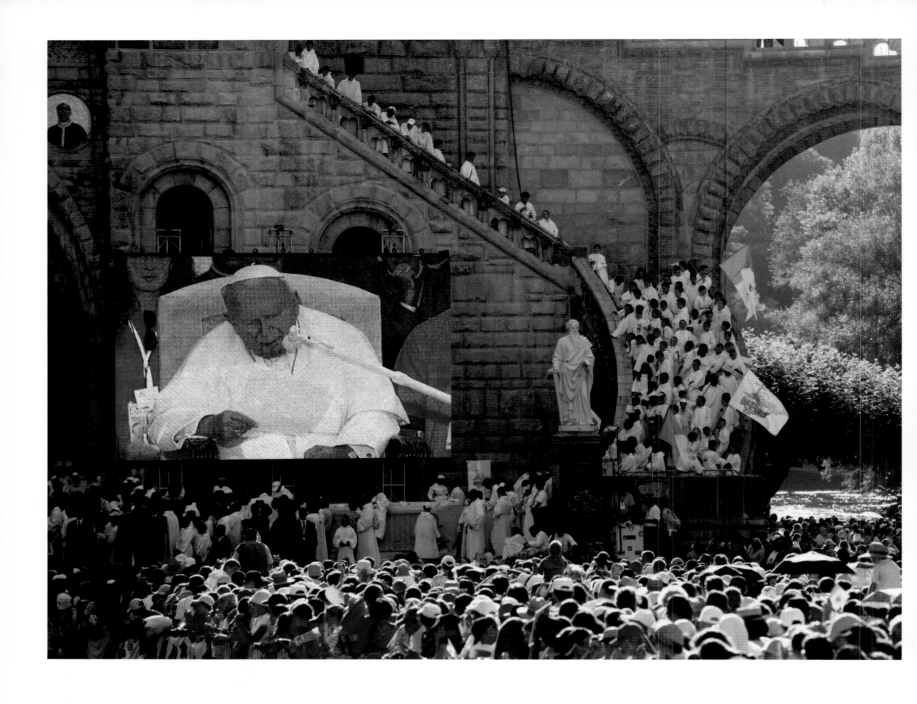

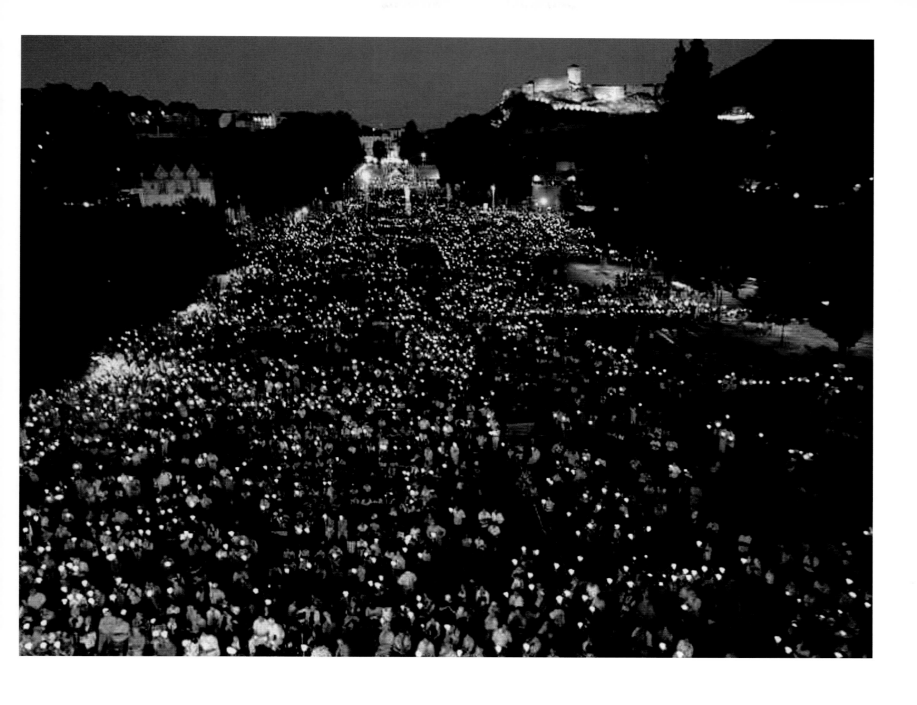

August 14, 2004 / Lourdes, France / John Paul II on a pilgrimage to Lourdes on the occasion of the hundred fiftieth anniversary of the proclamation of the dogma of the Immaculate Conception of Mary. This dogma of the Catholic Church was decreed on December 8, 1854 by Pius IX. It was at Lourdes, on March 25, 1858, that the Apparition spoke her name to Bernadette Soubirous, saying, "I am the Immaculate Conception." Lourdes has since become an important pilgrimage site.

"Do not forget me in your prayers. May this Pope, who is blood of your blood and heart of your hearts, serve well the Church and the world."

John Paul II

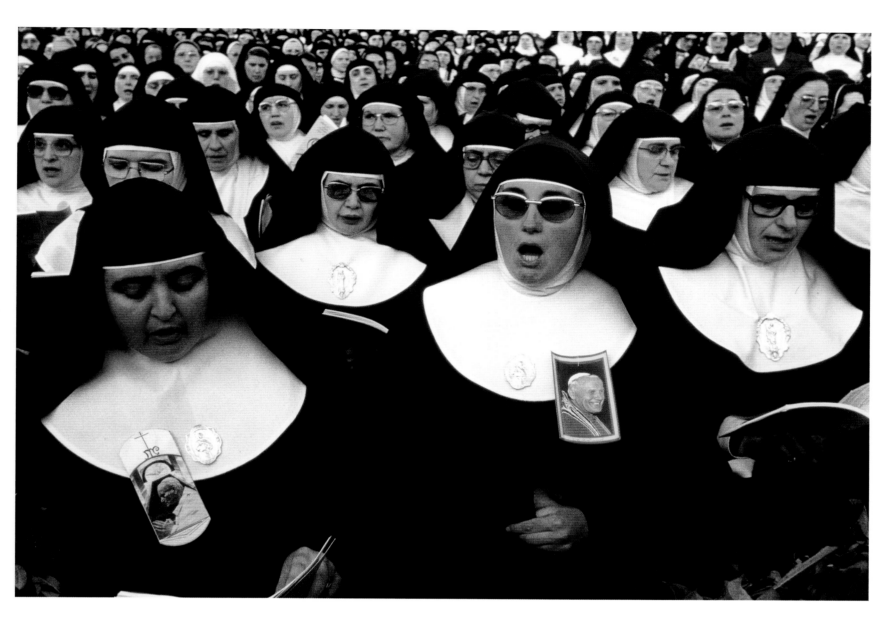

November 1982 / Spain / Sisters participate in an outdoor mass.

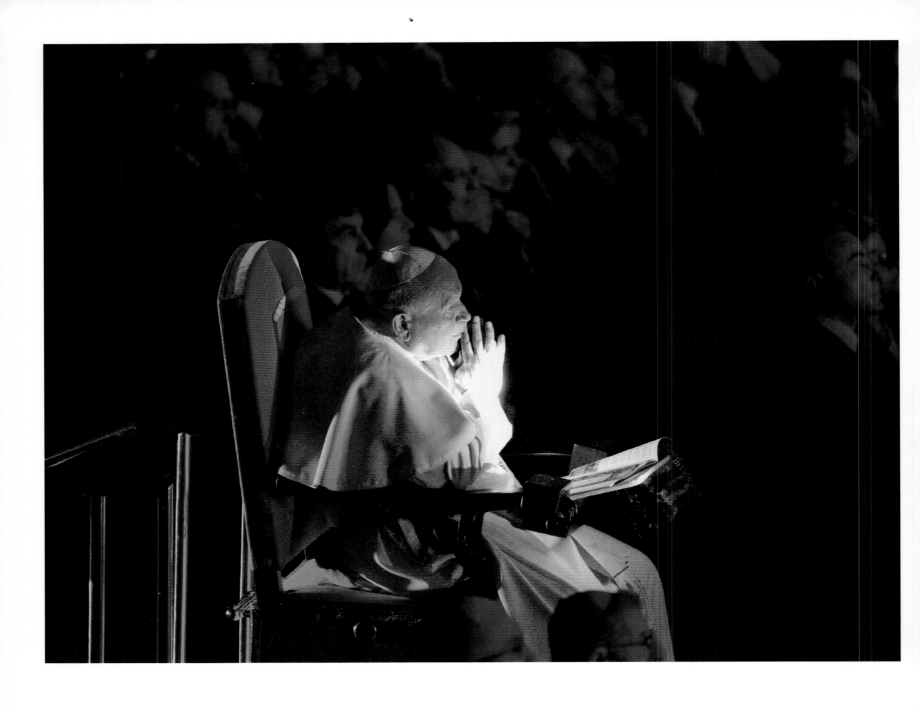

October 15, 2004 / Rome, Italy / John Paul II watches a performance by Russian Army choruses, who appear with an orchestra and a ballet troupe, on the occasion of the twenty-sixth anniversary of his pontificate.

January 5, 2005 / Rome, Italy / At 11:00 AM Greenwich mean time, the pope observes three minutes of silence, as does all of Europe, to pray for the victims of the tsunami that struck Asia on December 26, 2004.

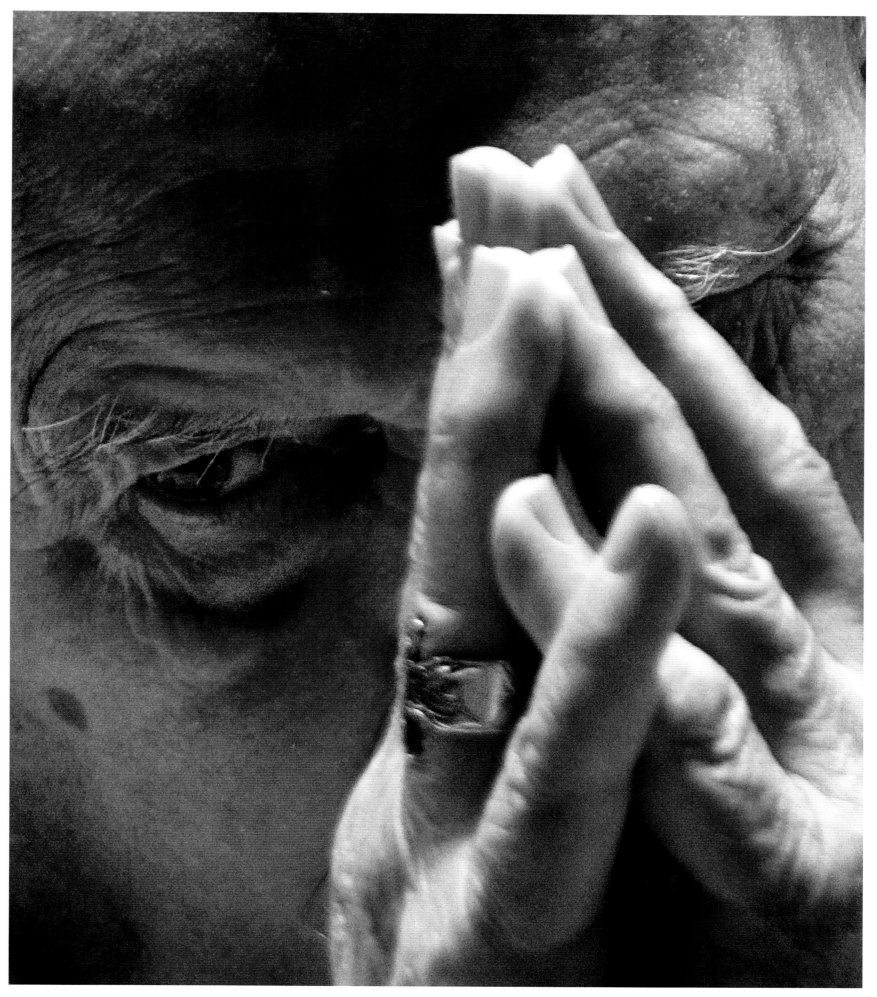

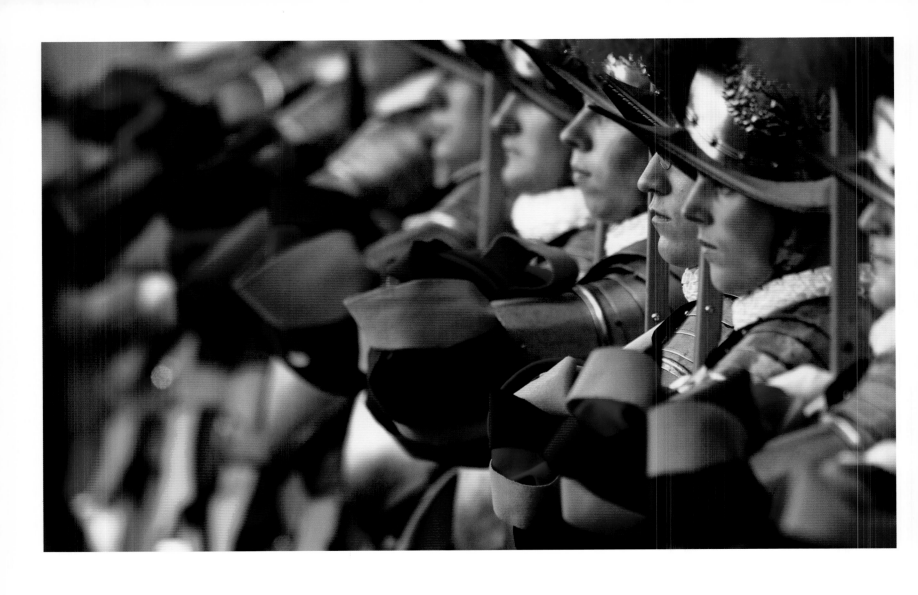

May 6, 2005 / Rome, Italy / The entire Swiss Guard is at attention during the induction ceremony for new recruits at the Cortile St. Damaso. This event takes place each year on the same date, in memory of the death of four hundred seven halberdiers who perished in 1527 while defending Pope Clement VII. It also marks the occasion when all the guards renew their oath of allegiance to the Pope.

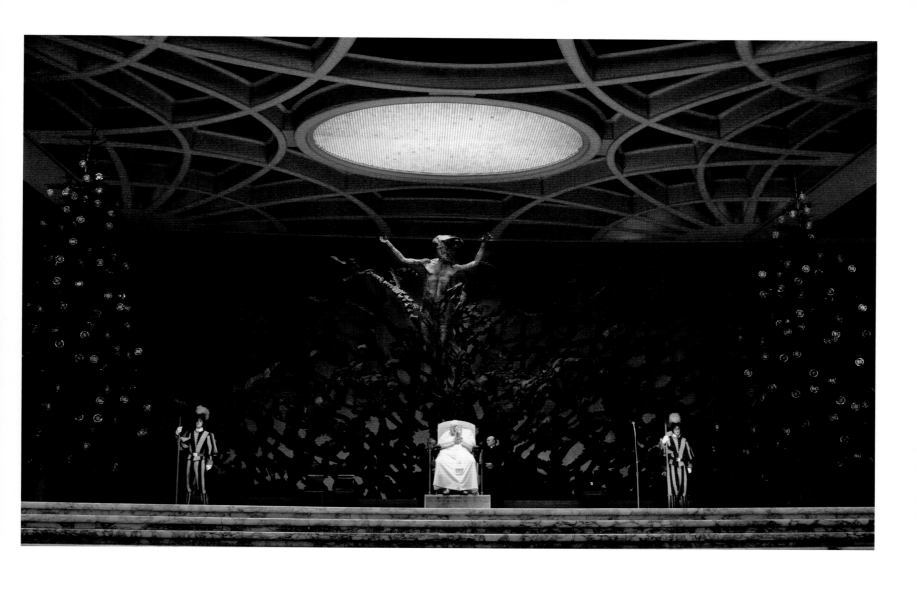

January 5, 2005 / Rome, Italy / At 11:00 AM Greenwich mean time, the pope observes three minutes of silence, as does all of Europe, to pray for the victims of the tsunami that struck Asia on December 26, 2004.

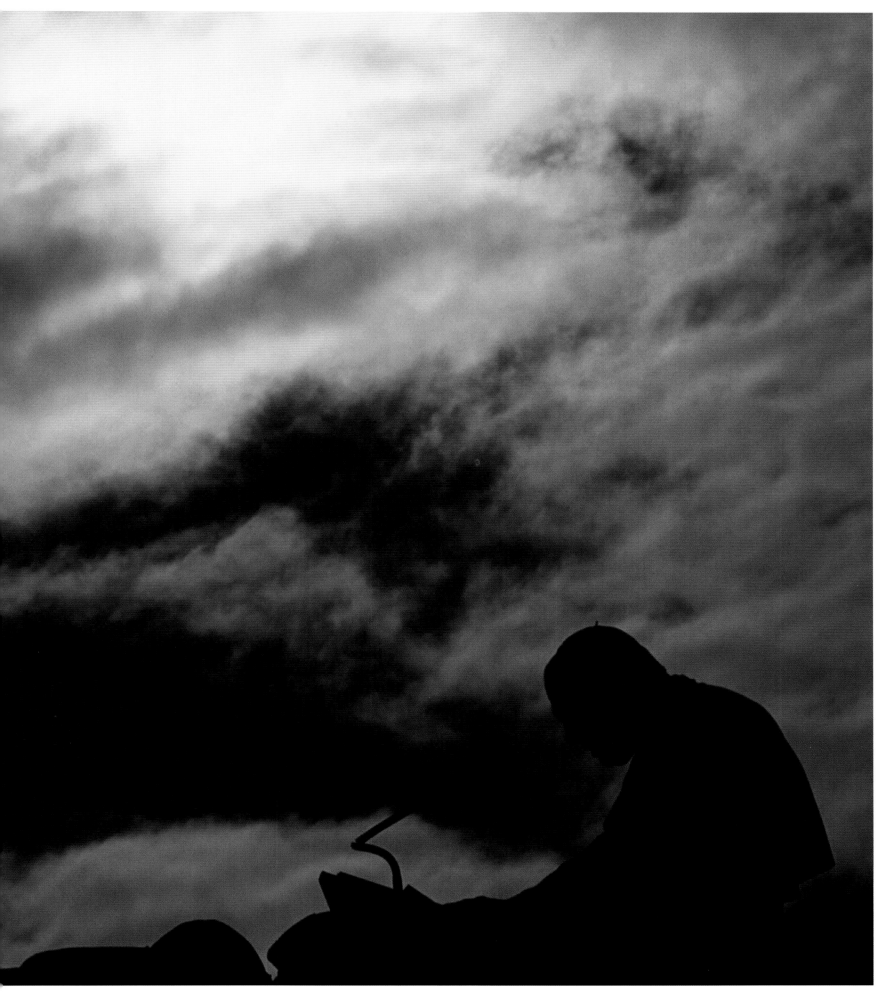

pp. 216–217:
January 3, 1998 / Assisi, Italy / John
Paul II visits the site of the
September 26, 1997 earthquake in
Umbria, which caused severe damage
to the city of Assisi.

April 28, 1996 / Rome,
Italy / Preparations for a ceremony at
which John Paul II will ordain priests.

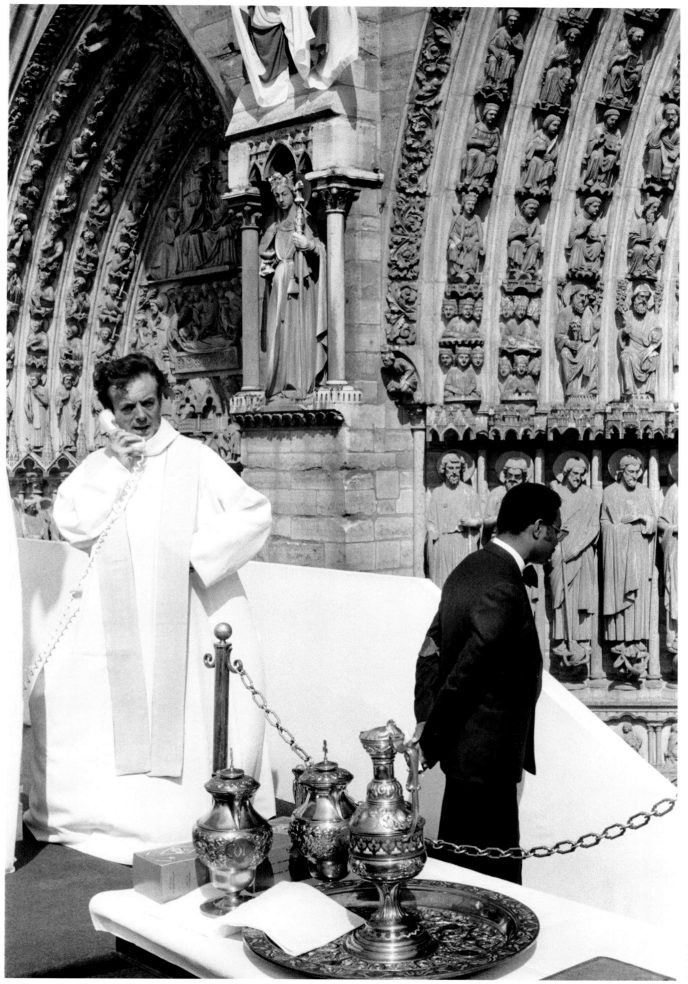

May 30, 1980 / Paris,
France / Awaiting the arrival of the
pope at Notre Dame in Paris.

April 2, 2005

7:37 PM Greenwich mean time. Death of Karol Wojtyla.

January 6, 2001 / Rome, Italy / John Paul II closes the Great Jubilee of the Year 2000 and marks the entry of Christianity into the third millennium with the symbolic closure of the Holy Door of Saint Peter's Basilica. On Christmas Night 1999, the pope had opened this door, inaugurating the Extraordinary Jubilee Year, marked by major events, commemorating the two thousandth anniversary of the birth of Christ. This hundred twenty-first jubilee celebrated by the Catholic Church since the year 1300 was based on two themes, repentance and the unity of the Church.

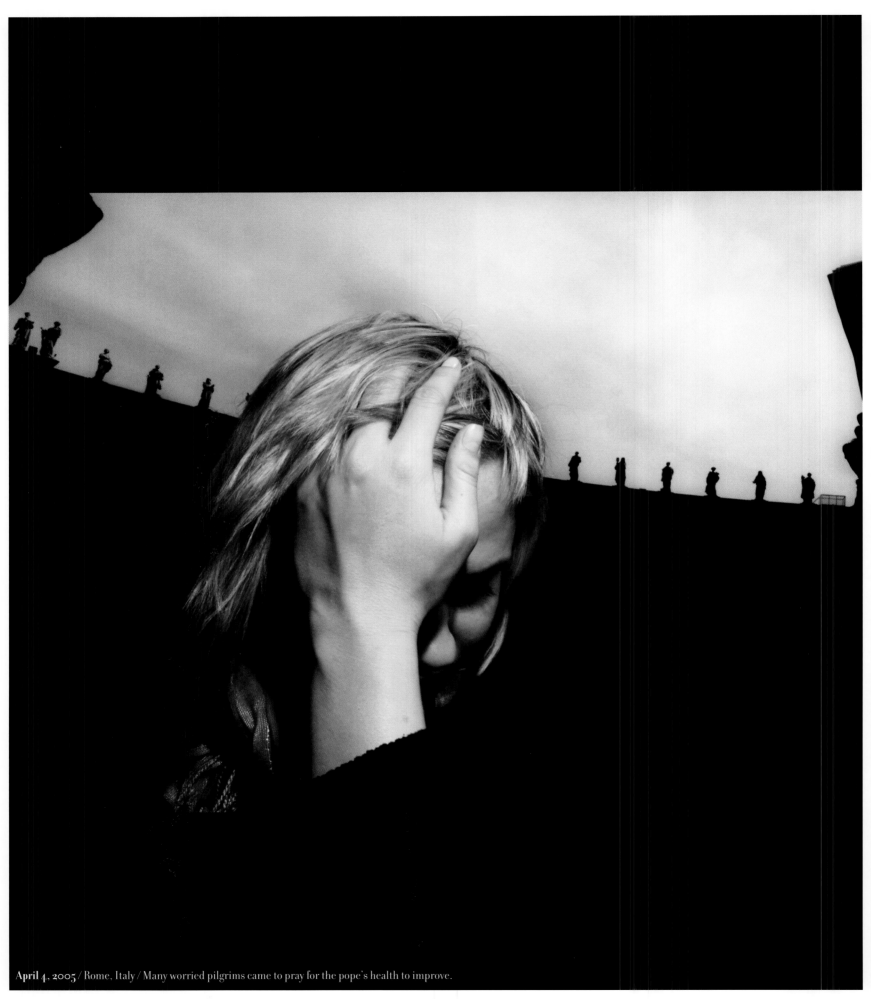

April 4, 2005 / Rome, Italy / Many worried pilgrims came to pray for the pope's health to improve.

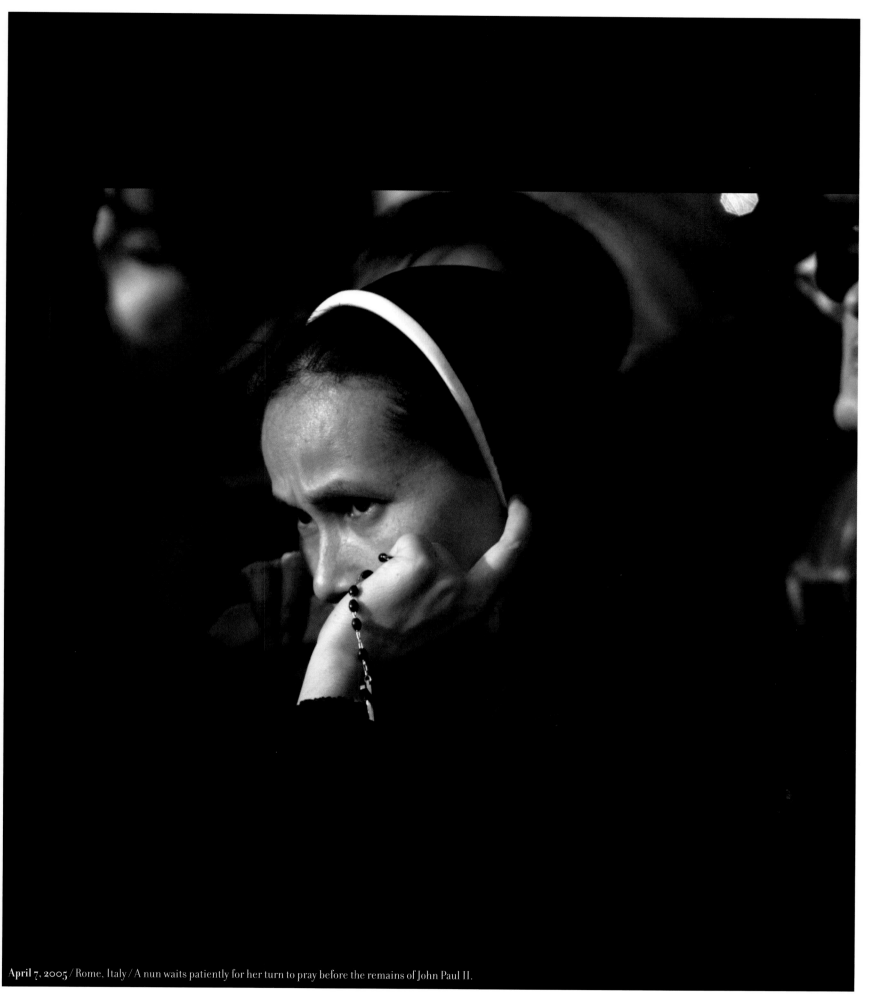

April 7, 2005 / Rome, Italy / A nun waits patiently for her turn to pray before the remains of John Paul II.

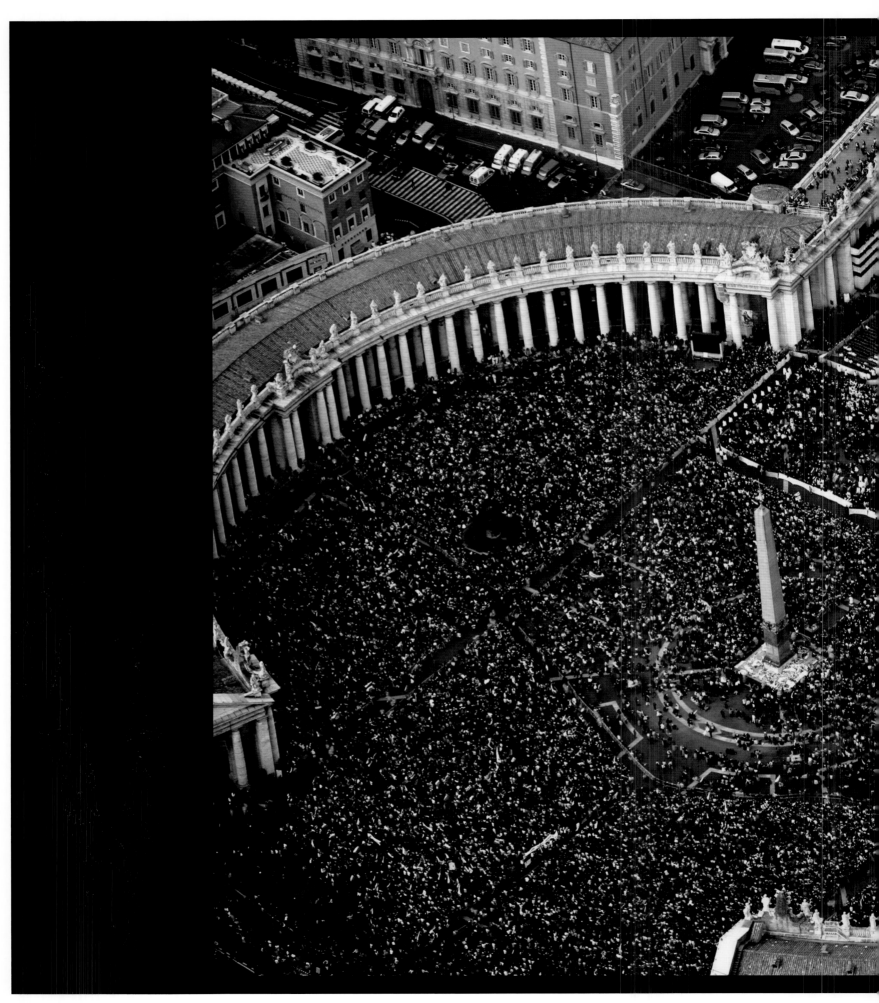

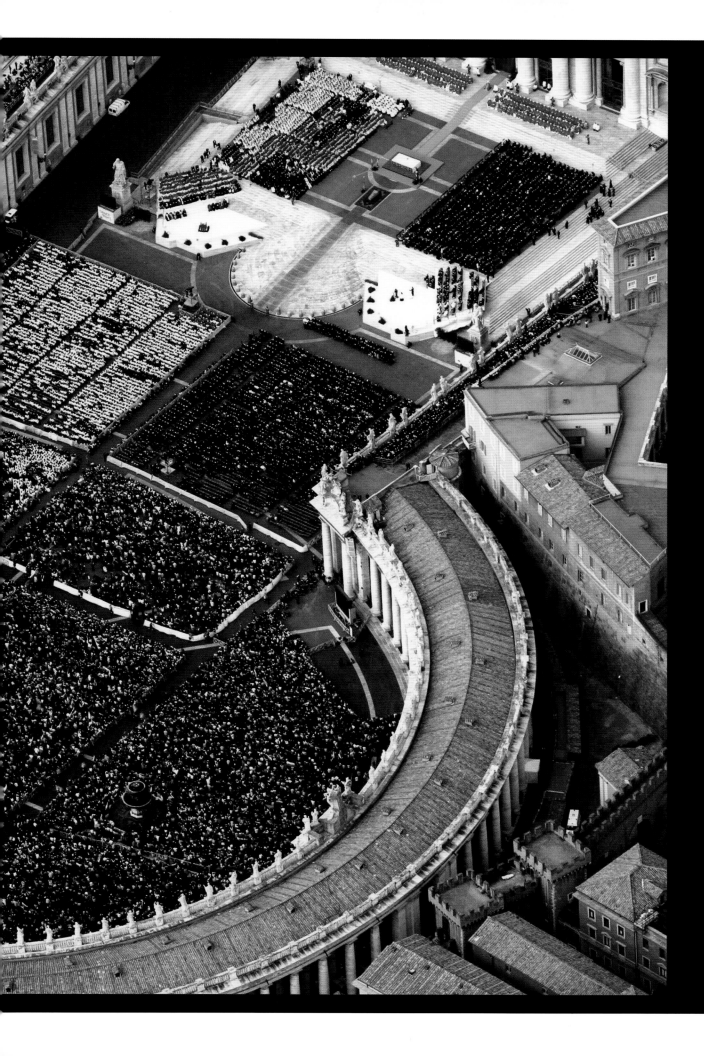

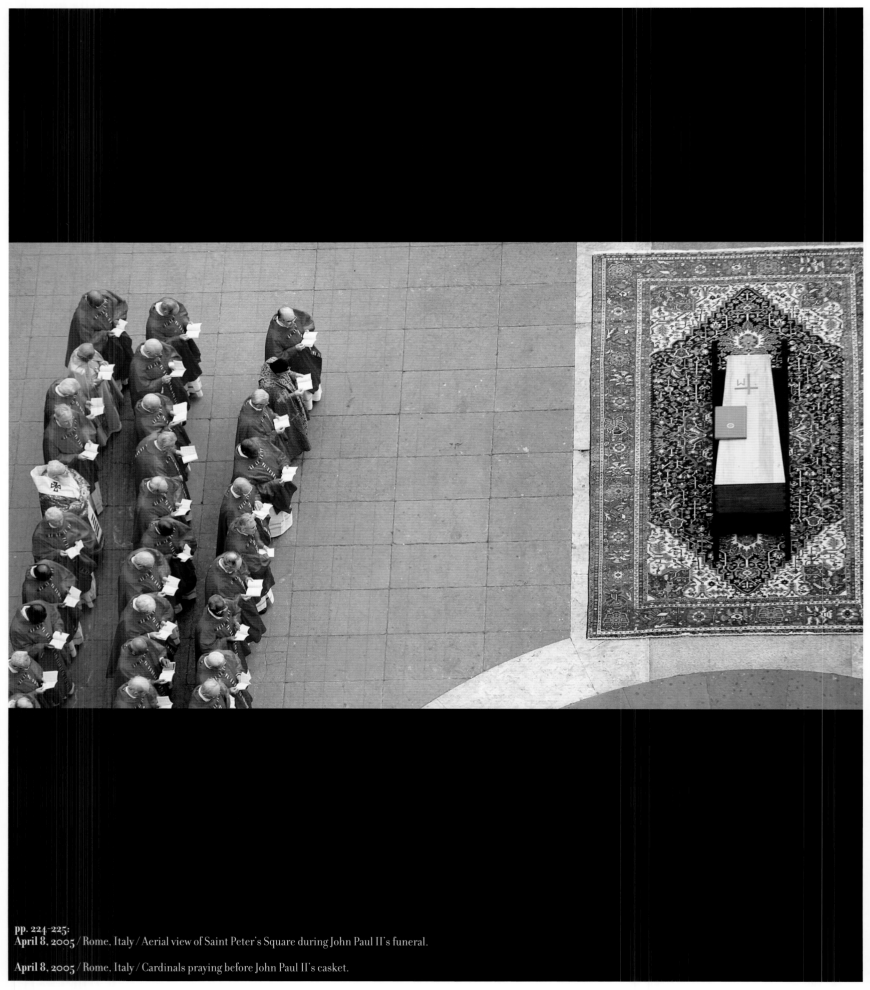

pp. 224–225:
April 8, 2005 / Rome, Italy / Aerial view of Saint Peter's Square during John Paul II's funeral.

April 8, 2005 / Rome, Italy / Cardinals praying before John Paul II's casket.

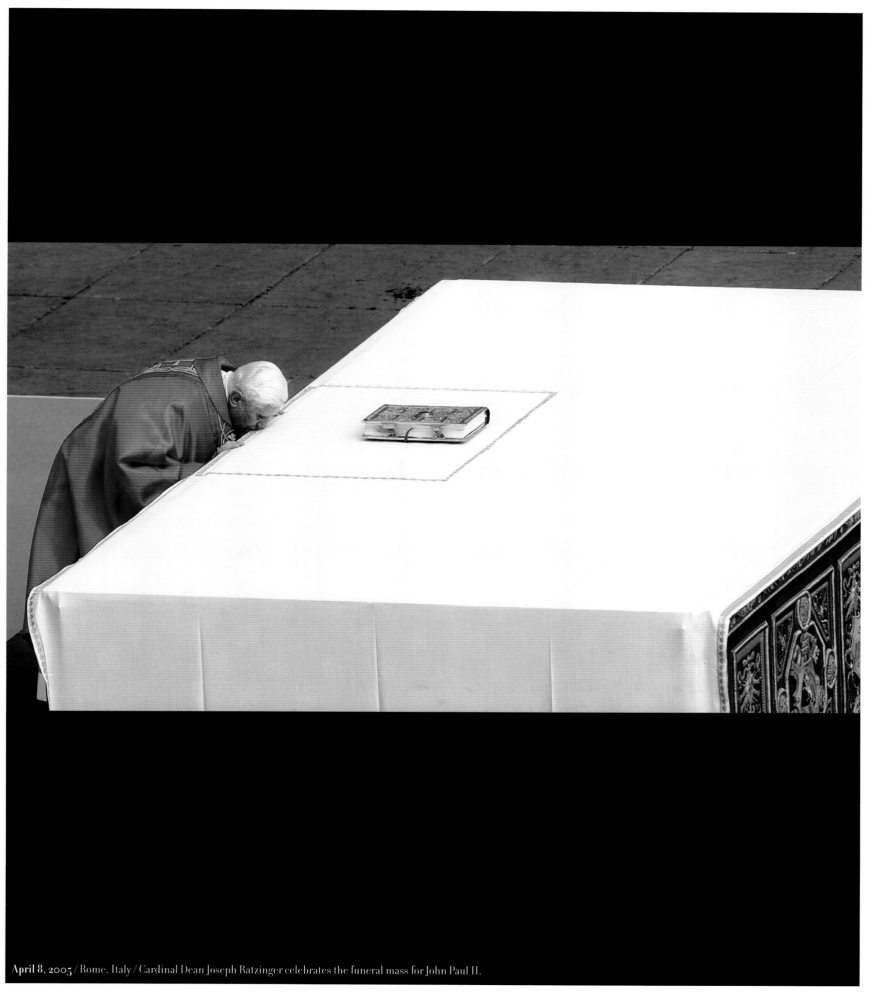

April 8, 2005 / Rome, Italy / Cardinal Dean Joseph Ratzinger celebrates the funeral mass for John Paul II.

June 30, 2000 / Rome, Italy / John Paul II's last will and testament, written in six sessions between 1979 and 2000. The document reveals that the pope considered retiring around the year 2000, and also that he considered the possibility of being buried in his native Poland.

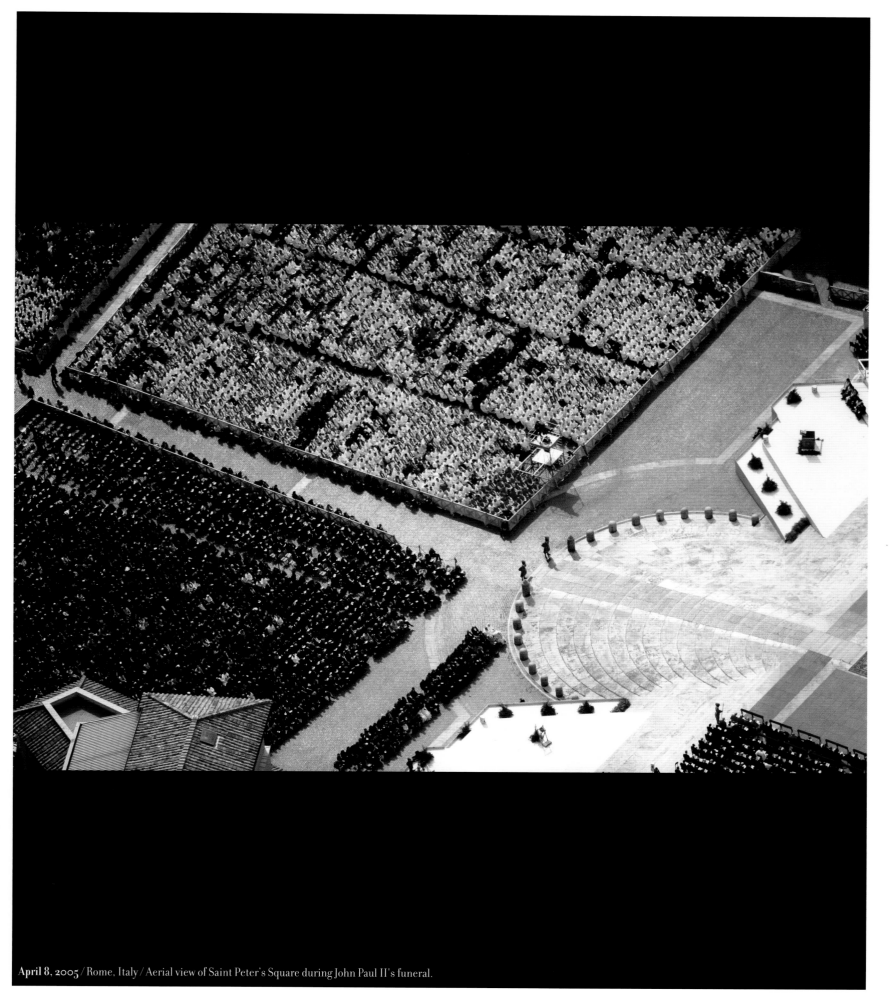

April 8, 2005 / Rome, Italy / Aerial view of Saint Peter's Square during John Paul II's funeral.

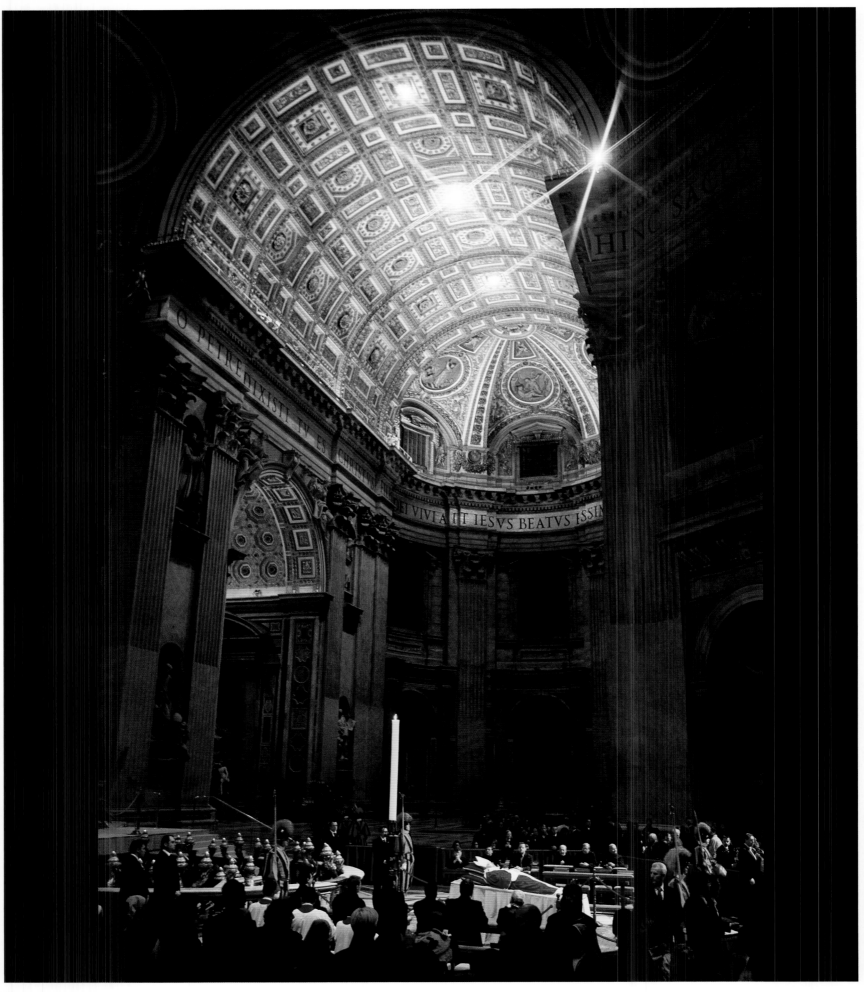

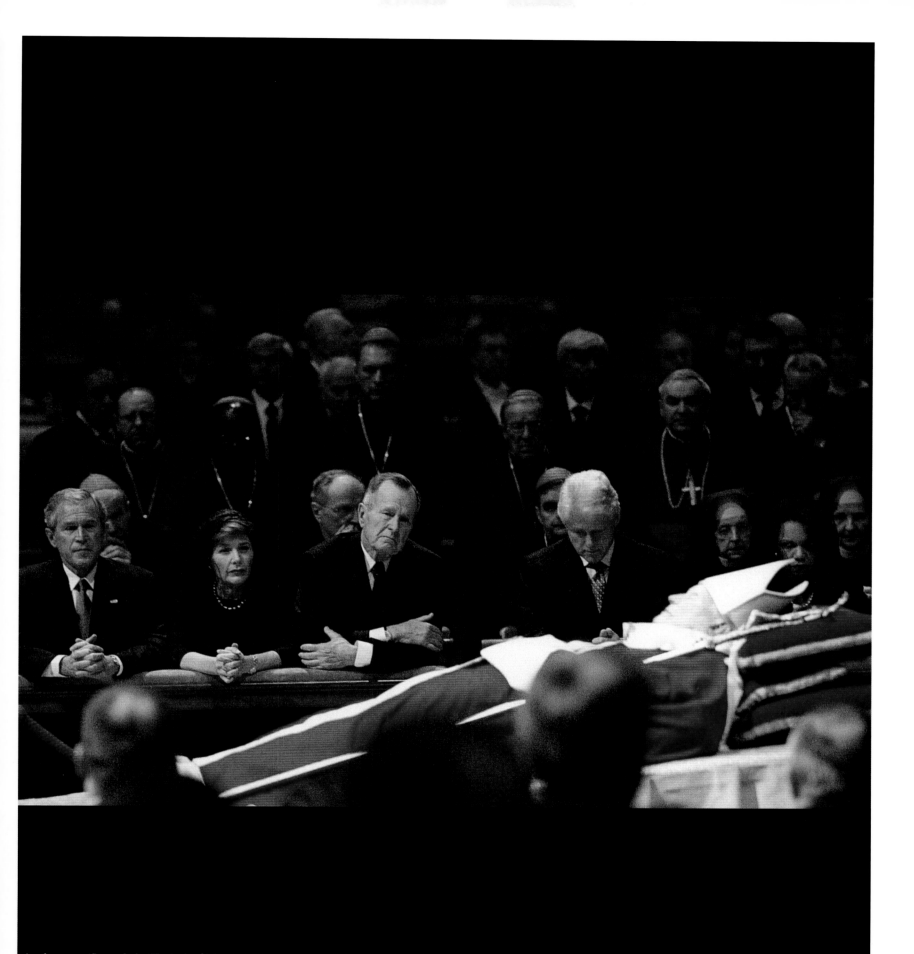

April 4, 2005 / Rome, Italy / The body of John Paul II lies in state inside Saint Peter's Basilica to allow everyone the opportunity to pray before his remains.

April 6, 2005 / Rome, Italy / President George W. Bush, First Lady Laura Bush, former presidents George H. W. Bush and Bill Clinton, and Secretary of State Condoleezza Rice pray before the body of John Paul II.

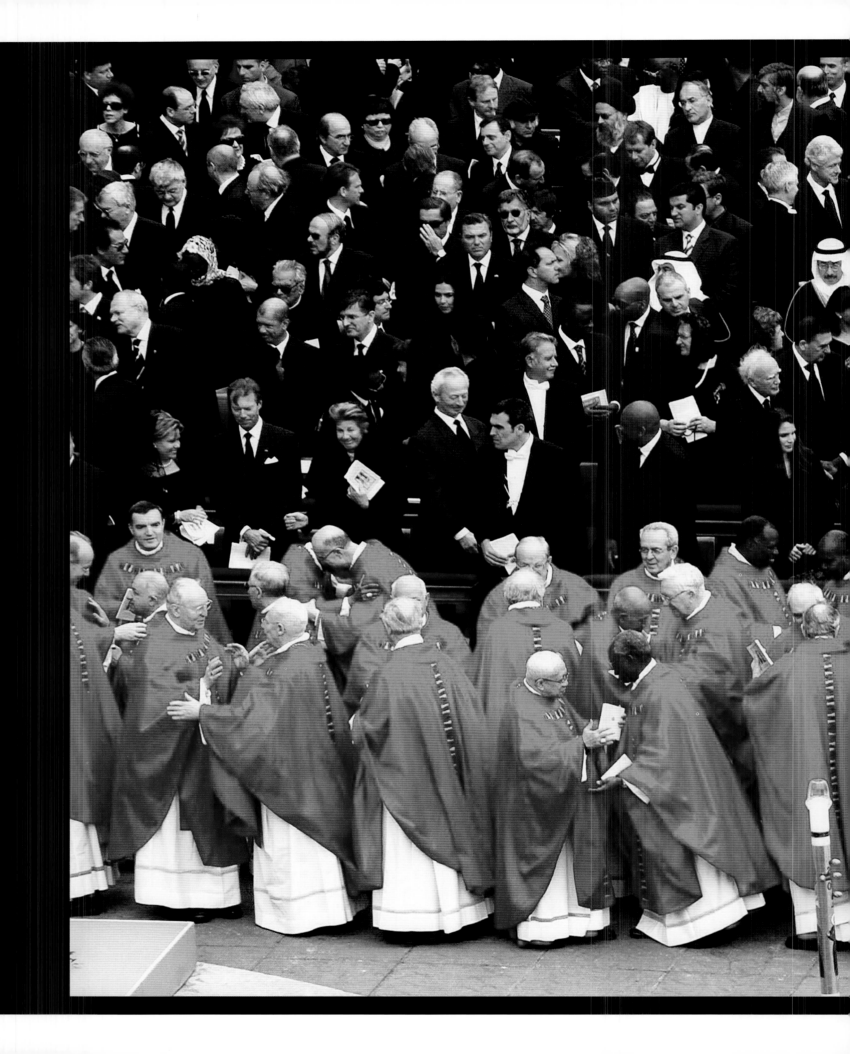

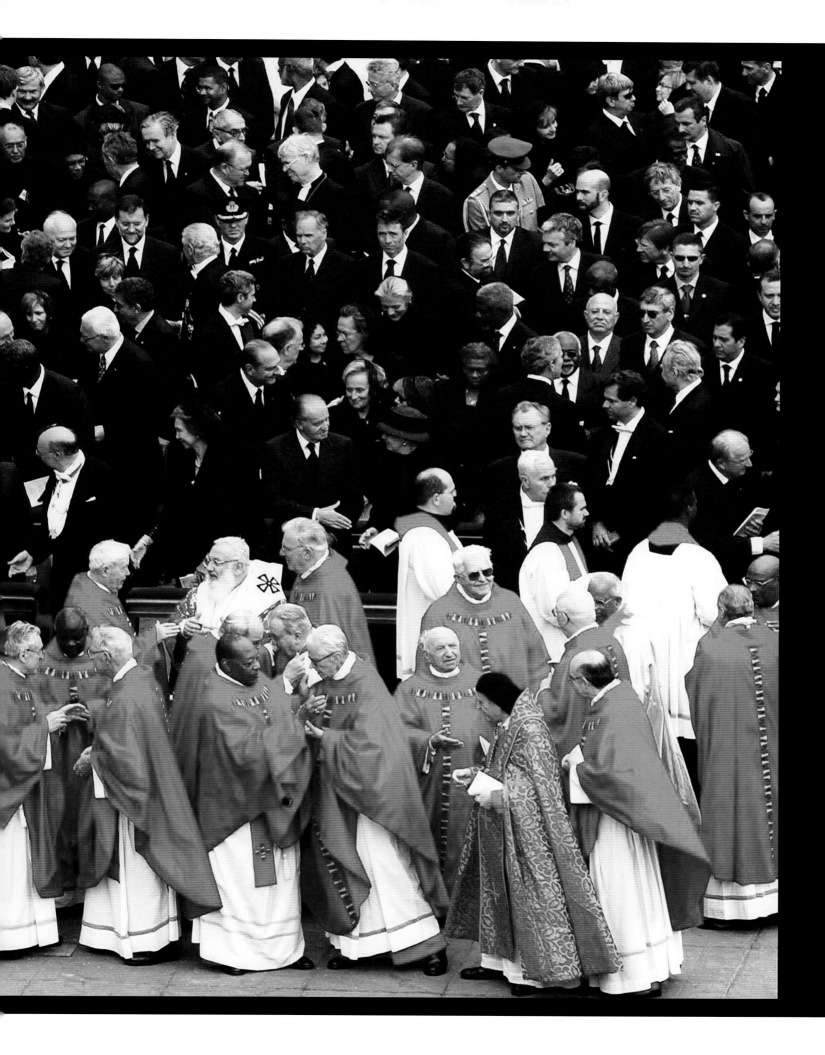

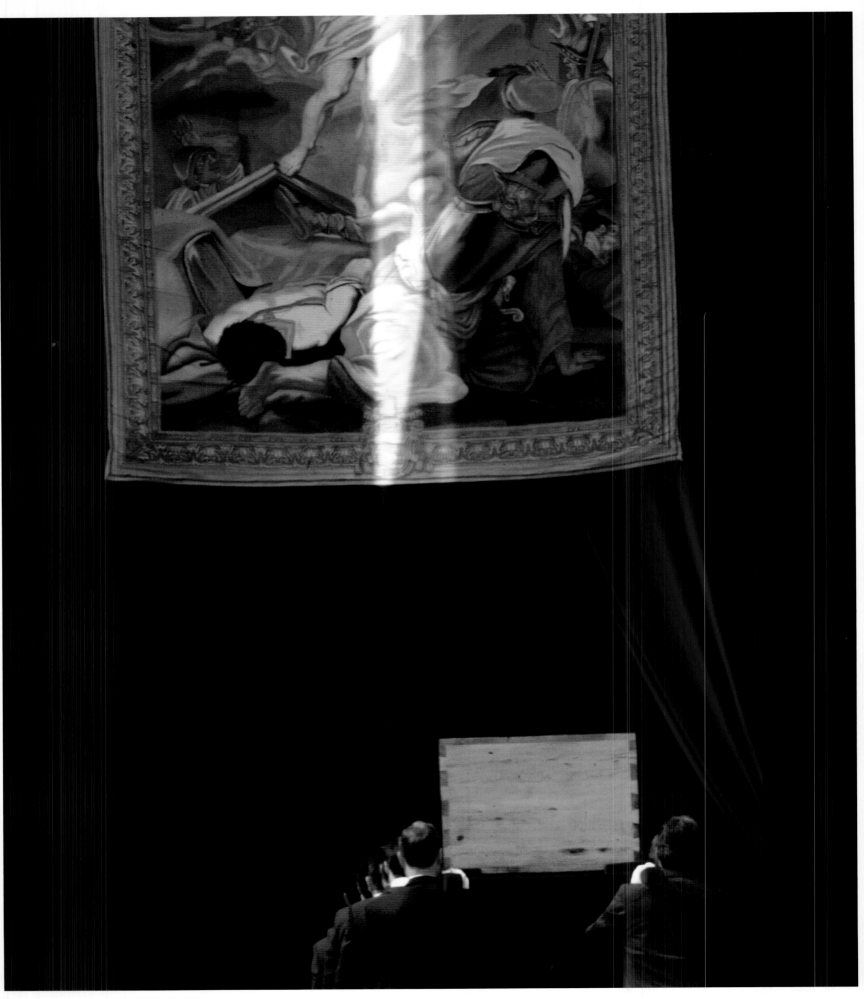

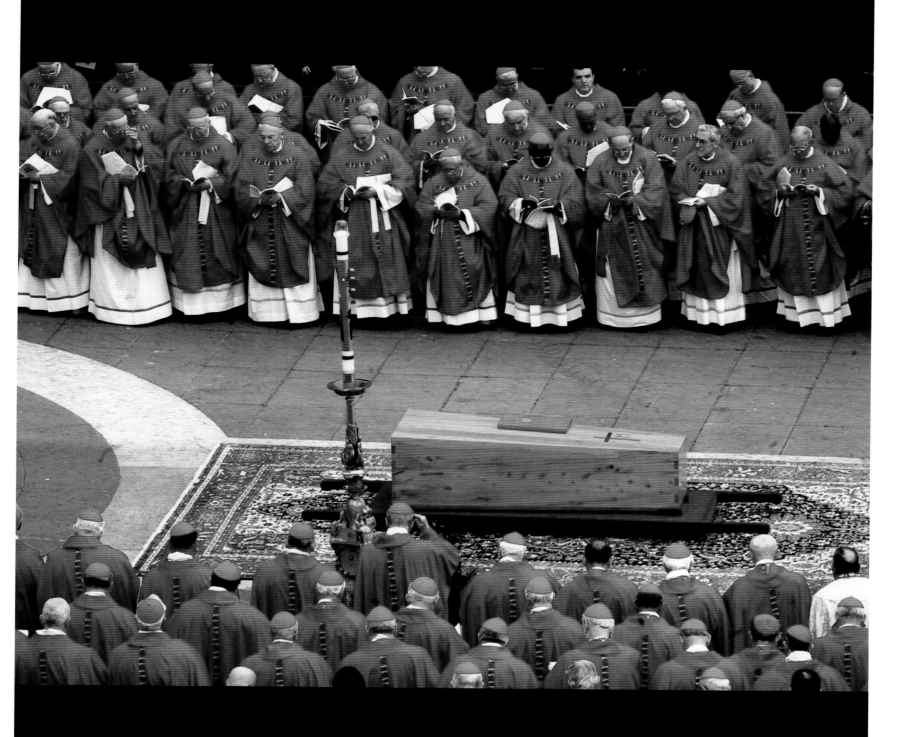

pp. 232–233:

April 8, 2005 / Rome, Italy / More than one hundred sixty dignitaries and heads of state attend John Paul II's funeral, which takes place in Saint Peter's Square.

April 8, 2005 / Rome, Italy / Following the mass, the casket containing John Paul II's body is carried into Saint Peter's Basilica by ten Sediari, who once served as bearers of the *seda gestatoria* (papal sedan chair), to the singing of the Magnificat.

April 8, 2005 / Rome, Italy / Led by Cardinal Dean Ratzinger, the cardinals, dressed in red and wearing their white miters in a sign of mourning, surround John Paul II's cypress-wood casket during the funeral mass.

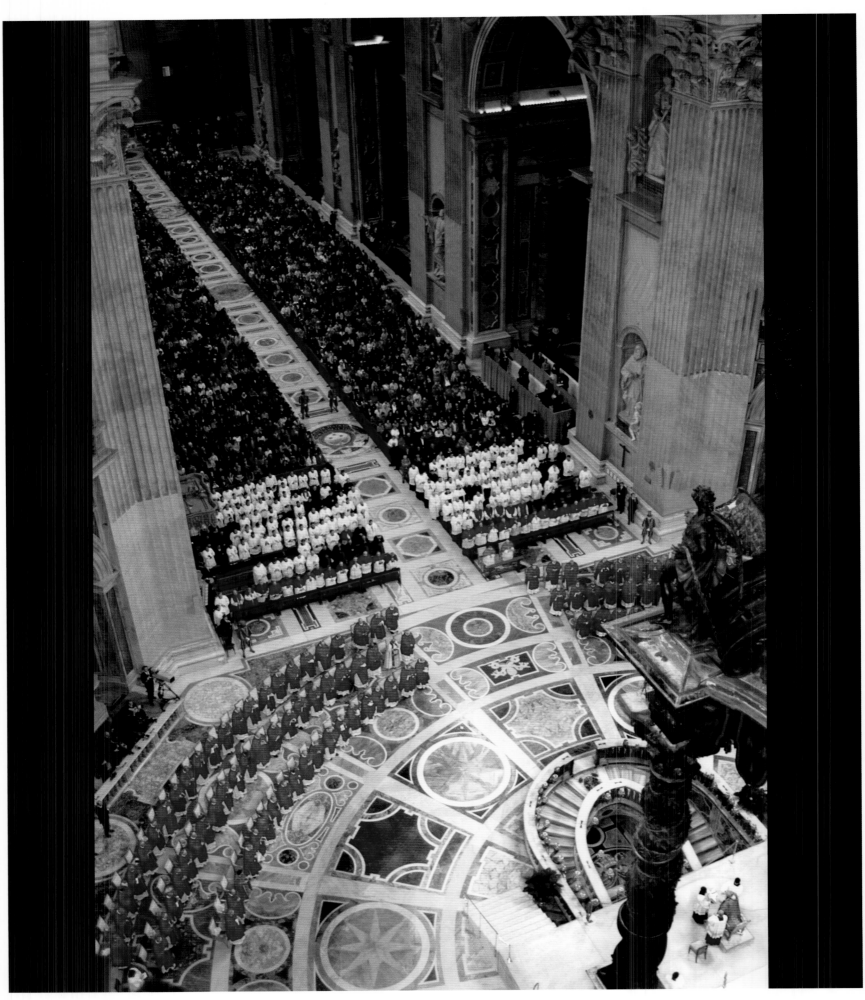

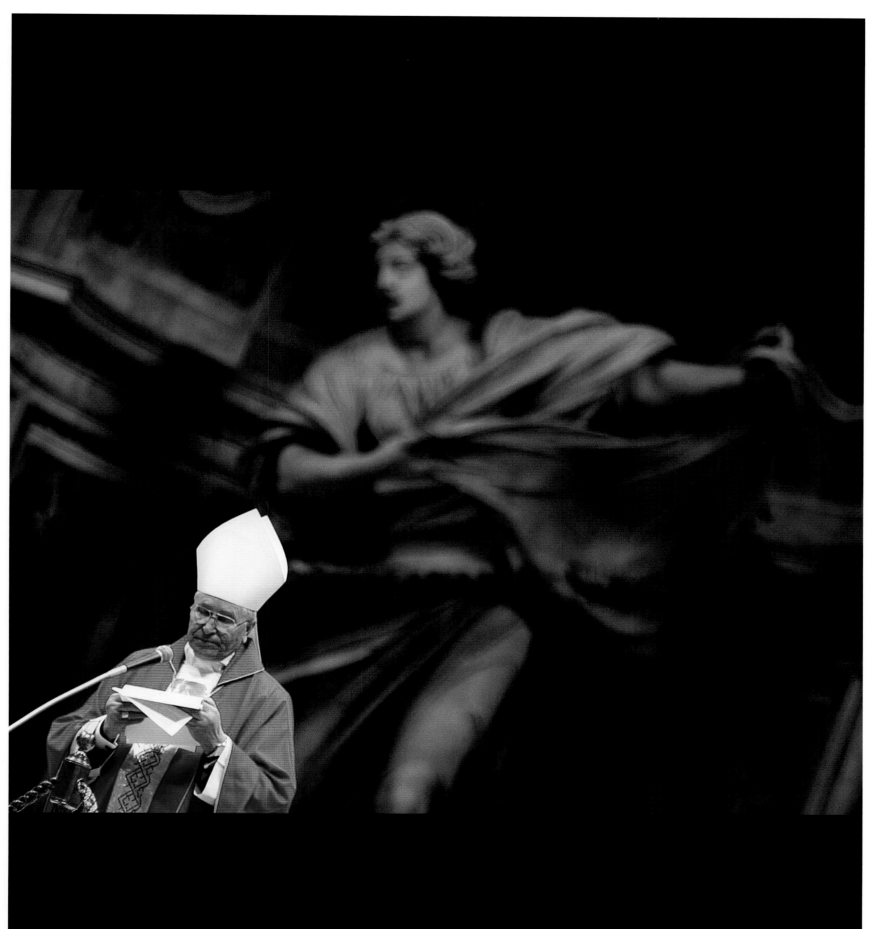

April 12, 2005 / Rome, Italy / The cardinals attend a mass celebrated in memory of John Paul II, while the crypt containing the late pope's body is briefly open to the public. After the April 8, 2005 funeral mass for John Paul II, the cardinals celebrated a nine-day series of masses of mourning called Novemdiales.

April 15, 2005 / Rome, Italy / Cardinal Piergiorgio Silvano Nesti celebrates the Novemdiale.

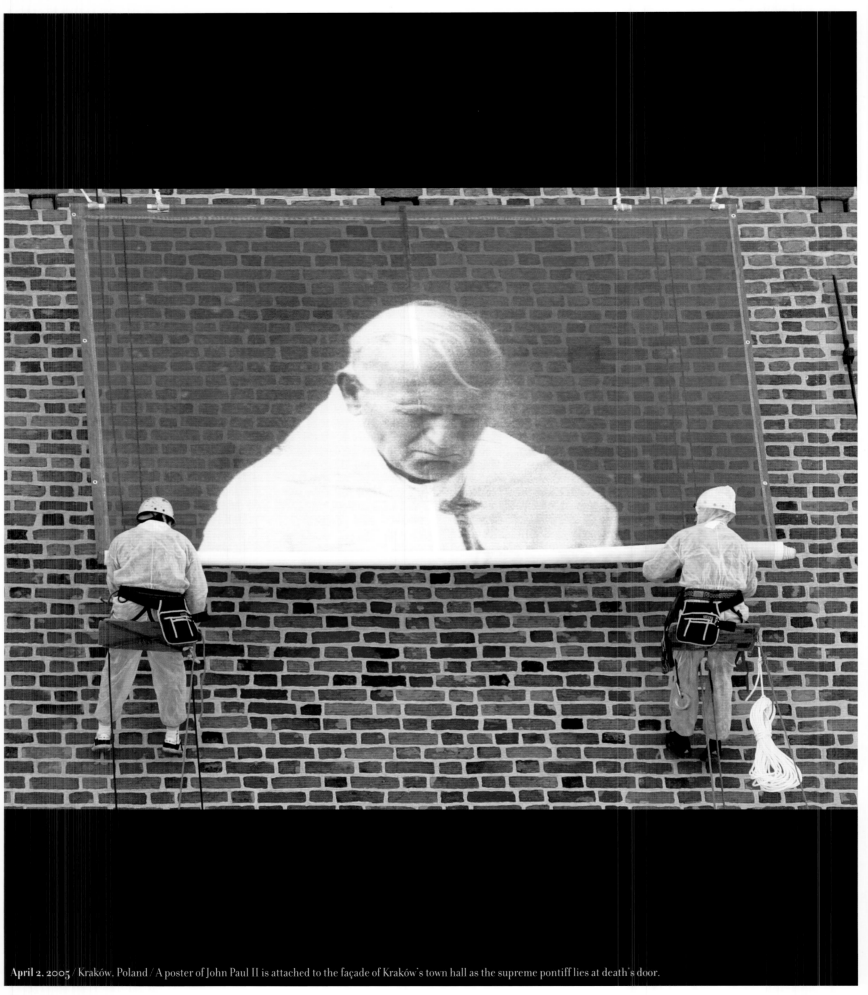

April 2, 2005 / Kraków, Poland / A poster of John Paul II is attached to the façade of Kraków's town hall as the supreme pontiff lies at death's door.

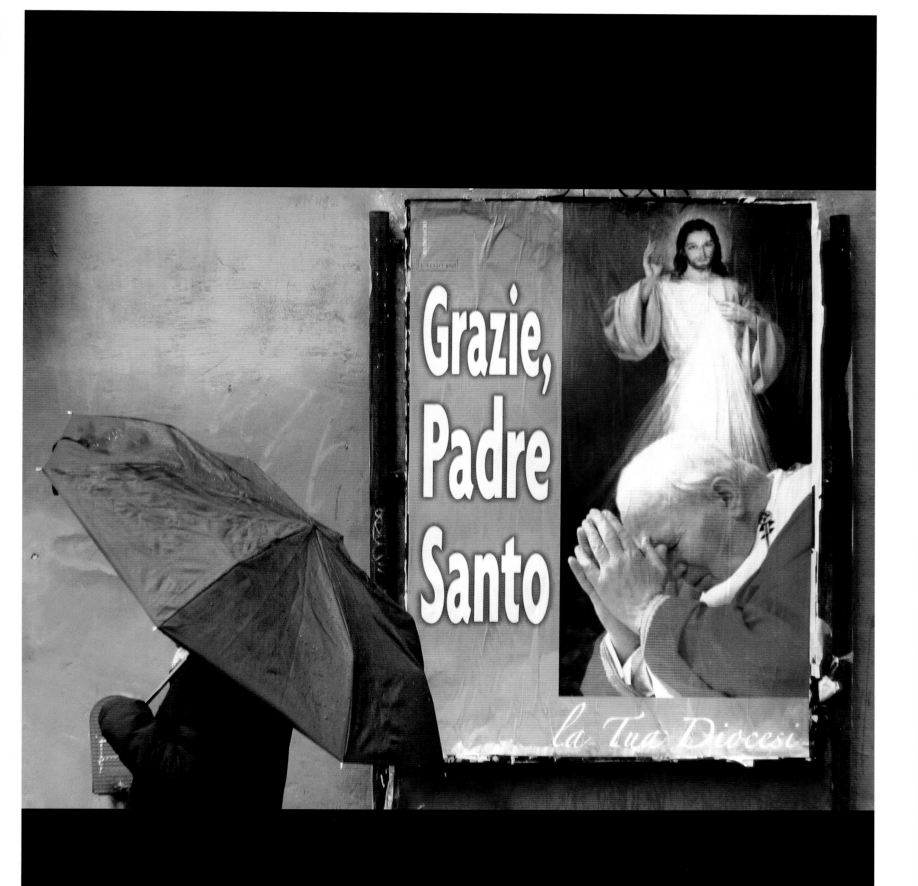

April 9, 2005 / Rome, Italy / Wall poster that reads, "Thank You, Holy Father."

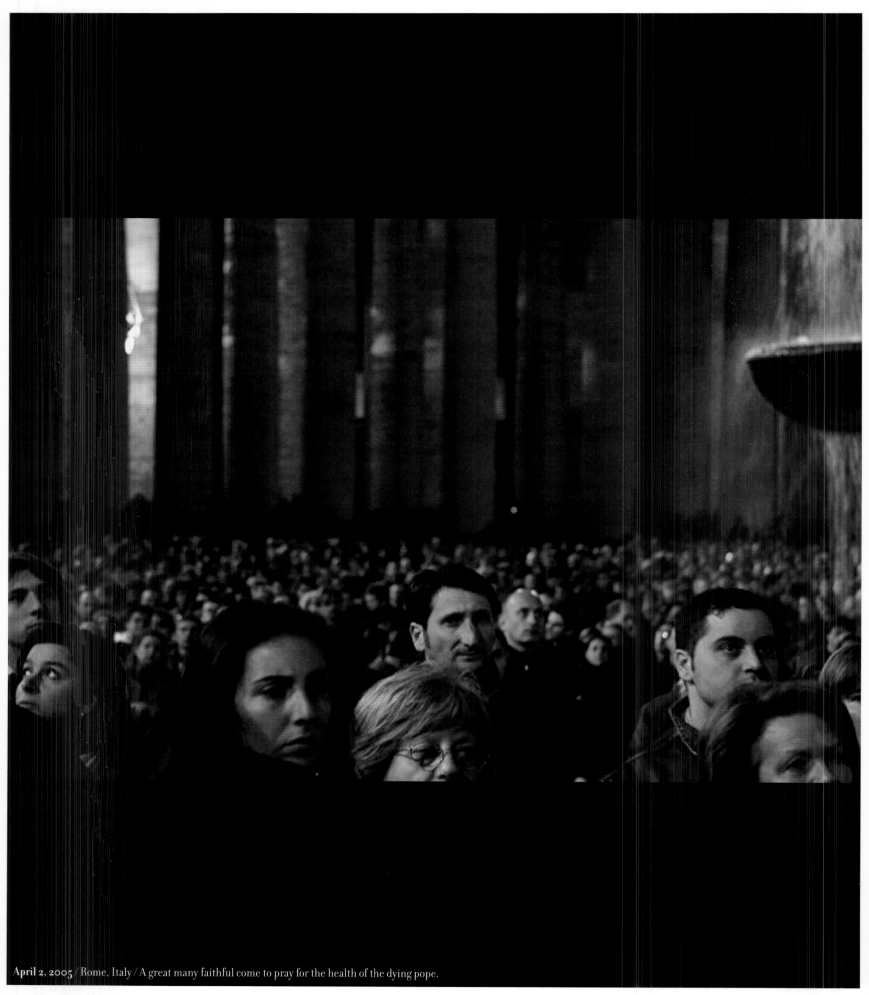

April 2, 2005 / Rome, Italy / A great many faithful come to pray for the health of the dying pope.

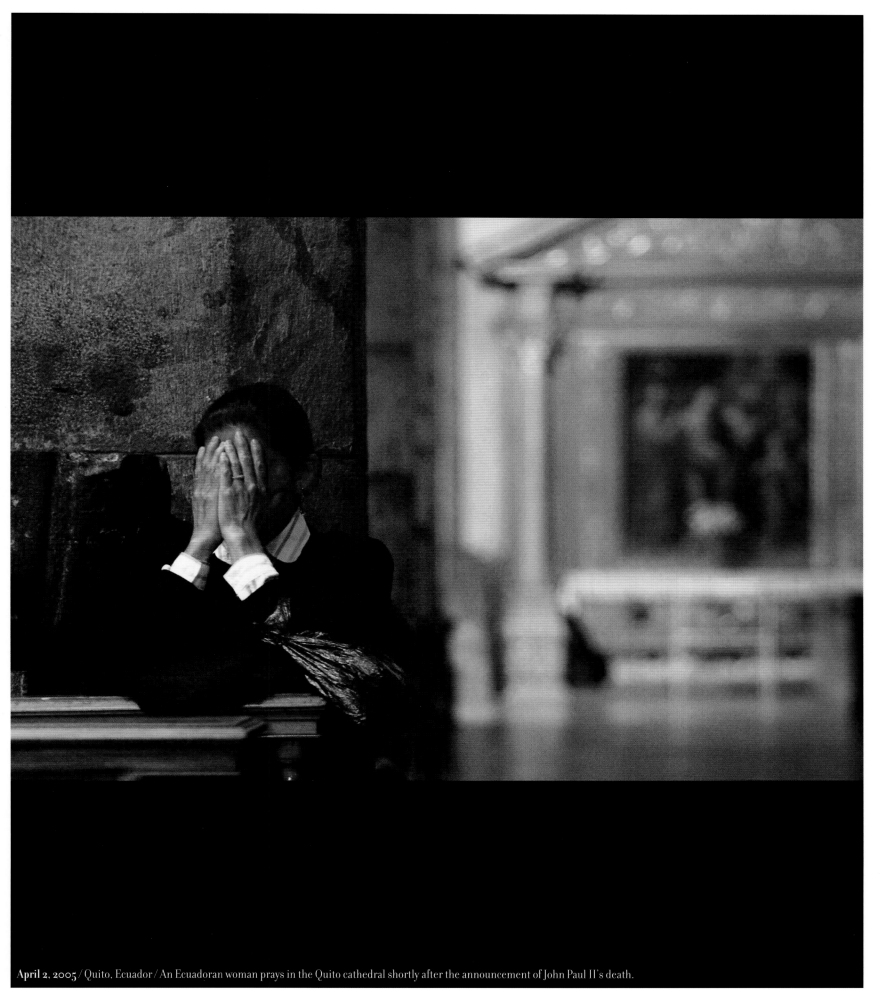

April 2, 2005 / Quito, Ecuador / An Ecuadoran woman prays in the Quito cathedral shortly after the announcement of John Paul II's death.

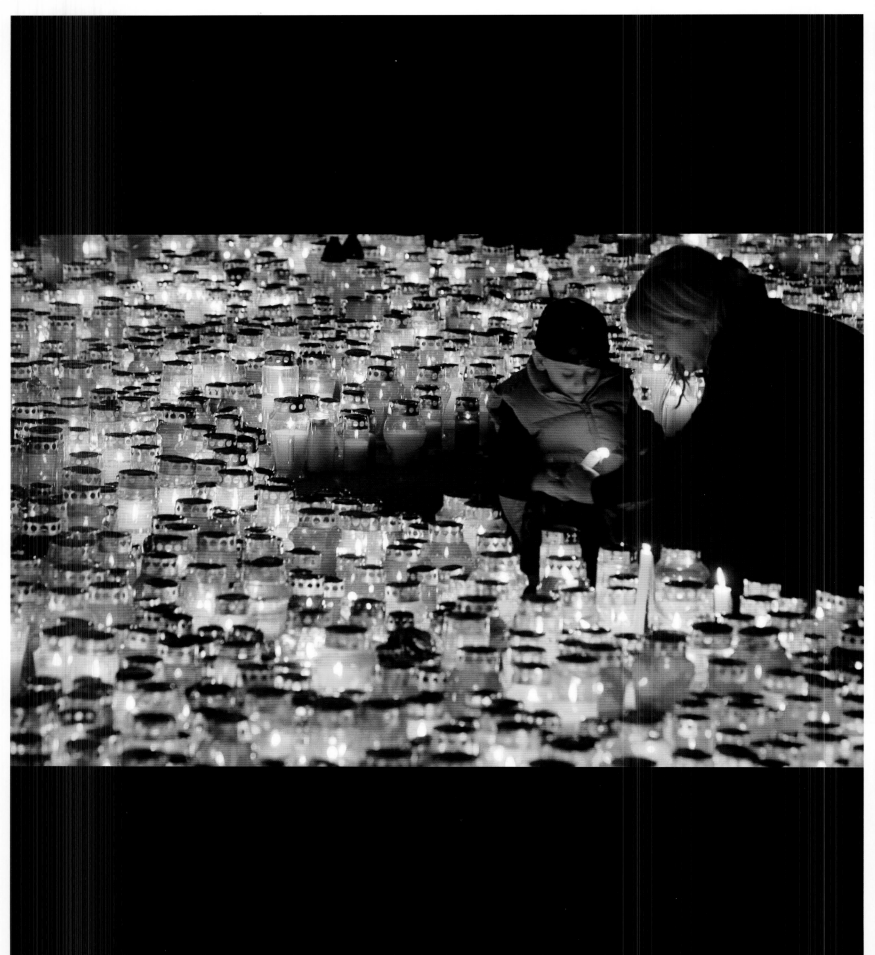

April 3, 2005 / Zagreb, Croatia / A young Croat lights a candle for John Paul II, dead the night before at the age of 84. Thousands of Croats spontaneously lit candles in memory of this pope who visited their homeland three times during his pontificate.

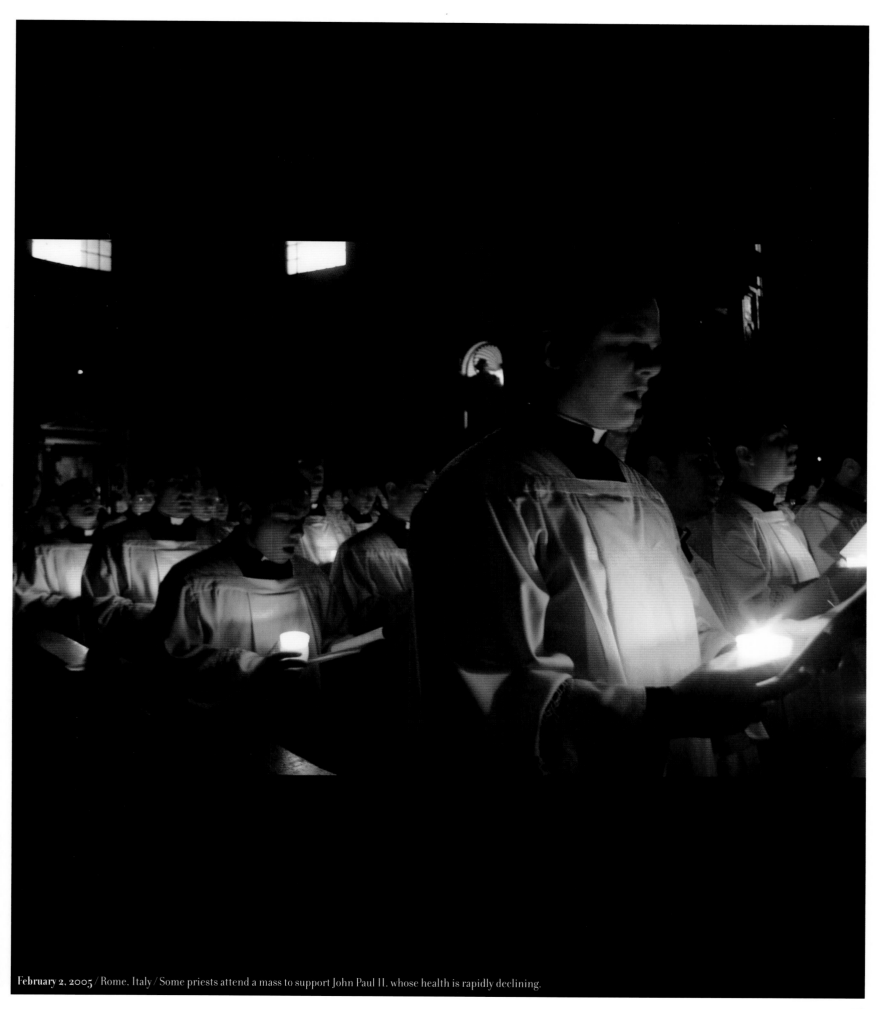

February 2, 2005 / Rome, Italy / Some priests attend a mass to support John Paul II, whose health is rapidly declining.

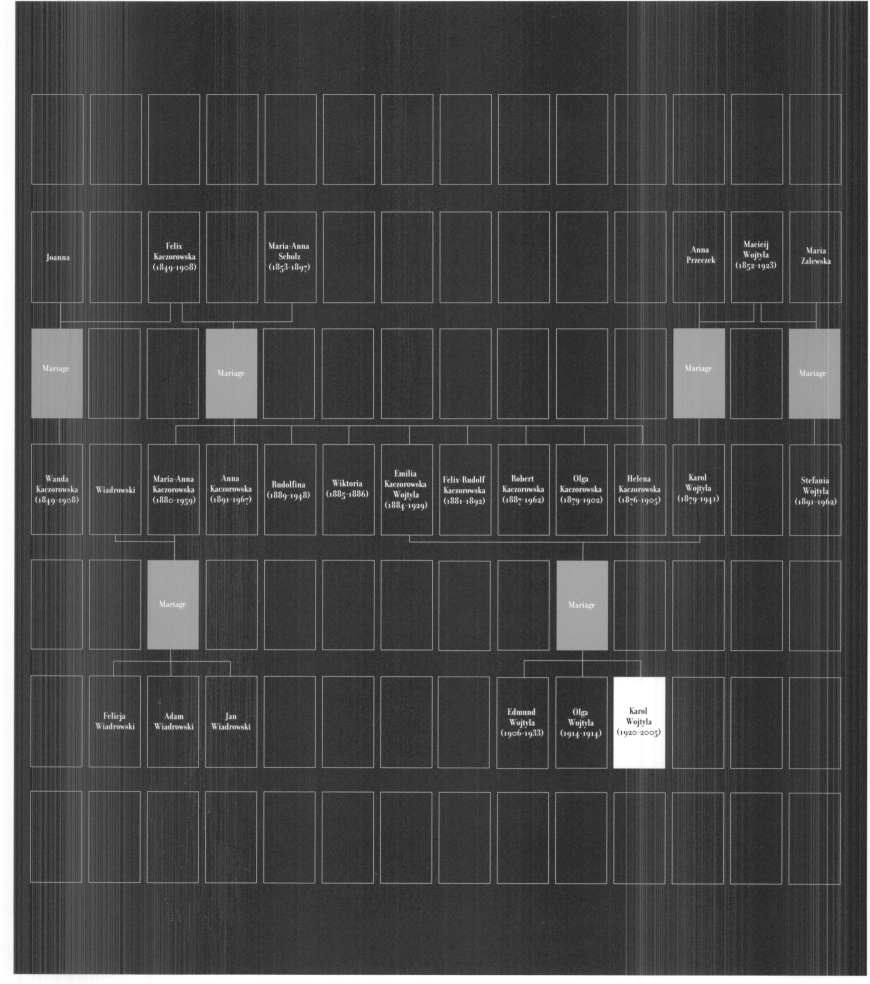

Joanna

Felix
Kaczorowska
(1849-1908)

Maria-Anna
Scholz
(1853-1897)

Anna
Przeczek

Macieij
Wojtyla
(1852-1923)

Maria
Zalewska

Mariage

Mariage

Mariage

Mariage

Wanda
Kaczorowska
(1849-1908)

Wiadrowski

Maria-Anna
Kaczorowska
(1880-1959)

Anna
Kaczorowska
(1891-1967)

Rudolfina
(1889-1948)

Wiktoria
(1885-1886)

Emilia
Kaczorowska
Wojtyla
(1884-1929)

Felix-Rudolf
Kaczorowska
(1881-1892)

Robert
Kaczorowska
(1887-1962)

Olga
Kaczorowska
(1879-1902)

Helena
Kaczorowska
(1876-1905)

Karol
Wojtyla
(1879-1941)

Stefania
Wojtyla
(1891-1962)

Mariage

Mariage

Felicja
Wiadrowski

Adam
Wiadrowski

Jan
Wiadrowski

Edmund
Wojtyła
(1906-1933)

Olga
Wojtyla
(1914-1914)

Karol
Wojtyla
(1920-2005)

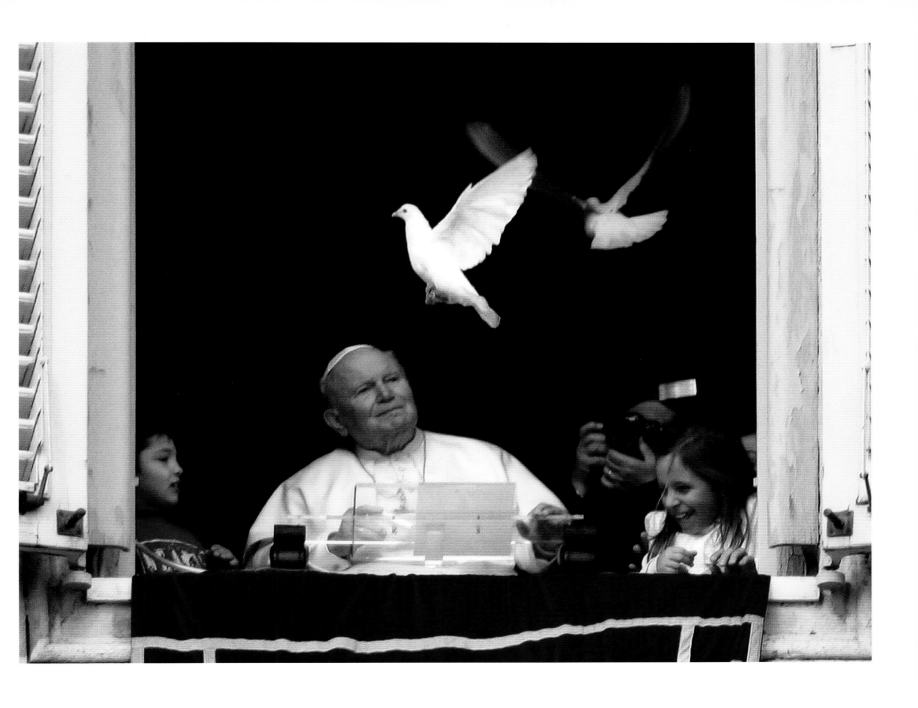

January 30, 2005 / Rome, Italy / John Paul II releases two doves from the window of his apartment in Saint Peter's Square, at the end of the weekly Angelus prayer.

Acknowledgments

Pierre-Henri Verlhac dedicates this project to Hortense, Raphaëlle, and Victoire.

Yann-Brice Dherbier dedicates this book to the woman he loves, Axelle.

The authors would like to thank:
… Bernard Bos, Antonio Pelayo, and Henri Tincq
for shedding new light on John-Paul II's life
… Alain and Daniel Regard for perfecting our selection of these timeless images
… Lara Adler, Marco Barbon, Anouck Baussan, Eléonore Bakhtadze,
Sophie Bertrand, Marie-Christine Biebuyck, Ewa Burdynska,
Boris Chague, Martine Detier, Kris Hook, Mohammed Lounes,
Gina Martin, Barbara Mazza, Chrystelle Raignault, Michèle Riesenmey,
Sébastien Robcis, Xavier Rousseau, Linda Ruzicic, Michael Shulman,
Fanny Steeg, and Suzanne Weller for helping us with our photo edit.

Credits

Abbas / Magnum Photos : 138, 148, 168, 181, 204, 218
Adam Gatty-Kostyal / AP : 41
AFP : 214
Alfred / Facelly / Sipa : 200, 206
Archives : 20, 30, 31, 59, 60, 63, 72
Associated Press : 74
Bernard Bisson / Corbis Sygma : 146
Bettmann / Corbis : 118, 129, 133, 155
Boccon - Gibod / Sipa Press : 114, 152, 153, 187
Bojesen / Sipa Press : 102, 103
Bruno Barbey / Magnum Photos : 97, 99, 107, 131, 175
Carlos Cazalis / AFP : 201
Collection Laski / East News : 65, 77
Collection Laski / East News / Gamma : 35, 39
Corbis Sygma : 193
Danilo Schiavella / AFP : 231
David Lees / Corbis : 80
Derrick Ceyrac / AFP : 202
Detroit News / World Picture News : 189
Diana Walker / Time Life Pictures / Getty Images : 191
Domenico Stinellis / AP : 213, 215
Elliott Erwitt / Magnum Photos : 92, 93
Emanuele Mozzetti / World Picture News : 223
Eric Vandeville / Gamma : 227, 232, 235
Fabian Cevallos / Corbis Sygma : 139
Facelly / Sichov / Sipa : 208, 209
Felici - Xy / Gamma : 142, 164
Ferdinando Scianna / Magnum Photos : 130, 167, 170, 173
Filippo Monteforte / AFP : 226
Franco Origlia / AFP : 243
Franco Origlia / Corbis Sygma : 216
François Lochon / Gamma : 98, 104, 106, 125-127, 135, 157, 166, 176
Francolon - Lochon / Gamma : 136
Fred Mayer / Getty Images : 82-87, 89, 90, 95, 100, 101, 109, 196
Gabriel Bouys / AFP : 203, 239
Galazka / Sipa Press : 145, 212, 221
Gamma : 224, 236
Gianni Giansanti / Gamma : 96
Gilles Peress / Magnum Photos : 111
Gueorgui Pinkhassov / Magnum Photos : 240
Guerrini / Gamma : 165
Guy Le Querrec / Magnum Photos : 160
Hrvoje Polan / AFP : 242
Ian Berry / Magnum Photos : 141, 161
Italfoto / Sipa Press : 177
James Stanfield / National Geographic : 159
Jean Gaumy / Magnum Photos : 120, 122
Jeff Mitchell / Reuters / Corbis : 140
Jun Dagmang / AFP : 182
Kevin Frayer / AFP : 205
Keystone France / Gamma : 117
Kirk Dozier / Detroit News / World Picture News : 190
Kurita Kaku / Gamma : 150
Marc Riboud / Magnum Photos : 123
Marco Longari / AFP : 237
Mark Peterson / Corbis : 180
Martine Franck / Magnum Photos : 156, 219
Max Rossi / Reuters / Corbis : 207
Michael Kappeler / AFP : 238
Mike Persson / AFP : 185
Nivière / Meigneux / Sipa : 230
OFF / AFP : 228
Paolo Cocco / AFP : 234
Paolo Pellegrin / Magnum Photos : 222
Patrick Hertzog / AFP : 245
Peter Marlow / Magnum Photos : 147
Peter Turnley / Corbis : 192
Polizia Moderna / AFP : 229
Pool Gamma : 121
Preisig / Magnum Photos : 132

Raghu Rai / Magnum Photos : 169, 178, 179
Ralph Alswang / White House / Time Life Pictures / Getty Images : 195
Raymond Depardon / Magnum Photos : 81
René Levêque / Corbis Sygma : 149
Rodrigo Buendia / AFP : 241
Rzepa / World Picture News : 197
Sintesi / Sipa Press : 186
Sipa Press : 154
Stuart Franklin v Magnum Photos : 174
Susan Meseilas / Magnum Photos : 143
Telegraph Herald / WPN : 112
UPI / AFP : 105
Vittoriano Rastelli / Corbis : 110, 115, 137
Viviane Rivière / Roger-Viollet : 15-18, 23, 26, 27, 29, 32-34, 36, 37, 42, 43, 49, 50-52, 54, 55, 62, 64, 66-69, 71, 73, 75
Viviane Rivière / Sipa Press : 47
Volpe / Sipa Press : 128
Wojtek Laski / Sipa Press : 14, 19, 21, 22, 25, 40, 45, 46, 53, 57, 58, 61, 78, 79, 88
Ziv Koren / Corbis Sygma : 199